L. S. LOWRY

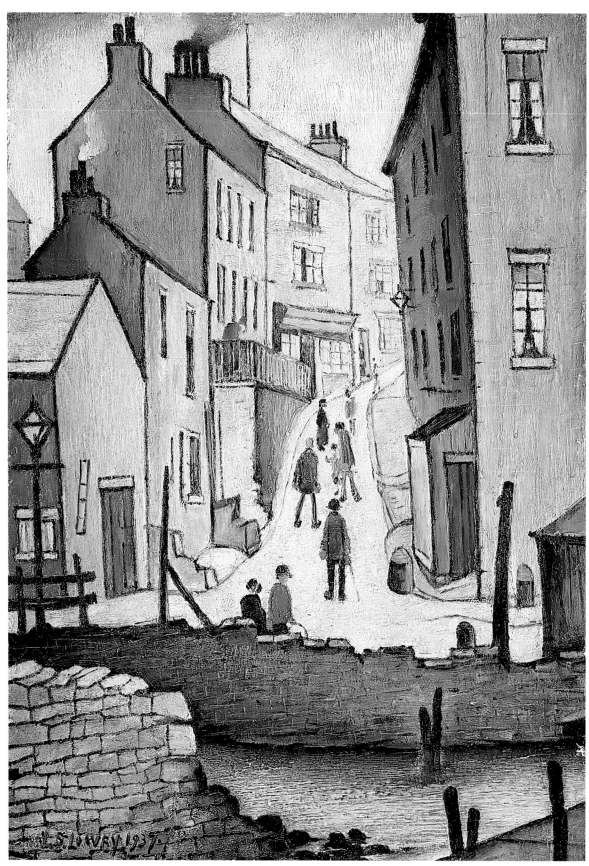

An Old Street. 1937. Kirkcaldy Art Gallery. Cat. 28

L.S. LOWRY

EDITED BY

Michael Leber and Judith Sandling

Phaidon Press and Salford Art Gallery

Sponsored by The Royal Bank of Scotland plc

Published for the L. S. Lowry Centenary Exhibition, organized by Salford Art Gallery with the help of the Arts Council of Great Britain

Salford Art Gallery, 16 October–29 November 1987. Exhibition selected and compiled by Michael Leber and Judith Sandling

Phaidon Press Limited, Littlegate House, St Ebbe's Street, Oxford OX1 1SQ

First published 1987
© Phaidon Press Limited 1987

British Library Cataloguing in Publication Data
L. S. Lowry: a definitive study of the
 artist's life and work.
 1. Lowry, L. S.—Criticism and
 interpretation
 I. Lowry, L. S.
 759.2 ND497.L83

 ISBN 0-7148-2475-5
 ISBN 0-7148-2476-3 Pbk

Typeset in Ehrhardt and printed by Balding + Mansell UK Limited, London and Wisbech

'The Lonely Life of L. S. Lowry' by Edwin Mullins first appeared in the *Sunday Telegraph* in 1966.

Acknowledgements

We would like to thank in particular Julian Spalding, Marina Vaizey and Edwin Mullins for their enthusiastic contributions to this project; Mrs Carol Danes, for her unstinting support and for giving copyright approval; the staff of all the public galleries and organizations which possess works by L. S. Lowry; the Cultural Services Committee and Department of the City of Salford, and the L. S. Lowry Festival Sub-Committee for their assistance. We would also like to thank Catherine Long, who has given much valuable support and effort, and the many people who have contributed their knowledge of the artist. We thank Lynne and Bob, whose unerring encouragement and enduring patience have made the task less difficult and more enjoyable. Finally, we acknowledge the debt owed to S. J. Cleveland, J. M. Maltby, James Bourlet and Sons, Alex McNeill Reid and Ted Frape who believed in Lowry and brought him to the attention of us all.

Michael Leber
Judith Sandling

Contents

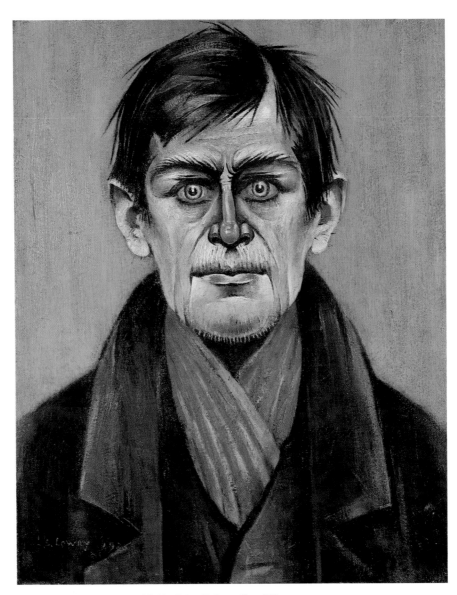

Head of a Man. 1938. City of Salford Art Gallery. Cat. 278

Foreword

1 November 1987 marks the centenary of the birth of L. S. Lowry. His art, being popular and northern, tends not to be thought of as being in the mainstream of British, let alone European, painting. Indeed, in the large exhibition surveying twentieth-century British art held at the Royal Academy earlier this year, Lowry himself was not included, even though this same institution organized the extensive and highly popular Retrospective of his work in 1976, the year of his death. It is a paradox that would have amused Mr Lowry but serves only to further confuse those who hold him in great esteem and affection.

To see the artist's work and to understand his life, you will have to travel to his native North West. If you want to see Lowry at home, you will have to go to Manchester City Art Gallery, where his living room and his studio have been reconstructed as he left them at his death. If you want to see his pictures you will have to go to Salford, where the art gallery has amassed by far the finest, largest and most comprehensive collection of his paintings and drawings.

The collection is a tribute to the skill, dedication and foresight of the gallery under successive curators over fifty years. Michael Leber and Judith Sandling have sustained this spirit by producing this catalogue, which lists for the first time all Lowry's work in public collections, and by organizing a major exhibition which draws many of these works together to create a vast, entertaining and moving tribute to Salford's most famous artist.

The Royal Bank of Scotland, which has done so much for the arts in the North West, has sponsored the exhibition of Lowry's paintings, a selection of which is being toured as a South Bank Centre/Arts Council exhibition.

Julian Spalding
Director
City Art Gallery, Manchester

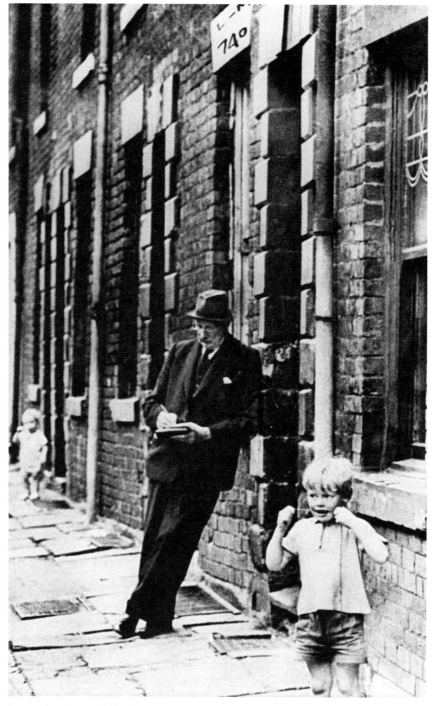

Lowry sketching in Salford

1

L. S. Lowry

MICHAEL LEBER

THE LONG APPRENTICESHIP

In November 1938 Laurence Stephen Lowry was fifty-one years old. After drawing and painting for over thirty-five years he stood on the threshold of an artistic breakthrough. He had just been offered his first one-man exhibition at the prestigious London gallery of Reid and Lefevre. For most other artists, this would have been a time of nervous anticipation and a realization that the years of effort were finally yielding results.

Lowry was in no such mood and, at this critical time in his life, there is remarkable evidence of the state of his mind and the reason for it. For in 1938 he painted *Head of a Man* (Cat. 278), for long considered an imaginary portrait but, in fact, a harrowing and introverted self-analysis. Few other portraits can project such an intense feeling of emptiness or of desolation. The unkempt hair, stubbled chin and sunken cheeks may merely indicate a degree of neglect; the deeply carved eyebrows and facial lines are evidence of tension and stress. But it is the eyes which haunt the observer. Ringed with a vivid red they are hollow. They stare vacantly yet piercingly. They are the eyes of a man who has lost his reason for existing.

At the time, Lowry's mother lay dying. Elizabeth Lowry had long been ill and had been bedfast for over six years since shortly before the death of her husband. In all that time, Lowry had nursed her and now, at the very moment that his proudest achievement was approaching, she was slipping away. No other person mattered to the artist. Dora Holmes, who knew the family well, recalled later 'he lived for her, for a smile and for a word of praise. He was absorbed in her and she took up all his time.' Elizabeth Lowry took leave of her life on 12 October 1939. For the middle-aged artist it was the cruellest blow imaginable. 'It all came too late,' he was to say repeatedly of his success.

Yet, although his life became meaningless, Lowry did endure. The inner man could not be blotted out, but a mask could be worn to hide the futility of it all. As Shelley Rohde succinctly reported, 'He changed a few of his ways, adjusted a few attitudes, bought a few things but his life-style remained the same—the frugality and abstention from indulgence as seen in the non-smoking, non-drinking, non-womanizing habits of a lifetime. His modesty and humility remained, and his determination to go his own way as an artist. The enjoyment he derived from what he liked to call the great Battle of Life was enough to bring him contentment, if not actual or lasting joy.' There was a life to be got through and work to

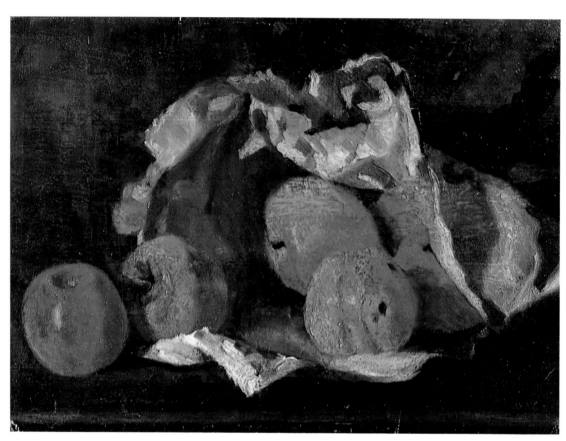

Plate 1 *Still Life. c.*1906. City of Salford Art Gallery. Cat. 102

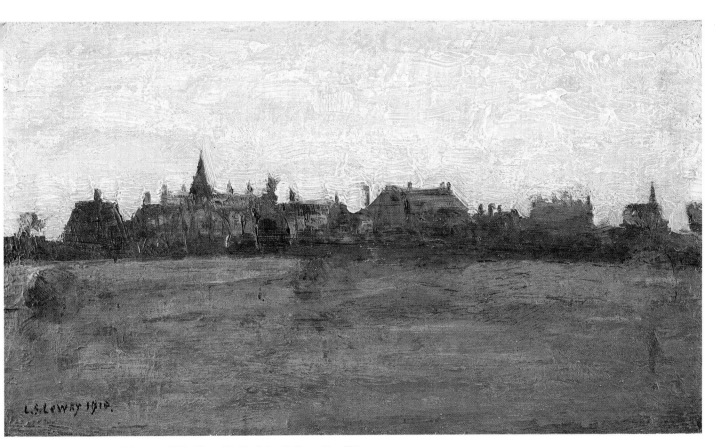

Plate 2 *Clifton Junction – Morning*. 1910. City of Salford Art Gallery. Cat. 111

Fig. 1 *The Artist's Mother.*
*c.*1920. City of Salford Art
Gallery. Cat. 181

Fig. 2 *Robert Lowry (The
Artist's Father): c.*1919. City of
Salford Art Gallery. Cat. 147

be done. The impulse to paint, which had maintained him for so long, reclaimed him. It
was all that he had.

Lowry was born in Stretford, now a suburb of Manchester, on 1 November 1887. He
was the only son of Robert and Elizabeth Lowry. Few of their friends or relatives
understood why the couple had married. Robert was a hard-working clerk of Irish origin.
Like many Victorians he was somewhat fastidious, punctual, and a man of regular habits.
He was generous, friendly and well liked. He was, sadly, also a marked failure in the eyes of
his wife. Elizabeth was a refined woman; an accomplished pianist, she collected china and
clocks. Early in life she had acquired the habit of becoming ill whenever circumstances did
not please her, and few things brought her pleasure in her marriage. Not a popular woman
outside her family, Elizabeth was idolized by her son. He recalled later that 'she did not
understand my painting, but she understood me and that was enough.'

Elizabeth's only triumph was when the family moved to a modest house on the edge of
Manchester's Victoria Park, a pleasant tree-lined suburb with almost palatial mansions and
beautifully laid out gardens. Her sense of achievement was short-lived. Financial troubles
blighted the family and they were obliged in 1909 to move to Pendlebury, an industrial
town to the west of Manchester. Robert continued his work; Elizabeth withdrew from the
world, became more and more unwell and finally took to her bed to stay there until her
death.

It was into this strange mismatch of a marriage that Laurence, or Laurie as he was called,
was born. By his own account, 'I did not enjoy being a child. I was not interested. It wasn't a
nice time at all.' This is, perhaps, scarcely surprising. He seems to have missed out on much
of the play and companionship which bigger, more contented, families offered. His
schooling, likewise, was unremarkable. He was, even in childhood, an onlooker and an
outsider, bound by the Victorian ethic and etiquette which were to remain with him
throughout his life.

The only pastime which appears to have brought him any pleasure or family note was
drawing. In this he received little parental encouragement and it was left to aunts and
uncles to show some appreciation for the one talent in sad Laurie's life. Little remains of his
very earliest work, although a small drawing survives in a private collection. *Yachts*, 1902,
is a sketch of boats drawn on a family holiday at Lytham, on the Lancashire coast. It was a
theme that Lowry would return to again and again and the only part of his work which was

Fig. 3 *Head from the Antique.*
*c.*1908. City of Salford Art
Gallery. Cat. 108

Fig. 4 *Seated Male Nude. c.*1914.
City of Salford Art Gallery.
Cat. 131

to gain the slightest glimmer of approbation from his mother.

The young Lowry had to gain employment and, in 1904, he 'drifted into' office work as a clerk with a Manchester firm of accountants. The small degree of financial independence allowed him to take a few private lessons with Reginald Barber at his studio in Brown Street. Lowry also sought tuition from William Fitz, a German who had taught in New York. 'Billy Fitz was very good in making research on the forms of anything. You had to search for the forms, and then work on that. It did me a lot of good,' was Lowry's assessment. These few lessons were the limit of Lowry's education in painting but they are important, for from Fi he gained encouragement and some knowledge of handling paint. It is likely that *Still Life*, *c.*1906 (Cat. 102), is evidence of this early influence on Lowry. An academic study, the painting reveals Lowry as undergoing proper, if not inspired, teaching.

Before the end of 1910, there were three other highly influential developments which were to affect and mould the young artist: he started at art school, his family moved house, and he took a new job. The first of these developments, his enrolment as an evening student at the Manchester Municipal College of Art at All Saints, took place in 1905. At college he wrestled with drawing from the antique, claiming that the plaster statuary presented greater problems than the life class—'if you draw from life, whatever you do, you can say it was like that when I drew it, but it moved. You can't say that about the antique.' Lowry enjoyed the classes—'I saw people there, I liked the life. It was good to meet people there. My temperament made me very unsociable although that was not my wish.' To his fellow students, Lowry was rather odd. Whilst they were rejoicing in the liberation offered by Edwardian society, in the fresh visions of the new century and the Bohemianism thriving in art circles, Lowry retained the Victorian values of his childhood. Of his work at the classes Lowry was critically honest. 'I did not draw the life very well. I was competent. But I did find it valuable, and I still believe that long years of drawing the figure is the only thing that matters.' Fellow students supported Lowry's self-assessment. Sam Rabin remembers that 'Lowry wasn't a great figure draughtsman, but he would always try. Whatever else he

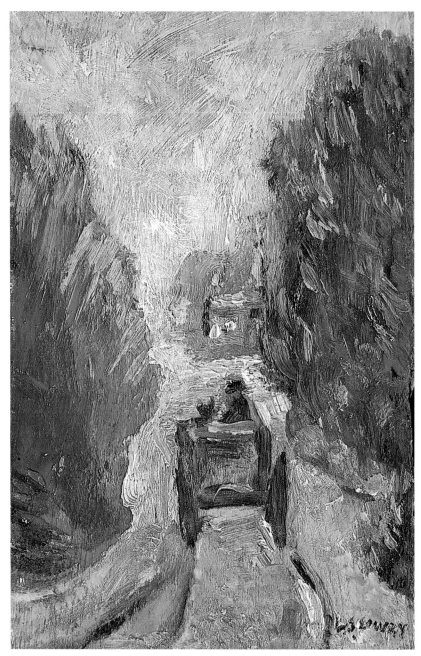

Plate 3 *Country Lane*. 1914. City of Salford Art Gallery. Cat. 125

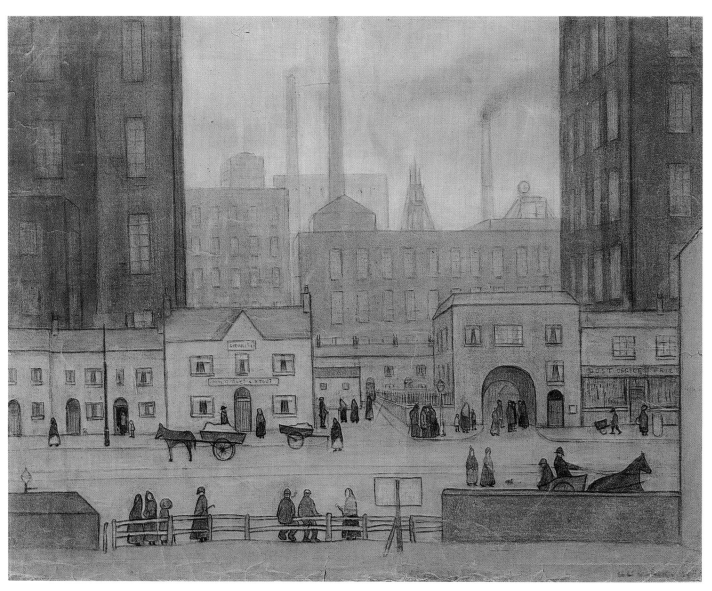

Plate 4 *Coming from the Mill. c.*1917–18. City of Salford Art Gallery. Cat. 140

Fig. 5 *Pendlebury Scene.* 1931.
City of Salford Art Gallery.
Cat. 269

Fig. 6 *Head of a Man* (profile
facing left). *c.*1920. City of
Salford Art Gallery. Cat. 160

lacked it wasn't enthusiasm.' James Fitton was more graphic: 'He used to sit in front of the
nude model and by the time he had finished—he made a swipe from the neck to the ankle
more or less—it looked as if it had been carved with a meat axe.'

If the antique and life classes were not sufficiently troublesome, Lowry also had to
contend with the tutelage of Adolphe Valette, a painter of no little note and an excellent
teacher. Valette found Lowry impossible to teach and 'gave up precise ambition for him
but never ceased to nourish him', remembered Fitton. Yet Lowry himself admitted that he
was greatly influenced by his master, recalling later that 'I cannot overestimate the effect on
me at that time of the coming into this drab city of Adolphe Valette, full of the French
Impressionists, aware of everything that was going on in Paris. He had a freshness and a
breadth of experience that exhilarated his students.' Two paintings in the Salford
collection, *Landscape, c.*1912 (Cat. 118), and *Country Lane*, 1914 (Cat. 125), undoubtedly
show Valette's influence.

The second of the critical events referred to above was a trauma from which the Lowry
family was never to recover. No longer able to afford the respectability of Victoria Park, the
Lowrys moved to 5 Westfield (later renumbered and renamed as 117 Station Road),
Pendlebury. It was the final loss of credibility for Robert Lowry, the defeat of the ambitions
of Elizabeth Lowry, and an awakening for L. S. Lowry. The artist developed a love-hate
relationship with Pendlebury. He bitterly reported later in his life that 'they laughed at me
for thirty years in Pendlebury', and yet is was undoubtedly this rather undistinguished
industrial suburb which created his vision. At first, Lowry hated the town as intensely as
did his mother but whereas she tended to confine herself indoors, Lowry enjoyed walking
and was, therefore, soon made aware of his surroundings.

As in many matters, he was to recall several versions of events which led to his 'vision'. It
is unlikely that any one circumstance caused this enlightenment: rather it was a gradual
awareness through intimacy with the subject. This view is somewhat reinforced by two of
the versions. In 'Mister Lowry', made for Tyne Tees Television in 1968, Lowry
reminisced: 'The whole idea started in m' mind on a walk . . . from Farnworth to Bolton,
and that's how the idea came in m' mind to do it. And in those days there was a colliery at
Kearsley and there was the thump, thump, thump of the engines as you went past that
colliery and that was it. That's how it started. That's where the *first* idea came of doing it . . .
and that was about 1912 or '13.' He also remembered that, in 1916 '. . . as I got to the top of

the station steps I saw the Acme Mill, a great dark-red block with the low streets of mill cottages running right up to it—and suddenly I knew what I had to paint.' (See *Pendlebury Scene* (Cat. 269); also *Street Scene* (Cat. 430).)

So Lowry became an industrial artist. By making that one decision he shaped his destiny. He was, of course, not the first painter of industry but he was unique in taking a conscious decision to record the industrial environment. The intensity of his vision is remarkable. For one who drifted in and out of situations, friendships and art school the strength of his decision is notable. The lack of appreciation for his efforts by his contemporaries could not shake his belief; more than this, nor could the antipathy of his adored mother. No matter what the opposition, Lowry held true to his mission.

From around 1912 to the late 1930s he painted the industrial scene with little commercial success. Few galleries and fewer collectors wished to be associated with his work. Yet he continued, and there can be little doubt that he would have continued to paint whatever the outcome.

The third circumstance to affect the artist's development was relatively minor, yet is severely underestimated. It was that, in 1910, Lowry joined the Pall Mall Property Company as rent collector and clerk. If Pendlebury was to provide the vision, then Lowry's employment was to provide the means. Calling on tenants in the meaner districts of Manchester, particularly around the Oldham Road, was to provide much subject matter; having the same tenants calling at the Pall Mall offices allowed him further acute observations. It is small wonder that he was to say, in 1943, 'If I was asked my chief recreation, I ought to say walking about the streets of any poor quarter of any place I may happen to be in.' It was no recreation, it was his job. The recreation came in mentally cataloguing people, places and events which could be later compiled on canvas. But Pall Mall is important for another reason. It was a family company and Lowry became a loved and trusted employee. When his success made him newsworthy, his colleagues loyally maintained his secrecy concerning his employment. Lowry was also able to take extended leave whenever he required, a useful concession for his increasingly frequent visits to London.

In 1915 Lowry began to take evening classes at the Salford School of Art based in the Royal Technical College at Peel Park. The classes allowed him to continue his long apprenticeship in draughtsmanship; he was not to leave until 1928. Besides working on the academic life studies, the artist began to look seriously at the way in which he could use figures in his paintings. It is still thought by some that the familiar, much criticized 'matchstick' figures were some sort of slapdash innovation at best, or primitive depiction at worst. Numerous sheets of detailed drawings and studies confound these beliefs. There is also a pronounced development in Lowry's figures—from the solid forms represented by *A Doctor's Waiting Room*, dated around 1920 (Cat. 191), through linear drawings like *Interior Discord*, 1922 (Cat. 433), to the 'typical' Lowry figures of his later work.

Pendlebury and Salford became the melting-pot of Lowry's drawing and painting. A succession of finely worked drawings record the industrial town, the mills, the terraced streets and their inhabitants. *River Irwell at the Adelphi*, 1924 (Cat. 201), set the scene for many of the artist's major industrial panoramas, whilst others including *The Flat-iron Market*, c.1925 (Cat. 224), and the Leaf Square drawings built up Lowry's architectural repertoire. At the same time, the artist walked regularly through the farmlands and countryside which surrounded Pendlebury. *Farm near Pendlebury*, 1920 (Cat. 66), and *House on Botany, Clifton*, 1926 (Cat. 235), are representative of local views, whilst travels further afield are reflected in *Country Road near Lytham*, 1925 (Cat. 219), and *Rhyl*, 1926 (Cat. 37). The relationship of town and country was a constant interest to Lowry and subjects such as *Wet Earth Colliery, Dixon Fold*, 1925 (Cat. 217), were to be developed in the 1930s in works like *View in Pendlebury*, 1936 (Cat. 85), to become an important part of

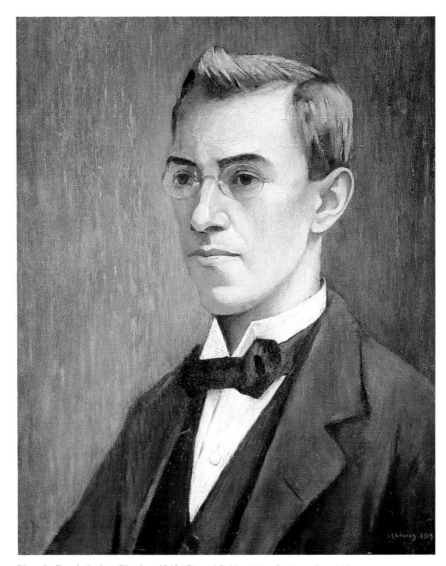

Plate 5 *Frank Jopling Fletcher*. 1919. City of Salford Art Gallery. Cat. 143

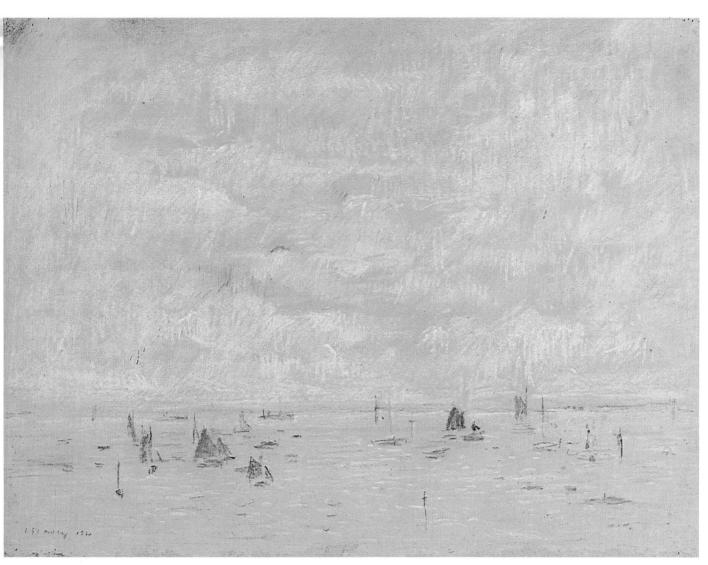

Plate 6 *Yachts*. 1920. City of Salford Art Gallery. Cat. 150

Fig. 7 *Interior Discord*. 1922.
Sunderland Museum and Art
Gallery. Cat. 433

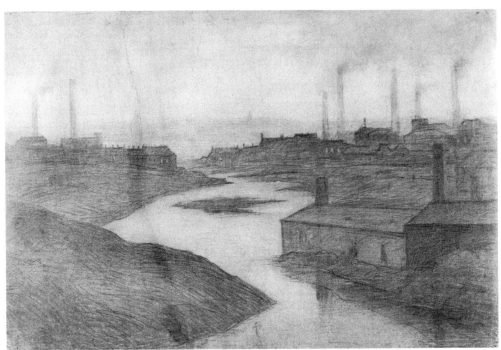

Fig. 8 *River Irwell at the Adelphi*.
1924. City of Salford Art Gallery.
Cat. 201

his later painting e.g. *Industrial Panorama* (Cat. 97) and *Ebbw Vale*, 1960 (Cat. 13). Lowry's close association with Peel Park resulted in his making painstaking and thorough records of the country within the town, with *Bandstand, Peel Park, Salford*, 1925 (Cat. 207), being particularly influential. The 1920s are the most prolific period of Lowry's career. Topographical studies, landscapes, seascapes and industrial scenes abound. There are studies of heads, recognizable as people who called at the Pall Mall Property Company but only one or two portraits, Lowry having abandoned them after particular criticism. 'I cannot make people look cheerful,' he said.

Fig. 9 *Belle Vue House, Leaf Square, Salford*. 1925. City of Salford Art Gallery. Cat. 208

Fig. 10 *House on Botany, Clifton*. 1926. City of Salford Art Gallery. Cat. 235

The decade also saw the emergence of the composite industrial scene. *Coming from the Mill*, *c*.1917 (Cat. 140), is one of the earliest of the mill scenes and *The Lodging House*, 1921 (Cat. 196), is one of his first 'incident' pictures. The early industrial paintings are drab and dour—*A Manufacturing Town*, 1922 (Cat. 53), is characteristic. Lowry painted things 'as I saw them' and it was difficult to bring smokefilled skies, soot stained buildings and darkly clothed people to life.

The final piece of the Lowry jigsaw fell into place as the result of a fierce argument between the artist and one of his tutors at Salford School of Art, Bernard D. Taylor. One of Lowry's first champions, Taylor praised his student's work in his column in the *Manchester Guardian*, but he thought Lowry's paintings were too dark. This opinion he transmitted to the artist who, in a fit of pique, painted a small picture with a completely white background. 'That will show him,' thought the artist only to find that this was exactly what Taylor believed to be necessary. Thus was born a discovery which was fundamental to the artist. Comparison of his *Coming from the Mill*, 1930 (Cat. 255) to the earlier pastel drawing vividly illustrates this development.

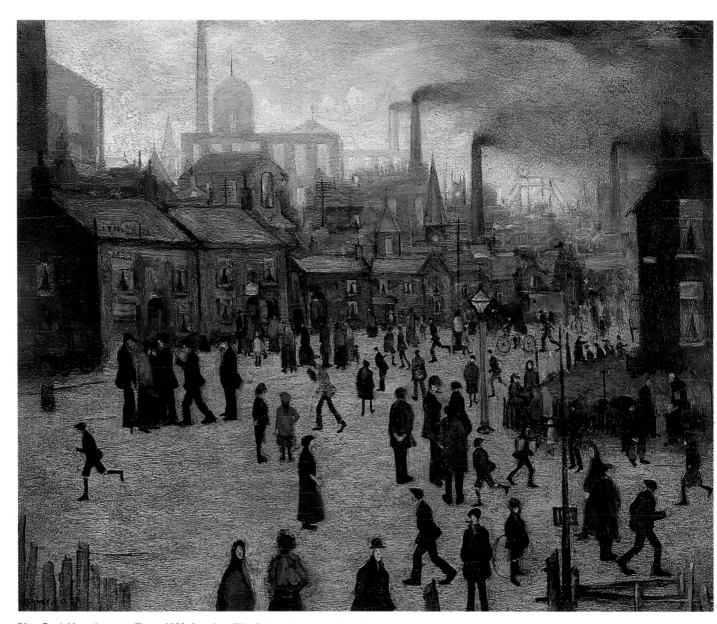

Plate 7 *A Manufacturing Town*. 1922. London, The Science Museum. Cat. 53

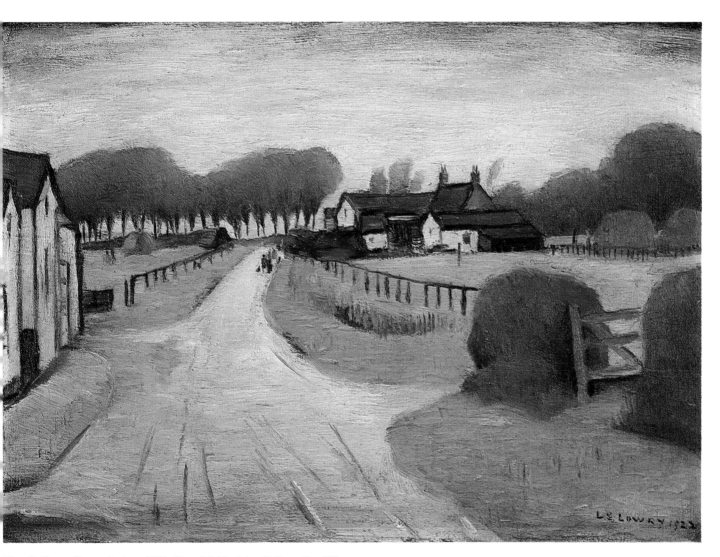

Plate 8 *Regent Street, Lytham*. 1922. City of Salford Art Gallery. Cat. 198

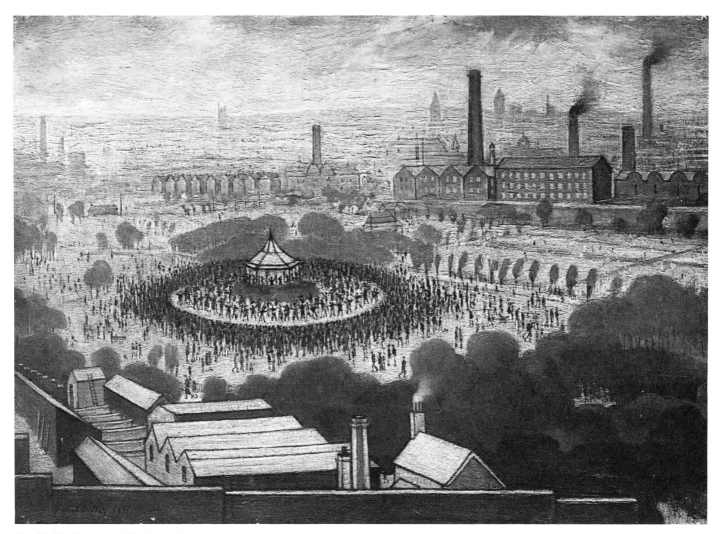

Fig. 11 *The Bandstand, Peel Park, Salford*. 1931. City of York Art Gallery. Cat. 439

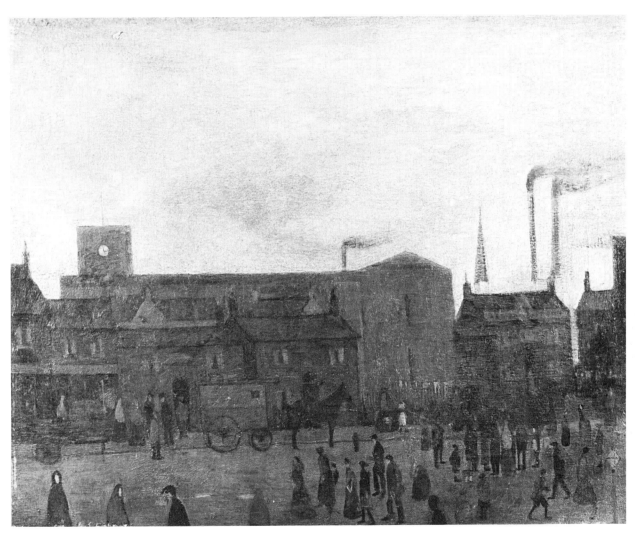

Fig. 12 *Street Scene*. *c*.1925. Sheffield City Art Galleries. Cat. 426

Plate 9 *Self-Portrait*. 1925. City of Salford Art Gallery. Cat. 205

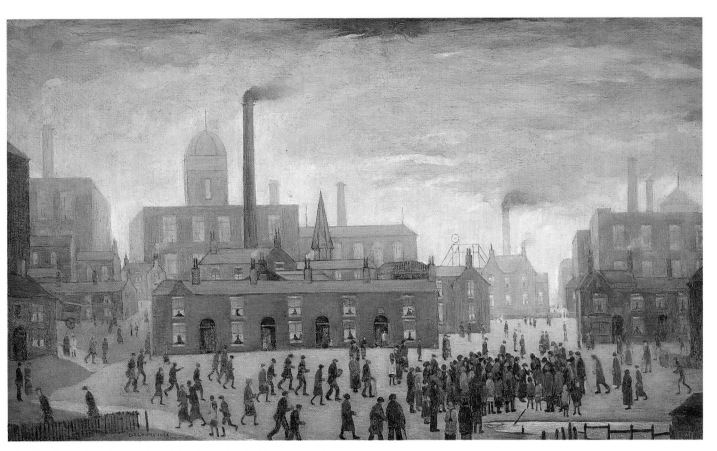

Plate 10 *An Accident*. 1926. City of Manchester Art Galleries. Cat. 69

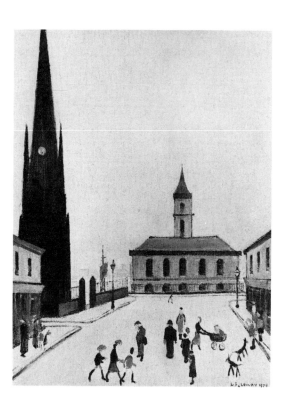

Fig. 13 *The Old Town Hall and St Hilda's Church, Middlesbrough.* 1959. Middlesbrough Art Gallery. Cat. 91

The use of a white background provided another benefit for Lowry. He used pure flake white to produce the base of his paintings and found, in an experiment he undertook with the assistance of his father, that over a period the 'dead white . . . had turned a beautifully creamy grey-white'. Many years later, Lowry was to paint *The Old Town Hall and St Hilda's Church, Middlesbrough* (Cat. 91) and was delighted to see on a subsequent visit that it was 'yellowing nicely'.

By 1928 the long apprenticeship of L. S. Lowry was over. He stopped attending art school. He had already exhibited at the Manchester Academy of Fine Arts and had exhibited his work with two other artists in a small Manchester show. Shortly after that show he had sold his first picture, a pastel, *The Lodging House* (Cat. 196) for £5. Sales were rare but his talent was noted particularly by the *Manchester Guardian*. Then, in 1927, he submitted *Coming out of School* (Cat. 54) to the Duveen exhibition in Leeds. The painting was acquired by the Duveen Fund administered by the Tate Gallery—Lowry's first major sale.

The 1930s started brightly for Lowry. He was, despite his personal feeling of failure, already achieving considerable successes. An exhibition of drawings of the Ancoats district of Manchester had sold out. Manchester City Art Gallery had purchased a painting, and his paintings had been exhibited at the Royal Academy and in Paris. He continued to record and depict the Pendlebury area, composing an evocative series of drawings of farms on the local mosslands. He illustrated *A Cotswold Book* for his friend, the author Harold Timperley.

Yet there are very few paintings which survive from 1932 to 1940. It was, for Lowry, the most distressing period of his life. The sudden death of his father on 10 February 1932 left Lowry to attend to a number of outstanding debts and to a bedfast mother. Elizabeth had ailed for years but went into serious decline after Robert's demise. Although others tried to assist in the care of Elizabeth, she would only find solace in the nursing provided by her son. He would go about his work at the Pall Mall Property Company and return home to spend the evening caring for his mother. Only when she slept could he give himself over to his

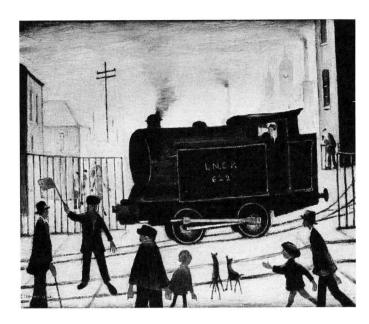

Fig. 14 *Level-crossing*. 1946. City of Salford Art Gallery. Cat. 288

painting and he often worked into the early hours. Yet it is clear that he could discover little relief in painting and the works which survive from this period serve only to reflect his anxiety and withdrawal. *A Fight* (Cat. 272) is a rare excursion into humour. More typical are *A Landmark*, 1936 (Cat. 274), a brooding study of isolation, and *The Lake*, 1937 (Cat. 276), an essay in desolation. *Market Scene, Northern Town*, 1939 (Cat. 279), returns to the theme of the industrial environment and must have been painted for the Lefevre exhibition of the same year. But *Head of a Man* (Cat. 278) remains a penetrating insight into the man at this time. On the very brink of the acclaim he most desired he was robbed of the only person to whom he ever felt attached. The limited response to over thirty years hard painting was to blossom into almost unparalleled contemporary success.

The futility of it all was never to leave him.

THE CONTINUING OBSESSION

117 Station Road, Pendlebury, stands much as it did fifty years ago. Cherished as it is by the present owners, the house cannot but look somewhat sombre. The brick, darkened by the industrial grime which enveloped much of the region, lacks warmth and the dark grey slates reflect too often the brooding northern skies. The house is scarcely welcoming today; how much less hospitable it must have been to L. S. Lowry after the death of his mother. Yet he returned here to exorcize not only the ghosts of his family life but also the compulsion that his vision of the industrial North had become.

Despite his success at the Lefevre Gallery in 1939 and subsequent major exhibitions at Salford in 1941 and Liverpool two years later, he did little painting in the 1940s. In part, this was a period of enforced inactivity caused by wartime stringencies. The Second World War, like most international events during his life, largely passed him by. He undertook irregular duties as a fire-watcher in Manchester, regretting in a postcard to a friend that his own home had not been bombed. Invited to become an official war artist, he painted *Going to Work* (Cat. 49), an industrial scene given a war footing by the addition of two barrage balloons. A few studies of the Manchester blitz survive but most, including *St Augustine's Church, Manchester* (Cat. 80), are mere portrayals of dereliction; the cause is secondary. In

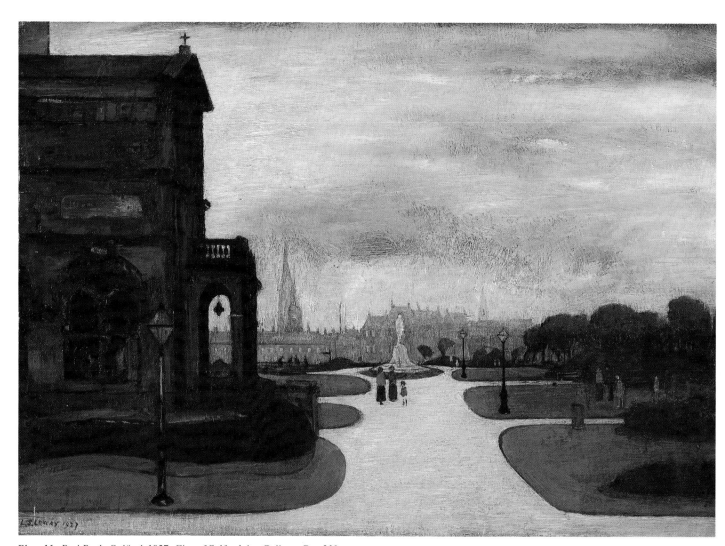

Plate 11 *Peel Park, Salford*. 1927. City of Salford Art Gallery. Cat. 238

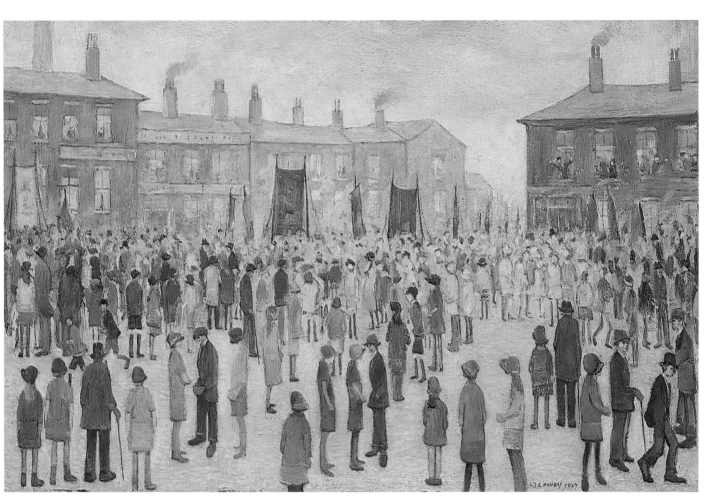

Plate 12 *The Procession.* 1927. Oldham Art Gallery. Cat. 98

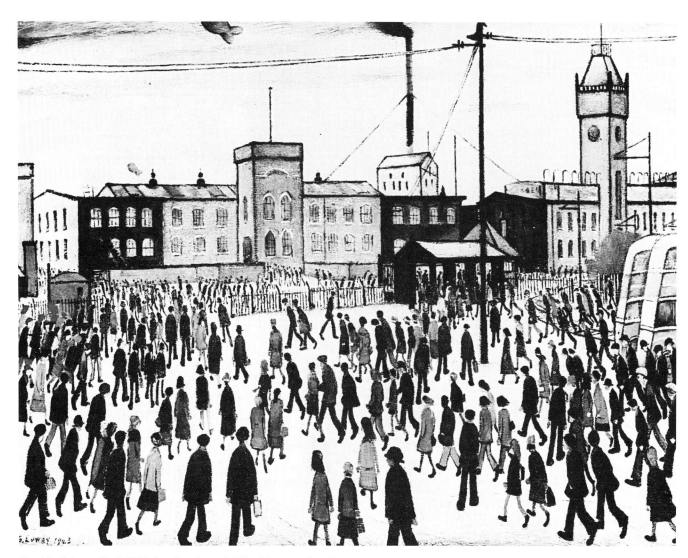

Fig. 15 *Going to Work*. 1943. London, Imperial War Museum. Cat. 49

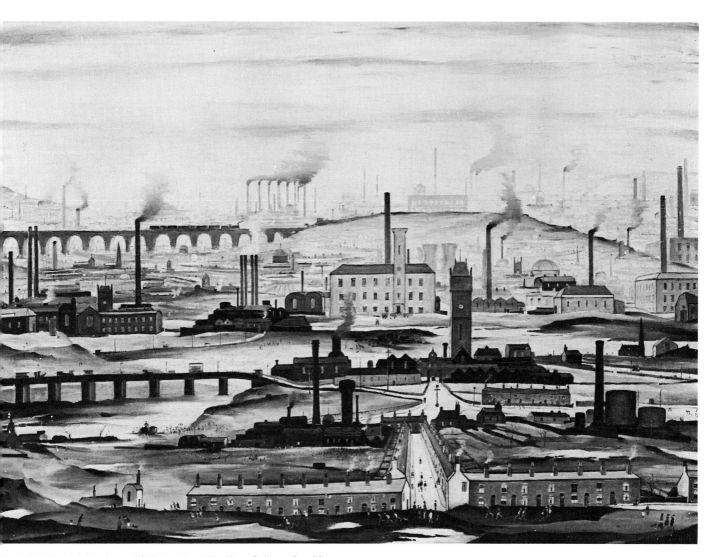

Fig. 16 *Industrial Landscape*. 1955. London, The Tate Gallery. Cat. 59

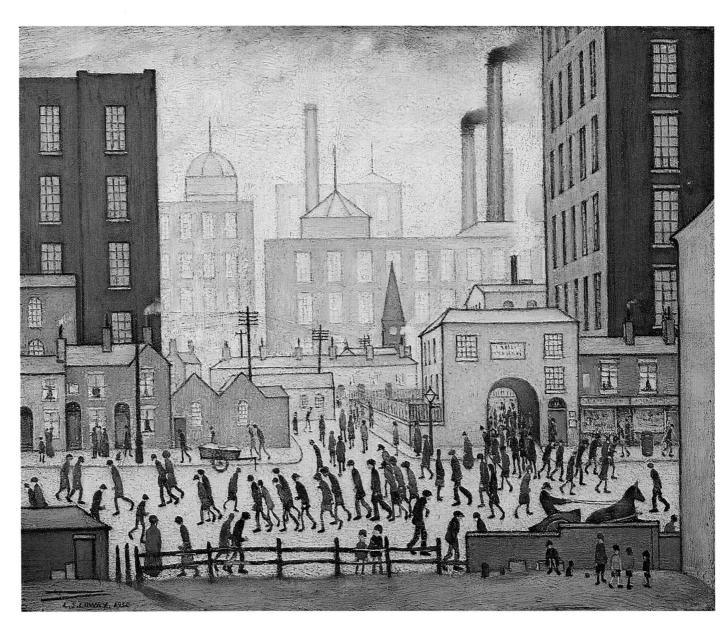

Plate 13. *Coming from the Mill*. 1930. City of Salford Art Gallery. Cat. 255

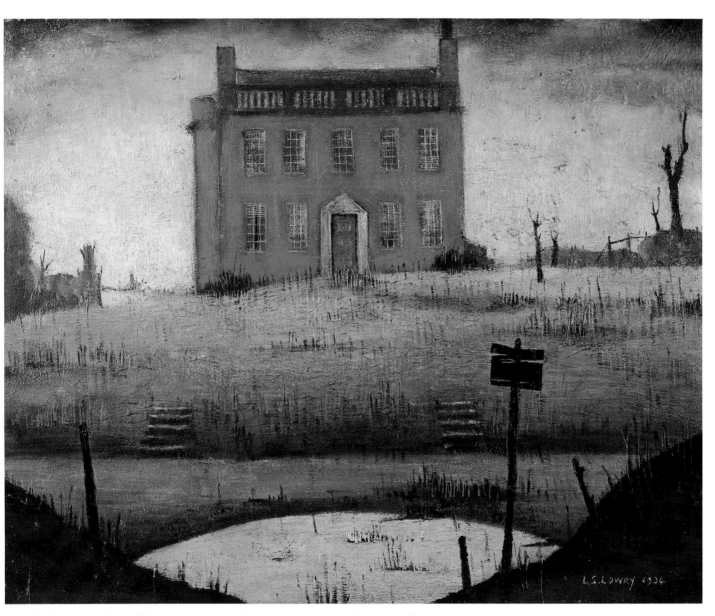

Plate 14 *The Empty House*. 1934. Stoke-on-Trent, City Museum and Art Gallery. Cat. 432

Fig. 17 *On the Sands.* 1921.
City of Salford Art Gallery.
Cat. 195

other paintings of the period, for example *Blitzed Site* (Cat. 284) and *An Island* (Cat. 78), it is perhaps too easy to infer self-portraiture.

Whilst the shortage of canvas presented problems, there is a clearer explanation of the reduction in his output. From around 1910 he had painted exclusively indoors. The close proximity of family and inspiration supported his passion. After 1939, the house in Pendlebury lost any charm it once had. 'There were too many memories there,' he later recalled. Lowry spent as little time as possible in Pendlebury. He began to travel widely, visited his friends and became a regular at the theatre and concert-hall. He formed close, if separate, associations with his patrons, in particular with Hugh Maitland with whom he explored the Derbyshire Moors and Burton-on-Trent, returning with several sketches which were used for paintings (Cat. 288).

The industrial composites continued to be the main platform of his work, but Lowry was beginning to tire of them. Never quite able to dispose of the theme altogether, he recognized that his world was changing. The cotton mills were in decline and Lowry saw little to interest him in modern developments, preferring to leave younger artists to interpret them. He had been pursuing his mission for over thirty years. He had aimed to put the industrial scene on the artistic 'map' and he had succeeded. He was later to lament jokingly that his work was done, 'but the blighters keep asking for more'.

It was as if he had explored every crevice of the industrial panorama. There were few other combinations of churches, mills, chimneys, lakes and houses he could develop. He continued to produce epic paintings like *The Pond* (Cat. 58) but a number of his paintings of the 1950s are simply reworkings of earlier themes or subtle variations of a composition. Only the discovery of the mining villages of South Wales with his friend and collector Monty Bloom, reawakened Lowry's interest. Even there, it was the stunning mix of rugged countryside and industrial towns which excited him. *Ebbw Vale* (Cat. 13) is an outstanding example.

If the wider industrial scene lost its appeal, Lowry was able to find inspiration in the inhabitants of the towns. Groups of people and unusual situations had consistently captured his attention. *On the Sands* (Cat. 195) and *Waiting for the Newspapers* (Cat. 262) are studies of people quite separate in intent from the figures that populate the industrial landscapes. But in the late 1940s and through the 1950s, Lowry portrayed small figure groups in a new way. Consciously searching out the odd, he compiled *The Cripples* (Cat.

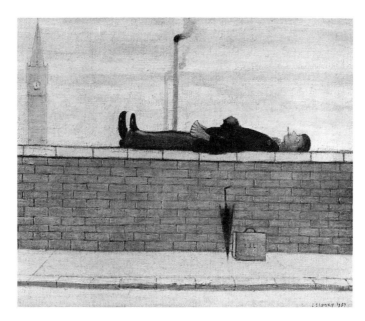

Fig. 18 *Man Lying on a Wall.*
1957. City of Salford Art Gallery.
Cat. 317

291), painted by his own admission with 'no sentiment'. He brought a new direction to his work which was becoming increasing satirical. *The Funeral Party* (Cat. 298), a savage comment on human behaviour, is characteristic.

It is probably coincidental that the change in emphasis in Lowry's painting dates from around 1948, but it was in this year that the link with Pendlebury was broken. Never a man to care for his creature comforts, Lowry had let the house fall into decay and it was reclaimed by his landlord. The artist moved, at a friend's suggestion, to Mottram-in-Longdendale, Cheshire, where he purchased a rather ugly stone-built house called The Elms which he occupied until his death. As he had drifted into art classes and into his job, so he drifted into Mottram. He cared little for the village and hated the house, but it was somewhere to set up his studio and large enough to accommodate his mother's collection of china and clocks. His retirement from the Pall Mall Property Company in 1952 meant that he could come and go as he pleased.

The artist was becoming a celebrity, with regular exhibitions attracting almost constant newspaper coverage of his activities. A plethora of honours and a series of films were to follow. At Mottram, Lowry held court, ever available, ever willing to talk. Friends, critics, writers, aspiring artists, dealers and con men all called and most took their leave feeling satisfied. Lowry seemed to adore the interruptions, he was also astute enough to realize the value of a 'good press'.

In retirement he was his own master. To the strains of Bellini or Donizetti he painted the odd industrial composite. He undertook an extensive series of drawings in Salford around *St Stephen's Church, Salford* (Cat. 304) and delighted in exhibiting his fondness for humour, as in *Man Lying on a Wall* (Cat. 317). The 1950s also saw a brief flirtation with watercolours, a medium which he did not like, and a series of portraits on the theme of *Portrait of Ann* (Cat. 316). His travels continued; he discovered the Lake District where the stark landscape appealed to him.

Election as a Royal Academician came in 1962 in his seventy-fourth year and it was around this time that he created a large number of single figure studies. These often portrayed tramps and odd-looking people set against a white background. For Lowry, these works were as important as anything he had painted previously. He had, at last, found a replacement for the industrial scene.

He returned also to the sea. There were no longer family holidays on the Fylde Coast or

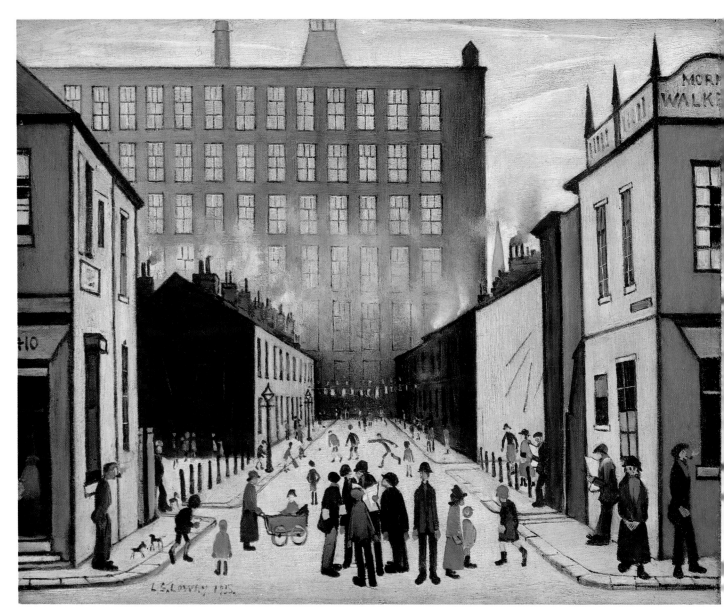

Plate 15 *Street Scene.* 1935. Southport, Atkinson Art Gallery. Cat. 430

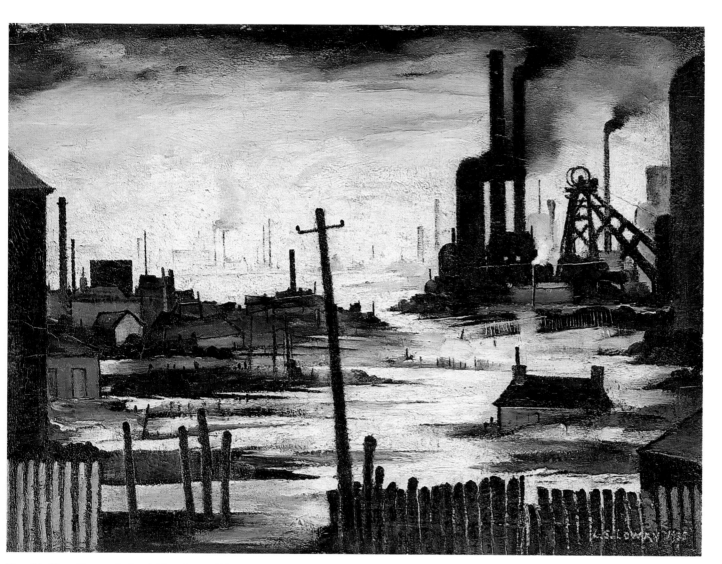

Plate 16 *River Scene* or *Industrial Landscape*. 1935. Newcastle-upon-Tyne, Laing Art Gallery. Cat. 92

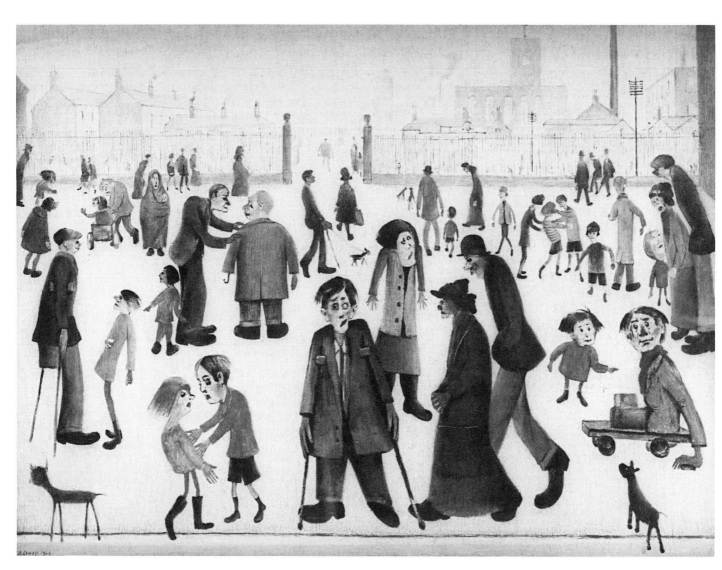

Fig. 19 *The Cripples*. 1949. City of Salford Art Gallery. Cat. 291

Fig. 20 *A Ship. c.*1965. City of Salford Art Gallery. Cat. 365

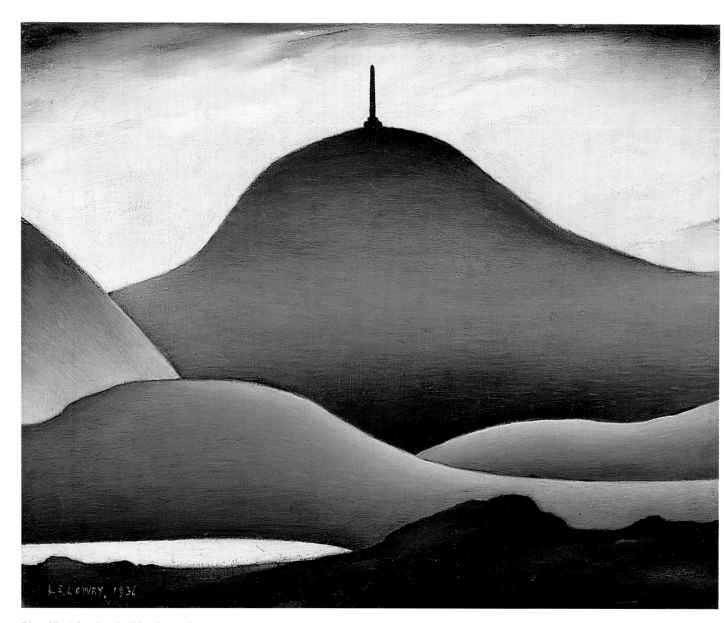

Plate 17 *A Landmark*. 1936. City of Salford Art Gallery. Cat 274

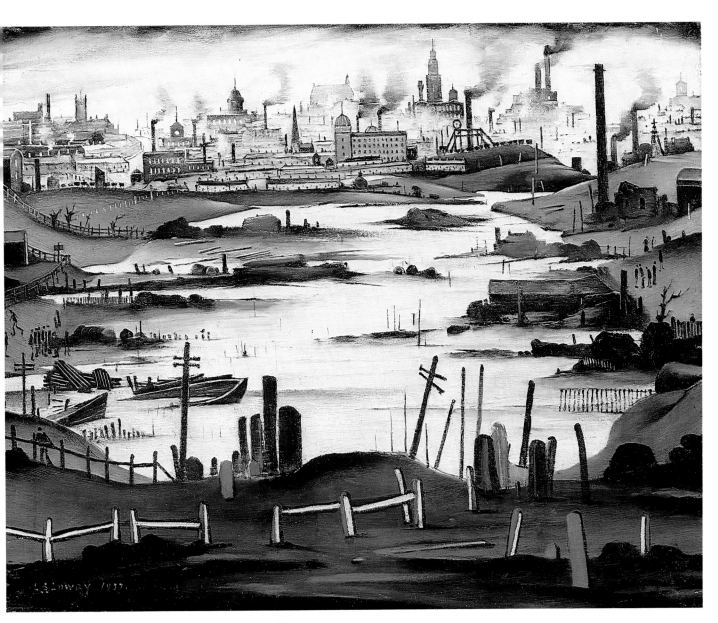

Plate 18 *The Lake*. 1937. City of Salford Art Gallery. Cat. 276

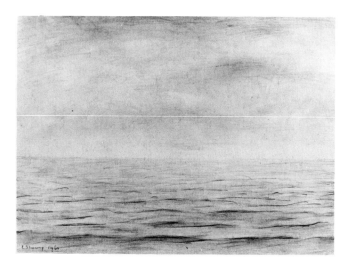

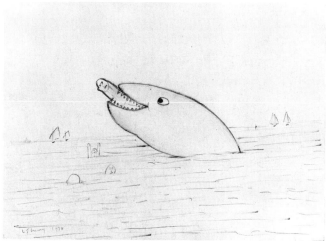

Fig. 21 *Seascape*. 1960.
Darlington, Museum Education
Service. Cat. 14

Fig. 22 *The Shark*. 1970. City of
Salford Art Gallery. Cat. 403

in North Wales but he escaped regularly to the relative anonymity offered by the North East. Staying at a modest hotel on the seafront at Sunderland, he could watch the ships coming into the nearby harbour and survey the moods of sea and sky. The affinity he found with the sea in his final years produced a number of remarkable seascapes, much criticized yet evocative and realistic renditions with more than a hint of self-analysis.

There remain, in the late 1960s and early 1970s, large numbers of drawings which reflect both failing interest and a necessity to exercise a talent. Some, like *The Shark* (Cat. 403), are incisive comments on the fate of artists. Others, with fantastic combinations of animal and human figures, Lowry left for others to explain. Another group, based on *Girl with Bows* (Cat. 417), still defy interpretation. But few of his later drawings were intended for exhibition. He continued to draw because he had to; the Victorian ethic and a lifetime's habits would not release him. He had, in his own words, 'painted from childhood to childhood'.

There was an inevitable sadness at the conclusion of his life. He had achieved considerable artistic success but asked frequently 'Will it all last?'. He was undoubtedly a popular figure talked of by most people with affection. His faults were forgiven, the character he weaved had taken him over. His final months were marked and marred in unseemly controversy, as galleries fought a media war on the future of his house and estate. 'They could at least wait until I'm dead,' he protested, but they did not. The artist who had spent a lifetime protecting his privacy had become public property.

The death of his mother had robbed Lowry of the joy of his success. His own death, from pneumonia on 23 February 1976, denied him the final accolade—a unique Retrospective exhibition at the Royal Academy. The unparalleled attendances at this exhibition were more than a tribute to a remarkable artist, they were a homage paid by many ordinary people to a painter who had touched their lives.

'Enough legends have attached themselves to Lowry's life to make it all but impossible to see the man clearly,' wrote John Read in 1977. L. S. Lowry remains an enigma but all the clues to solving the puzzle are contained within his paintings.

2

Pencil and Five Colours

JUDITH SANDLING

It is an artist's choice of subject, the method by which he depicts his images, and the manner in which he uses his material that set him apart and make him identifiable.

Laurence Stephen Lowry, primarily known as the painter of the industrial North, was a fastidious workman. The very earliest of his paintings and drawings are the result of careful observation and a practised hand. Having studied privately and then at art school for over twenty years, Lowry understood the importance of accurate drawing. He knew what the figure looked like, how the head, arms and legs were connected to the body, what happened to a person when the body was bent, the leg extended or the head tilted. He saw where the weight was distributed in any number of poses, what happened to the clothes as the figures moved and changed position, and he used this knowledge throughout his career.

For Lowry, drawing was extremely important; it was not only the means to the end—a painting—it was the end in itself. Lowry's earliest drawings, dating from the first decade of

Fig. 23 *Figure Studies. c.*1920. City of Salford Art Gallery. Cat. 176

Fig. 24 *Page from the Anatomical Sketchbook. c.*1919–20. City of Salford Art Gallery. Cat. 148

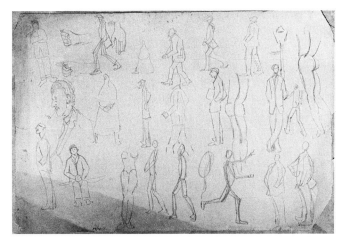

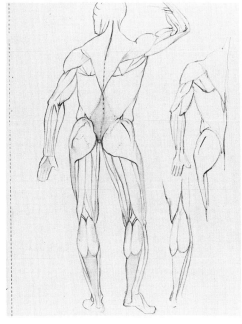

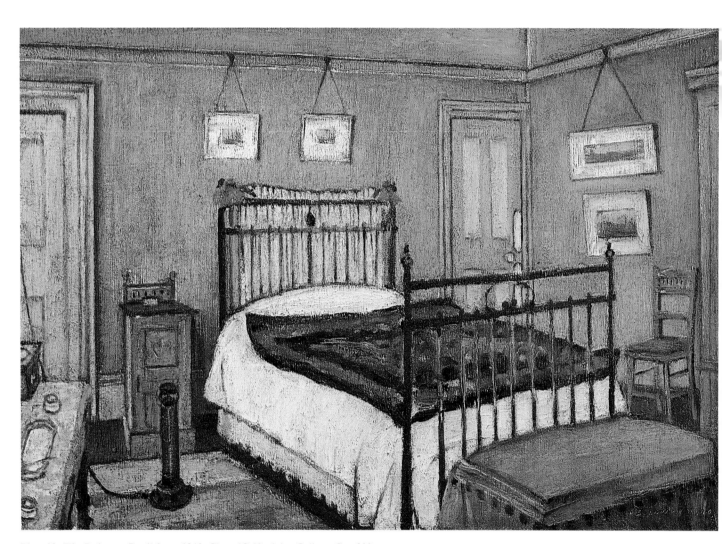

Plate 19 *The Bedroom, Pendlebury*. 1940. City of Salford Art Gallery. Cat. 280

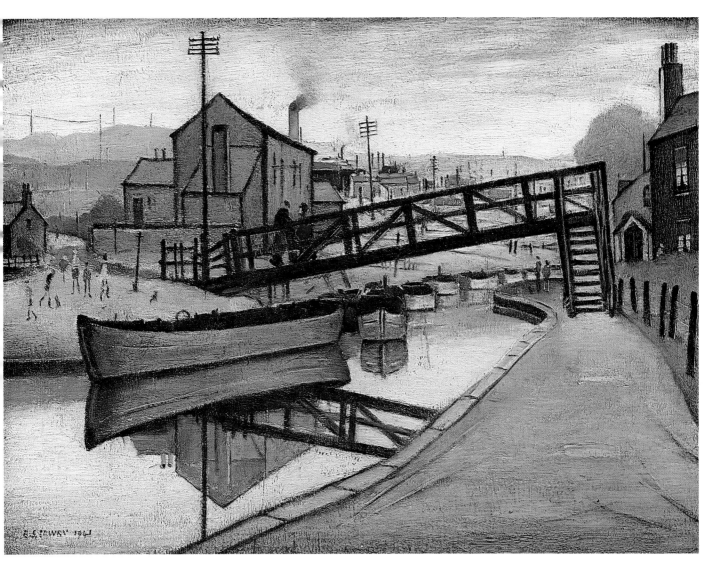

Plate 20 *Barges on a Canal.* 1941. Aberdeen Art Gallery and Museums. Cat. 1

Fig. 25 *Blitz, Piccadilly, Manchester. c.*1942. City of Salford Art Gallery. Cat. 285

Fig. 26 *Worsley – Canal Scene (View of the Packet House)*. 1925. City of Salford Art Gallery. Cat. 212

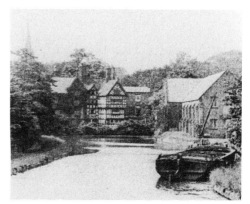

Contemporary photograph of the Packet House, Worsley

the twentieth century, were done in pencil, pastel, conté crayon, and any combination of these. In his later drawings, he expanded his range of media. He used ballpoint pen, either alone or in combination with pencil and felt tip pen.

Lowry's pencil, in which he did most of his drawings, was expressive, often painterly. He used his finger to smear the graphite and indiarubber to lighten it. The varying depths of grey thus formed created a delicate surface of 'colour'. His lines showed great variety, from the sinuous to the harsh and abrupt. Every possible tone and texture that a pencil could make is apparent in his drawings.

Even while continuing his studies, Lowry was experimenting with how best to convey his ideas. He retained the naturalistic approach for his topographical subjects, but when, during the early 1920s, he began to depict imaginary scenes (the forerunners of the industrial composites of the 1930s and 1940s), he chose a linear mode. The sense of depth

Fig. 27 *The Result of the Race.*
1922. City of Manchester Art
Galleries. Cat. 67

Fig. 28 *Offering a Hand. c.*1970.
City of Salford Art Gallery.
Cat. 406

was created by the placement of the figures and the buildings; the feeling of weight by the lines themselves, without recourse to shading. Caricature also began to appear at this time. But it is not until the late 1960s and early 1970s, when Lowry again combines linear drawing with figure and face distortion, that caricature is used to such a great effect.

In his last years, Lowry devoted himself completely to his drawings. There is nothing to show that they were produced by a man in his late eighties. His lines retained their strength to the end.

Lowry, of course, did not only draw. He produced a large number of oil paintings and a small number of watercolours. His methods of painting, like his drawing techniques, were used in order to create an effect. The oil paint, no matter what the support, is applied very thickly. Lowry prepared each board or canvas with layers of paint, and then often worked into the wet ground. His earliest works show the influence of his Victorian environment. The paint is dark and often the images are obscured by the density of opaque colours. Unlike his later paintings, these early ones have been varnished—a further characteristic of nineteenth-century art. His subjects, too, are reminiscent of the conventionality of the Victorian age: portraits, still lifes and landscapes. Like his drawings of this period, his paintings are naturalistic.

After attending the class of Adolphe Valette at the Manchester School of Art, Lowry began to paint in a kind of Impressionism. But unlike the French Impressionists, who recorded the change of colours determined by the change of light, Lowry consistently used the colours he had chosen from the beginning: ochre, blue, black, white and red, sometimes

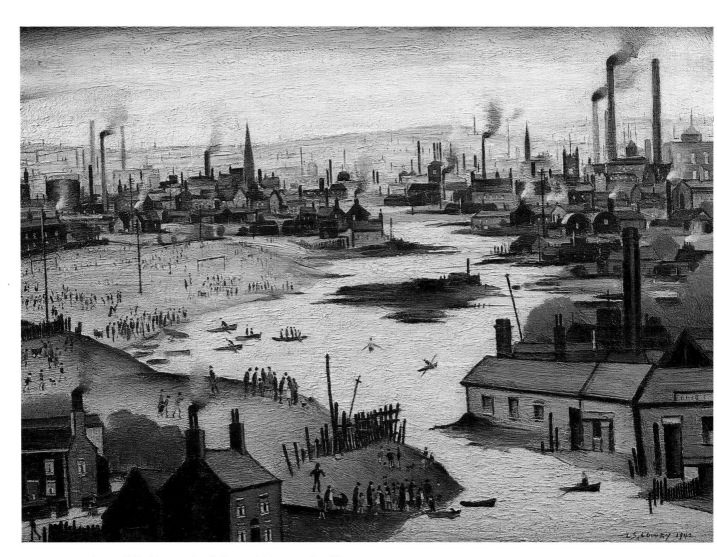

Plate 21 *River Scene*. 1942. Glasgow Art Gallery and Museum. Cat. 20

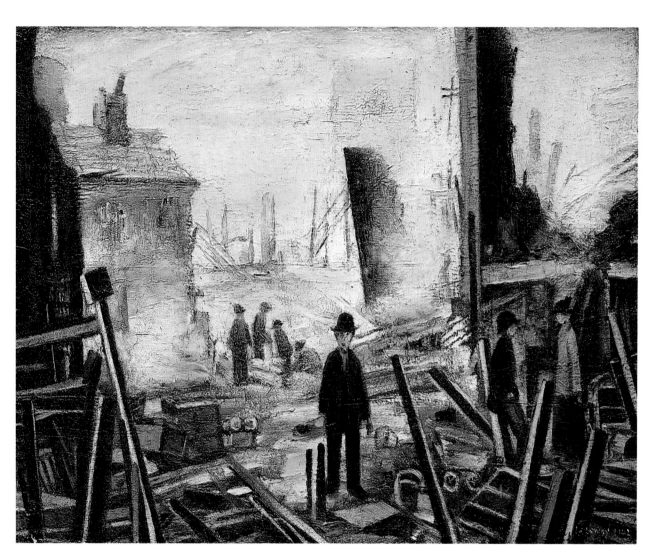

Plate 22 *Blitzed Site*. 1942. City of Salford Art Gallery. Cat. 284

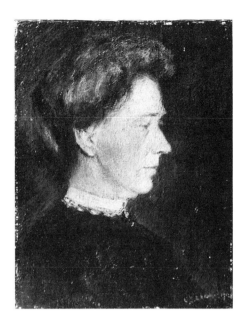

Fig. 29 *Portrait of the Artist's Mother*. 1912. City of Salford Art Gallery. Cat. 115

mixed but often separate. The effect is an amorphous image created by short uneven brush strokes, but without the dazzling input of the sun. Only his pastels, perhaps because of the nature of the medium itself, are light and airy.

Lowry began to mature as an artist after a criticism by one of his teachers at the Salford School of Art in the latter part of the 1920s. He had chosen his subject, and now, reacting to the comment, he chose his manner of depiction. Abandoning the dark background of the Victorian period, and the choppy surface of the Impressionists, Lowry began to place his images on white. Not a clear, smooth white, but a white full of subtle colours, a white that given time would change from sharp and brilliant to a soft, creamy hue. He experimented with his background in the same way that he experimented with his images. He had ideas and he ensured that they came to fruition. He found that flake white produced the effect he wanted and he used it from then on. He never varied the original five colours, he never used a medium to thin the paint, and after his original use of varnish, he never used it again. As he did with his drawings, Lowry used mechanical means to create the effect he desired. Aside from a variety of brushes, he used a pallet knife, he rubbed away areas of paint, and he scratched through the surface with nails and with other sharp instruments.

With the white background, came the industrial scenes filled with the images that he had observed as he rode on the bus between Pendlebury and Manchester, as he collected rents from the back streets surrounding Piccadilly and as he wandered throughout Pendlebury and Swinton. Although Lowry had depicted aspects of his industrial environment prior to this, it now became his primary subject. Sketching on anything that was handy—old envelopes, cards, letters, bits of scrap paper—Lowry was forever noting what was around him. Over and over again, landscape features, particular buildings or parts of buildings, and other architectural images appear in drawings and in paintings: the church spire, tall and pointed, the domed mill, the mill-gates, the gas lamp and the river Irwell—they are either uniquely or in combination an integral part of Lowry's industrial vision.

In the late 1950s, Lowry did a series of watercolours. The number is very small, as the medium was not appropriate to his method of work. The colours dried too fast; there was no time to change things. Once the brush was applied to the paper the colour had to remain untouched or it would lose its clarity. Unlike oils, which could be worked on for years—a time-span that was typical of many of Lowry's paintings—watercolours had to be finished in a relatively short space of time.

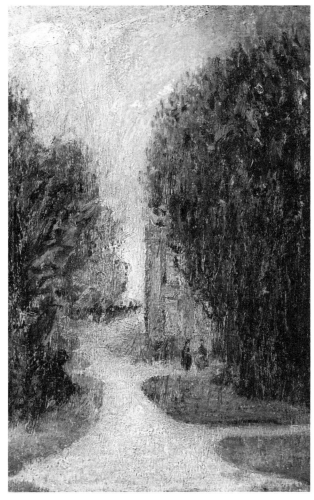

Fig. 30 *Landscape. c.*1912. City
of Salford Art Gallery. Cat. 118

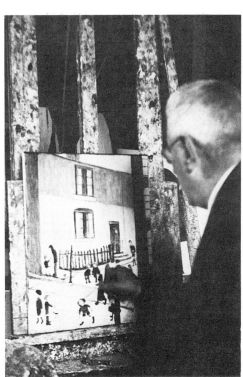

Lowry's working technique:
(left) scratching in detail; *(right)*
rubbing with a cloth

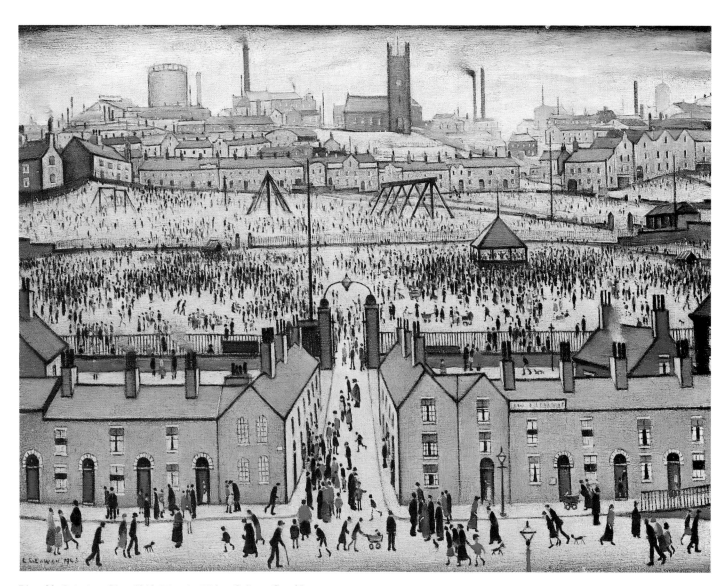

Plate 23 *Britain at Play*. 1943. Lincoln, Usher Gallery. Cat. 35

Plate 24 *Winter in Pendlebury*. 1943. Swindon, Borough of Thamesdown Museum
and Art Gallery. Cat. 437

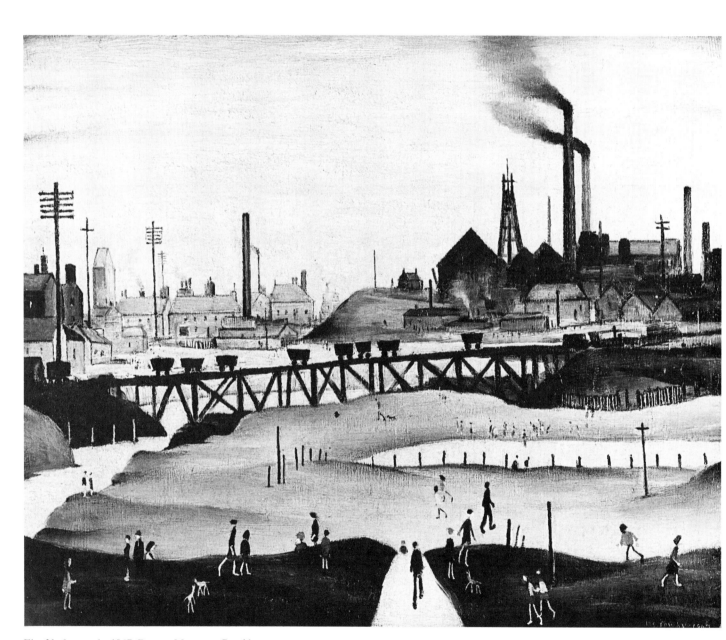

Fig. 31 *Ironworks*. 1947. Buxton Museum. Cat. 11

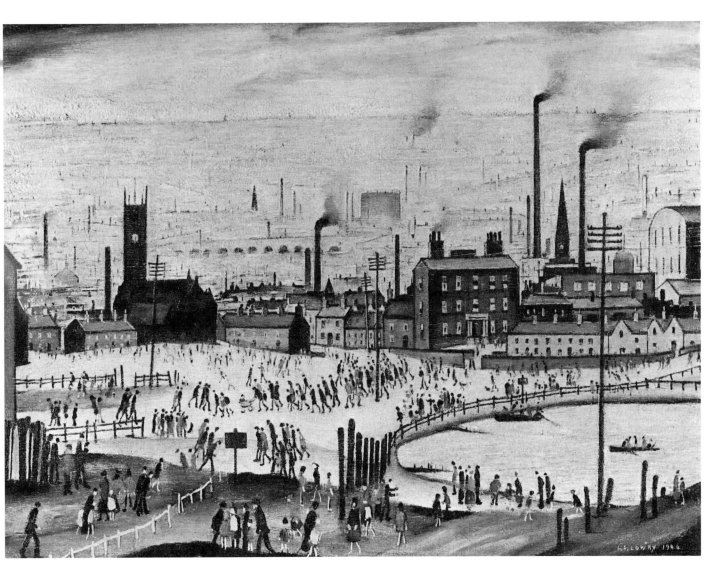

Fig. 32 *An Industrial Town*. 1944. Birmingham City Museums and Art Gallery. Cat. 6

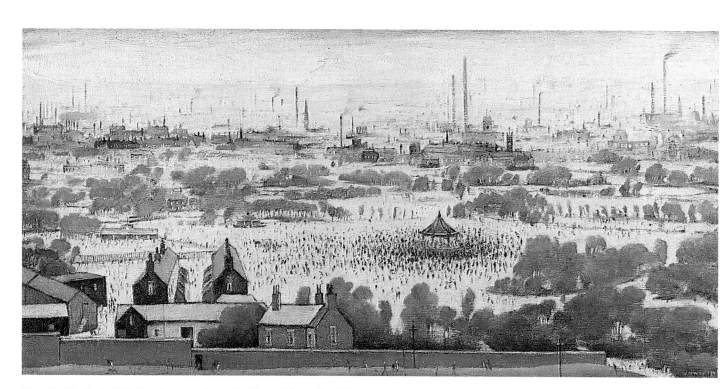

Plate 25 *The Park*. 1946. London, Arts Council of Great Britain. Cat. 39

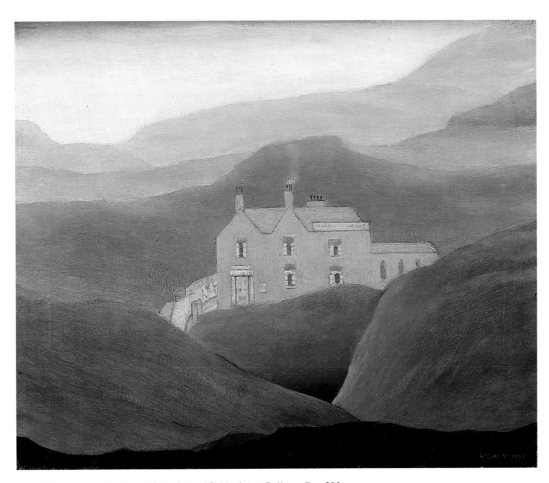

Plate 26 *House on the Moor*. 1950. City of Salford Art Gallery. Cat. 293

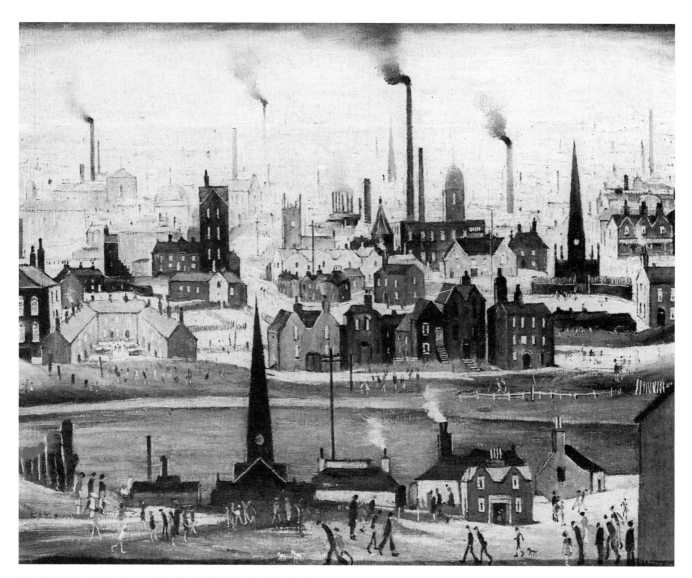

Fig. 33 *Industrial Landscape: The Canal.* 1945. Leeds City Art Gallery. Cat. 31

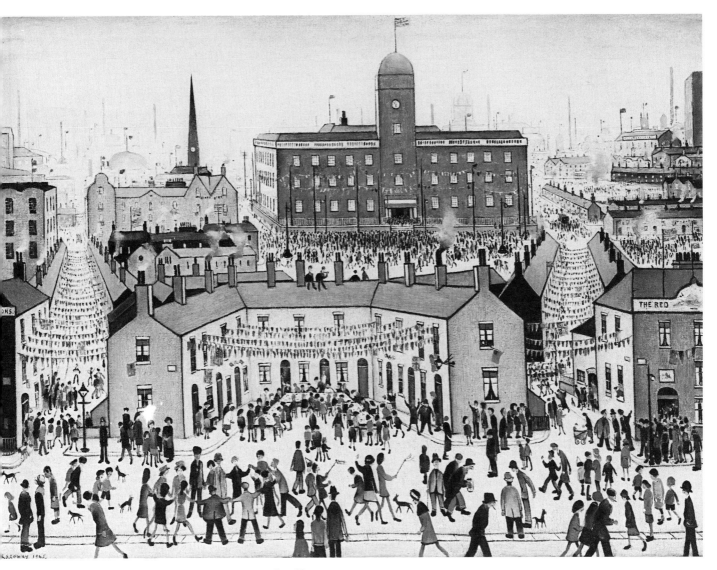

Fig. 34 *VE Day*. 1945. Glasgow Art Gallery and Museum. Cat. 22

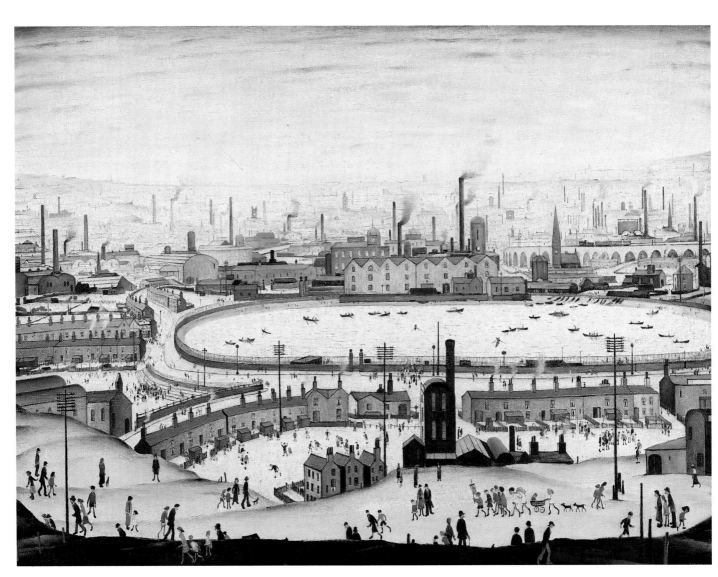

Plate 27 *The Pond*. 1950. London, The Tate Gallery. Cat. 58

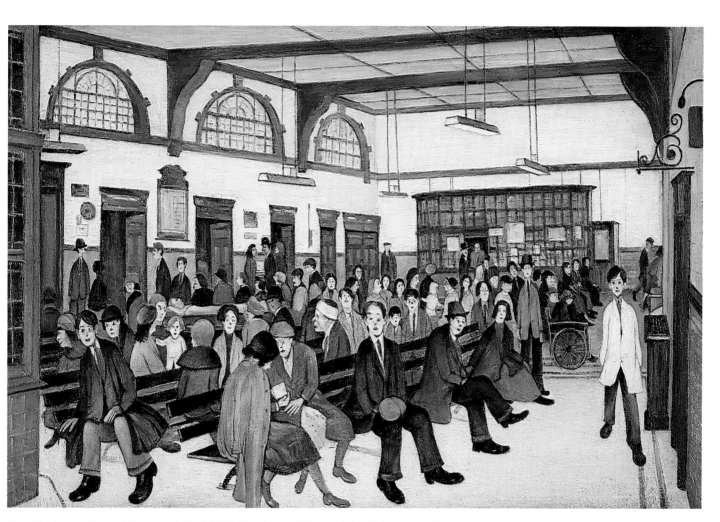

Plate 28 *Ancoats Hospital Outpatients' Hall.* 1952. Manchester, Whitworth Art Gallery. Cat. 88

Lowry's stated aim as an artist was to explore and record the industrial North. He was able, because of his job and the area in which he lived, to absorb the images which form the industrial landscape. He used the architectural structures as a backdrop for human activity. His early works are peopled by figures originally recorded on sheets of studies. By the 1930s, these same figures had become stylized and abstracted, their motion created by a few strokes of the brush. Lowry was able to capture the essence of his images. He did not need to elaborate, to detail. Even his colours were minimal. This explains another prominent characteristic of Lowry's paintings: the lack of shadows. His works are not photographic renditions of the views and people before him, they do not require shadows which would detract from the images boldly set out on the white background, and he chose not to incorporate them.

Careful composition lies behind all of Lowry's most famous works. His great industrial scenes, his composite paintings are full to overflowing. There is scene within scene. Each section of the painting shows something of interest. Lowry draws the viewer into the activities by compositional means: rows of walking figures lead into the heart of the picture; foreground figures, divided from the main activity by a line or other device, stare into the picture; raised arms lead the eye where Lowry guides it. But only rarely does he allow the viewer a look at inter-personal relationships. Only rarely does he bring the viewer inside a house and never inside the factory or mill which is the object of his art.

When the industrial areas that had motivated his vision began to disappear, Lowry turned to the figure and began to produce images of great intensity which draw the viewer with staring eyes and strange bodies. Lowry consistently produced works in which the onlooker had to participate.

Just as Lowry was not content to stay within accepted style, no more was he able to join the avant-garde movements. He devised his own manner of working and remained true to it throughout his life.

The Lonely Life of L. S. Lowry

EDWIN MULLINS

The following account by Lowry of his life was put together by me from long conversations with him which I recorded over a period of several days early in 1966, either at his home in Mottram, or in various favourite Manchester cafés, in the Salford Art Gallery, or out of doors while the artist was showing me round what still remained of the places he had drawn and painted. At this time I was art critic of the *Sunday Telegraph*, and I'd known and corresponded with Lowry for a number of years since being introduced to him by Mick Marshall of the Stone Gallery in Newcastle. I was also engaged in writing the catalogue introduction to the 1966 Retrospective of his work being organised by the Arts Council at the Tate Gallery. Since Lowry spoke so marvellously and entertainingly I thought that, rather than write yet another piece about him in the paper, I would record what he said about his life and then stitch it together—as an interview without the interviewer. He was rather tickled by the idea, and his letter in reply to my suggestion was typical. 'About where to stay', he wrote 'there is nothing at all in Mottram or near. It is a dreadful place, and I spend a lot of time wondering why I ever came to live in it. Hope you are keeping as well as can be, and looking forward to seeing you.' He was, as ever, delightful company as we talked in his room full of clocks and gloom and Rossettis, or as I drove him round the places he most loved to hate. I miss him.

'It was suggested I went in for art as I was fit for nothing else. My father was an estate agent; my mother an accomplished pianist, and an invalid. We lived in Rusholme, a suburb of Manchester, and I was their only child.

At school I had few friends, and I never passed any exams. Time went on and on and on, until finally an aunt remembered that I'd drawn little ships when I was eight years of age. So that was that. It was any port in a storm.

And as we lived in Manchester I went to the Manchester School of Art, in 1905, and stayed there a great many years—I suppose about ten years in all. I liked the school because it meant meeting people, and normally I'm very unsociable, I'm afraid. Sometimes I've felt I'd like to go back to art school now. But eventually they did suggest I leave; so I did, and they tried not to look happy. At art school we did free-hand, light and shade, preparatory antique, full-length antique, and life. No design. Afterwards I suppose I would have taught in the normal way. I never intended to paint pictures, you know. And I didn't want to do any work—ever! But then I got strangely fascinated by those antique casts. I think that

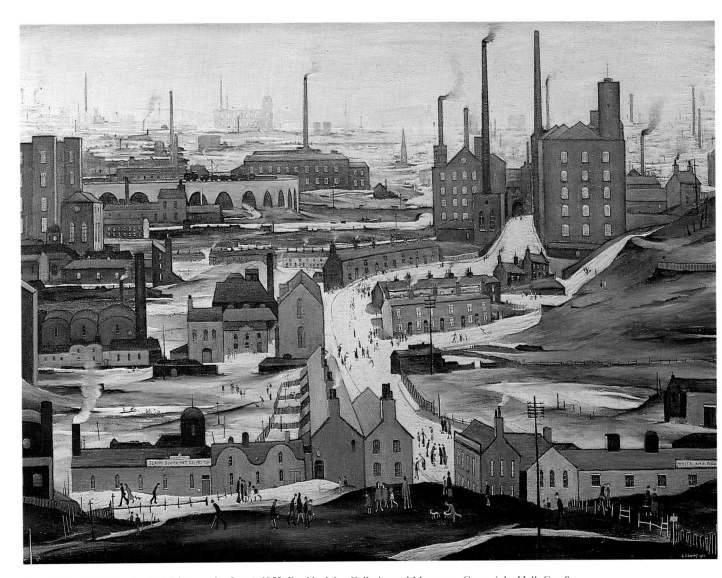

Plate 29 *Industrial Landscape (Ashton-under-Lyne)*. 1952. Bradford Art Galleries and Museums, Cartwright Hall. Cat. 9

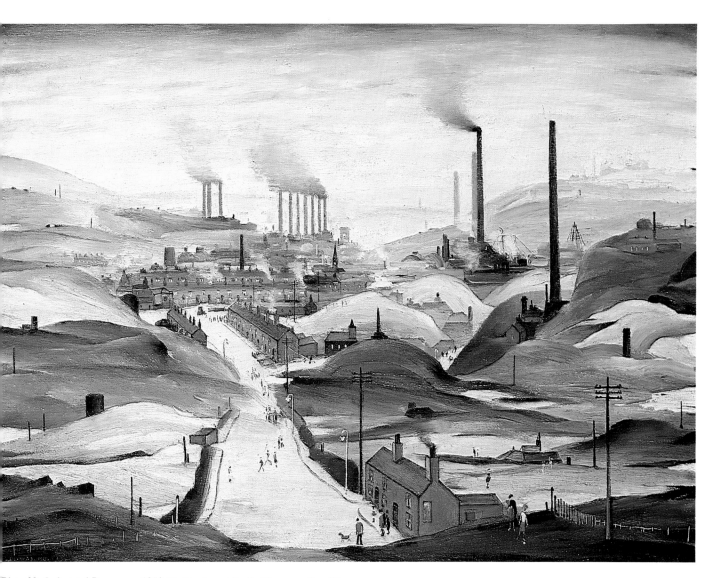

Plate 30 *Industrial Panorama*. 1953. Nottingham, Castle Museum. Cat. 97

Fig. 35 *St Augustine's Church,*
Pendlebury. 1930. City of Salford
Art Gallery. Cat. 259

must have started it. I did little sketches of them and my teacher, Mr A. Valette, thought there was something in it, he didn't know what. It all came up on me gradually. And during the holidays I started painting landscapes that nobody wanted, and portraits that nobody wanted.

In 1909, when I was 22, we moved from the residential side of Manchester to Pendlebury, which was a suburb of Salford and as industrial as could be. At first I didn't like it at all. It took me six years. Then I got used to it; after that, interested. I wanted to depict it. I couldn't recollect that anyone else had ever done it before. Finally I became obsessed by it, and I did nothing else for 30 years. . . .'

Apart from the industrial areas of Manchester, Stanley Houghton's play about Lancashire life, *Hindle Wakes*, which Lowry saw in 1912, made a deep impact on him. Until 1915 his work remained Impressionist in manner. Between 1915 and 1920 he established the conventions of figure-drawing by which his work is now so well known.

'. . . To begin with I did a lot of studies of little figures, drawing them as well as I could. I didn't know they had big feet until people told me. I was doing the industrial scene as I saw it. And the figures got better with practice. They got movement.

For a great many years, when I was very active, I used to visit all the industrial towns and stop a couple of nights in each. Huddersfield in particular I'd go back to. And I always gravitated to the poorer areas. It wasn't that I felt sorry for those people; they were just as happy as anyone else, and certainly as happy as I was. I didn't draw there—Oh, I might have made quick sketches—I just went and looked round, and thought. When it came to painting I really liked to do imaginary compositions in my room. I used to start in the morning in front of a big white canvas, and I'd say: "I don't know what I'm going to do with you, but by the evening I'll have something on you."

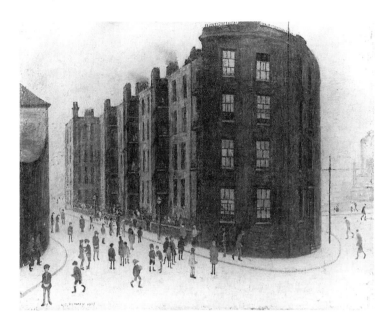

Fig. 36 *Dwellings, Ordsall Lane, Salford*. 1927. London, The Tate Gallery. Cat. 55

In the 1920s I did a lot of drawing in Salford. There were special parts I liked, a bit Georgian, older than the rest. My favourite places were houses built round factories. They just attracted me more than others. I cannot explain it. But all those places I used to draw have come down in the last five years. . . .'

Then Lowry remembered there was one left, and we promptly drove in the direction of Salford. It was a grim tenement block, scaly with fire-escapes and squatting incongruously in an open space like a car left abandoned. One end of this building was strangely curved, in the manner of a ship's stern. The streets around it were narrow and cobbled.

'. . . There we are! Ordsall Lane Dwellings. It's the only one left. 1927 I came here. I'd stand for hours on just this spot where we are now; and scores of little kids who hadn't had a wash for weeks would come and stand round me. And there was a niff, too. The Tate Gallery has the picture I did of it now. Later, I often used to come here and take another look.

What was that line of Sheridan? "There's nothing so noble as a man of sentiment."

I'm attracted to decay, I suppose; in a way to ugliness, too. A derelict house gets me. Until very recently I've been going to London once a month for fifty years—I had an aunt there for a long time—but I did almost no work in London except one of St Luke's Church, Old Street. I'd been told it had the ugliest spire in the world. So naturally I had to go and look at it.

I've done one or two things of the Thames as well. I'm very fond of ships. The sea, too, I love. To watch it is like letting off steam: it's so vast. But generally I put nothing on the sea when I paint it. Perhaps a tiny boat if I must. I'm particularly fond of watching large ships coming into harbour, or being brought down a river by tugs. I love the Tyne for that reason. It's a wonderful river. Yet somehow I just can't paint a ship entering a harbour as I would like to. I've never mastered it, and it worries me.

When I started painting industrial scenes fifty years ago I painted them very dark. But when I showed them to Bernard Taylor, who was then art critic of the *Manchester Guardian*, he said: "Now put them up against the wall," and of course they both looked equally black. I was very cross with him. Then I started painting crowds against a

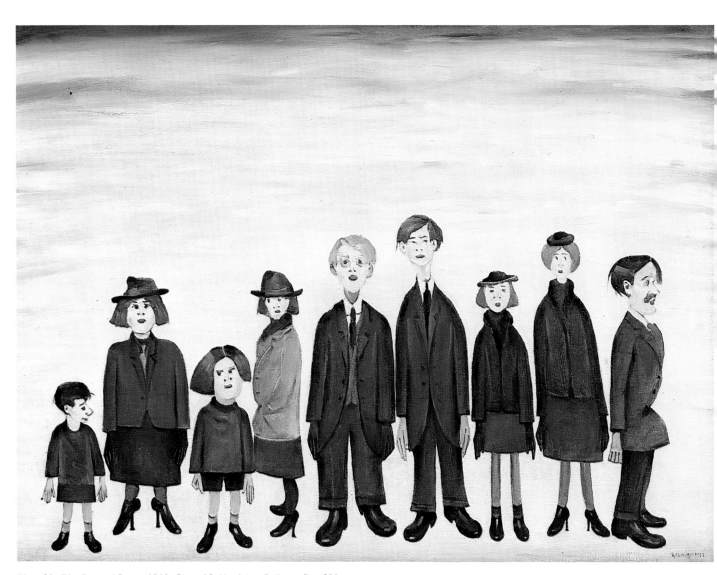

Plate 31 *The Funeral Party*. 1953. City of Salford Art Gallery. Cat. 298

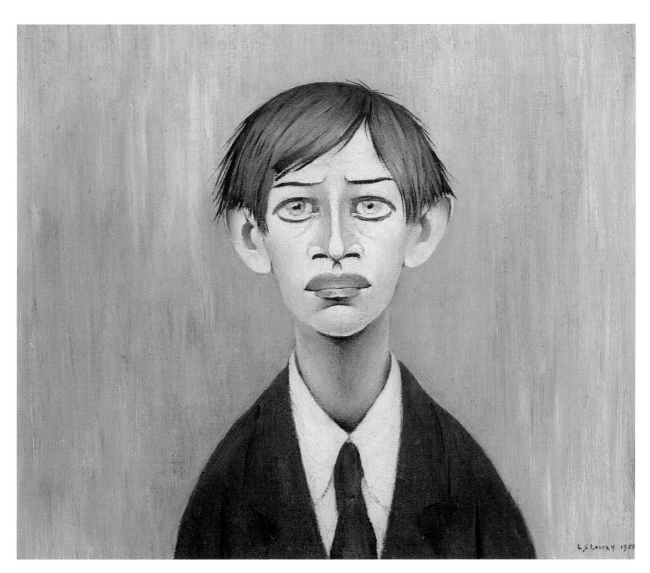

Plate 32 *A Young Man*. 1955. London, The Tate Gallery. Cat. 60

Fig. 37 *Huddersfield*. 1965. Huddersfield Art Gallery. Cat. 25

Fig. 38 *Greenwich Reach towards Deptford Power Station.* 1959. London, National Maritime Museum. Cat. 50

Plate 33 *The Estuary*. 1956–9. City of Salford Art Gallery. Cat. 314

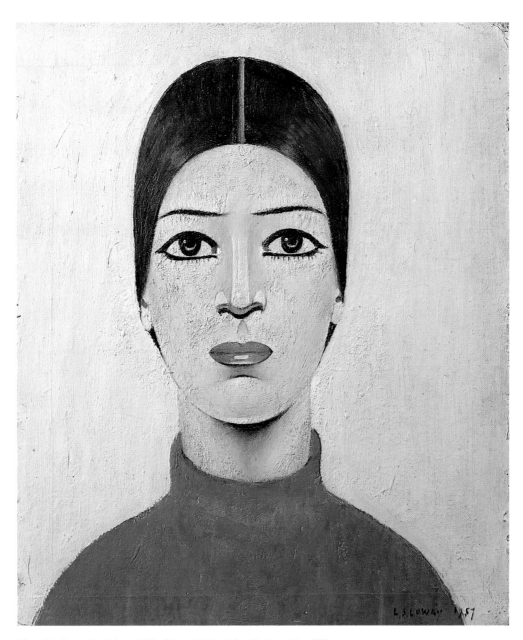

Plate 34 *Portrait of Ann*. 1957. City of Salford Art Gallery. Cat. 316

practically white ground, and he said, "That's right, and you've lost nothing in quality."
And I had to agree with him.

I've grown increasingly fond of whites. I began to notice how they changed with time. I
remember it was in 1924 I got a little piece of wood and painted it flake-white six times over.
Then I let it dry and sealed it up; and left it like that for six or seven years. At the end of that
time I did the same thing again on another piece of board, opened up the first piece I'd
painted and compared the two. (It was the only thing my father was interested in about my
painting.) The recent one was of course dead white; but the first had turned a beautifully
creamy grey-white. And then I knew what I wanted. So, you see, the pictures I've painted
today will not be seen at their best until I'm dead, will they?

But, you know, there are such simple things I still cannot do. Only the other day there
was something I couldn't get right, and while I was struggling a fifteen-year-old called on
me. "You'll have to take those figures out at the top, won't you?" she said straight away.
"Go on! Take them out now, while I'm here. You can always put them back in afterwards.
You're a strange man, Mr Lowry. What did you ever put them in for?" So I did as she said.
"And now you can put one or two figures at the side, but not at the top. Can't you see?" And
of course she was right, but I hadn't been able to see it.

Had I not been lonely, none of my work would have happened. I should not have done
what I've done, or seen the way I saw things. I work because there's nothing else to do.
Painting is a marvellous way of passing the time, and very interesting when you get into it.
Between 1909 and 1939, when I had my first exhibition, there's really nothing to tell. After
about 1909, when we moved house, I lost sight of everybody. I had no close friends at all.
I've never been married. I've never had a girl, in fact. And now I'm nearly 80 I think it's too
late to start.

There was one girl: at art school. We met in life class for three years; and used the same
railway station to go home. It went on like that. When the summer holidays came we'd say,
"See you again in October." I never thought of arranging to see her. And one October she
wasn't there, and that was the end of it.

I think I must have been what they call a "cold fish". Even now I usually prefer to be by
myself. I didn't even notice there was a Great Slump. It didn't come into my curriculum.
My mother died in 1939, and I know it sounds ridiculous and sentimental to say so but I've
never felt much interest in life since then. . . .'

Since 1948 Lowry has lived alone on the farthest outskirts of his native Manchester, on the edge of the moors. His house in Mottram-in-Longdendale is bleak, dark, cluttered, full of clocks. The garden is not kept up. Like his work, Lowry's house is almost without colour.

'... I've no scenic sense whatever. One place is much like another to me. Some years after the Second World War a friend said "Why not come to Mottram? I know you don't like the place, but that won't make any difference to you." So I went for twelve months, and I've stayed here ever since. But it's a dreadful place. I can't think why I stay here.

Going back to the 1930s—I said that nothing had happened in my life for thirty years until my first exhibition in 1939. But that's not quite true. I did show here and there. And in 1927 a dealer wrote very nicely to say he'd been seeing my work in the *Salon d'Automne* in Paris, and he felt he could sell some of it. I was then forty, and no dealer had ever approached me before (nor would again for another eleven years). He said he was going away for a few weeks and would get in touch. He never did. I thought it was shabby. Many years later I asked a gentleman who I thought might know about him. "Very sad, wasn't it?" he replied. "Oh, didn't you know? He died." Yes, he'd been going in for an operation when he wrote to me, and had passed away a week later. I've never judged a man for not answering letters since.

Some years later again, it must have been in 1933, another dealer did write to me—come to think of it—to say he'd like a show of my work. He too felt sure he could sell them. But by then I couldn't be bothered, and with what the Iron Duke called "masterly inactivity" I did nothing.

Of course I often used to wonder if I'd ever make any money. I was living at home, so it wasn't urgent, but every now and then I felt thoroughly fed up and I'd say "This is ridiculous; I'll take a job." But I didn't like the thought of going to the office with a bag in my hand at half-past nine every morning. And then some little sale would come along— there were always a few private buyers in Manchester and Salford—and that was enough to keep me going for another year.*

Very, very few people liked my work at all. As a younger man I used to do portraits. There's one in the Salford Art Gallery now, that originally I'd done specially to please the man. I thought it was 'l sweet. But his wife said she wouldn't have it in the place, so it stayed in the attic for forty-three years: never once down! Then he died, and his son didn't like it either, so I got it back and gave it to Salford. It's very sad, you know.

It was in 1938 that things at last changed for me. The dealer Alexander Reid of the Reid and Lefevre Gallery saw some paintings of mine on the floor of Bourlet's, the framers and packers. They used to send them round the exhibitions, and nearly all of them would come back unsold. Bourlet's told him there was a roomful of them upstairs. "Send them all round to the gallery," he said. He was quite excited.

So he gave me a show a few months later, in 1939. And I sold about sixteen. My God, it was dreadful. It nearly gave us all apoplexy at home. Our brains almost weren't powerful enough. The Tate bought one. I got more pleasure out of that first show of mine than out of anything else in art.

Looking back, I don't know what I would have done if I'd not had that show. I think I couldn't have kept going much longer. By 1939 I was already losing interest a bit. I was fifty-two, you know, although I don't resent having to wait that long. No one ever asked me to paint. They didn't owe me anything.

As it is, I often feel I should have dropped out about 1945, the time of my third exhibition. I'd done what I'd set out to do. I had proved my point—that there was subject-matter for a painter in the industrial scene. Perhaps I should have stopped then. Some years later the Royal Academy suggested I join them. I was a bit surprised. I'd hardly ever sent

*But see p. 17 for a discussion of his professional life.

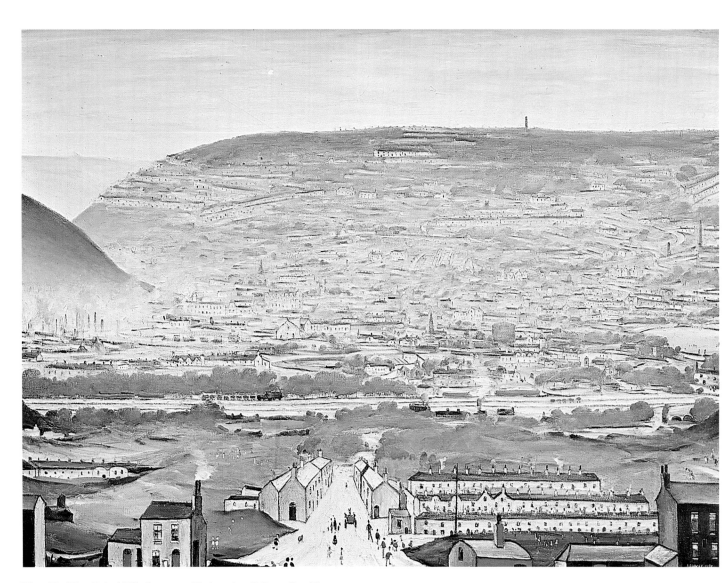

Plate 35 *Ebbw Vale*. 1960. Coventry, Herbert Art Gallery. Cat. 13

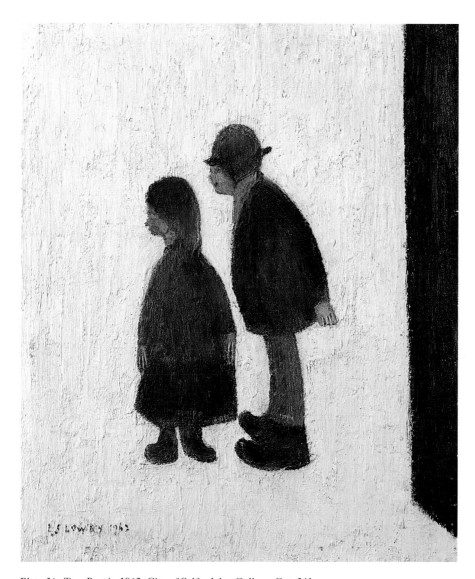

Plate 36 *Two People*. 1962. City of Salford Art Gallery. Cat. 341

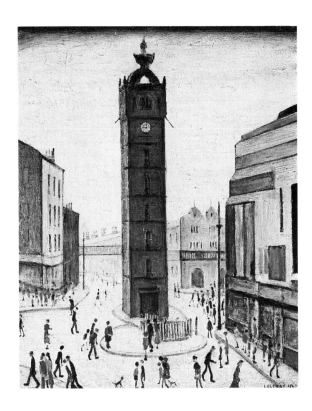

Fig. 40 *The Tollbooth, Glasgow.*
1947. Wakefield Art Gallery.
Cat. 438

anything up to their Summer Exhibitions: about twice in twenty-five years. I didn't think I was the kind of man they would want. "Can we put your name down?" the Secretary said to me. "Yes," I replied, "if it would give you any pleasure." I was very pleased, though, to be elected an ARA in 1955, and later an RA. I've got great respect for the Royal Academy.

Money? It has come too late. I've never been abroad, and now I don't want to travel. Naturally I feel pleased that my pictures fetch several thousand pounds at auction. They are all over the world now, and that's good enough for me.

I could go off now and forget about painting. I'm not dedicated, you know: not dedicated at all. I've never felt like some artists, who take it all frightfully seriously. I go long stretches without doing any.

There's nothing in my life, except what I've said. I've never robbed a bank, or shot someone, or married. I'm really a man without ambition. Now I'm waiting and not caring. People are gone, and the worst is that you think that when people go the places will stay the same. But they change, too, and that's very sad. Now I have music. That's tremendously important to me in my old age. Bach, Bellini, Donizetti, Beethoven, Vivaldi, Haydn. Bellini in particular: I've acres of him on records. When the Hallé Orchestra were to do a special concert for me, they asked me for my choice of music and I said Bellini. But they couldn't: they'd no singers for him, they said.

As for my Rossetti paintings all round this room: he's the one man whose work I have ever wanted to possess. I said to my father: "I wish you'd buy me a Rossetti painting." Now I've got about twelve. I have always been fascinated by certain types of women he painted. I'm a Victorian all right, you know.

At art school the Impressionists were just beginning to come in. There was an exhibition in Manchester, I think it was 1908. I liked them up to a point, but I didn't see the battle of life in them. But I saw it in Daumier all right. I thought very much of him. But I don't go to art shows as I should. I just do my stuff as best I can in my own house, and then I go and see my friends who are stockbrokers and so forth. I often think I should have been a stockbroker and not an artist. . . .'

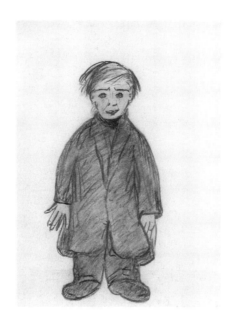

Fig. 41 *Man in Overcoat*. 1960.
City of Salford Art Gallery.
Cat. 328

During the past ten years Lowry has tended to abandon his panoramic mill scenes and massed figure-subjects in favour of close-up studies of strange, individual figures, described with a distinctly grotesque humour. Lowry generally has a story about each of them.

'. . . It just happened that way. Everything in my life has just happened. There's a grotesque streak in me and I can't help it. My characters? They are all people you might see in a park. They are real people, sad people; something's gone wrong in their lives. I'm attracted to sadness, and there are some very sad things you see.

There is something about these people that is remarkable, you know. They have a look in their eye. You wonder what they are really looking at. There is mystery about them. I feel I am compelled to try and draw them. I wonder all the time: what is their life? They are dreadfully sad.

One day I met a man in a park and he reeked of beer. "Would you like to give me tuppence?" he said. "I haven't had anything to eat or drink for two days." I said "No", and he laughed. I gave him a shilling. Later on I met him again on the other side of Manchester. It was like a meeting of Wellington and Blucher—until I asked him about his life, and he shut up like a clam.

They are not always so friendly. I think you know my painting called *The Contraption*. I came across that thing during one of my perambulations. There was this man travelling slowly along in an extraordinary upright box on wheels. I followed it. I couldn't help it. And the man had the face of a poet. Suddenly he stopped and turned on me: "What the bloody hell are you following me about for?"—and plenty more of like language. I felt a fool.

You see, I'm a very lonely man. But I like to be lonely. I can go where I please. I don't have to worry about anybody. One penalty of being successful is that now I'm worried by young people coming to see me. They have to do a thesis and they seem to choose me. Today I don't seem to get any rest. And that is why music is so important to me. And of course these clocks. There are nine of them in this room, and others all over the house. They come from my old home: my mother's collection. They all keep different times, but you get used to it. You have to be thankful they go at all at that age.'

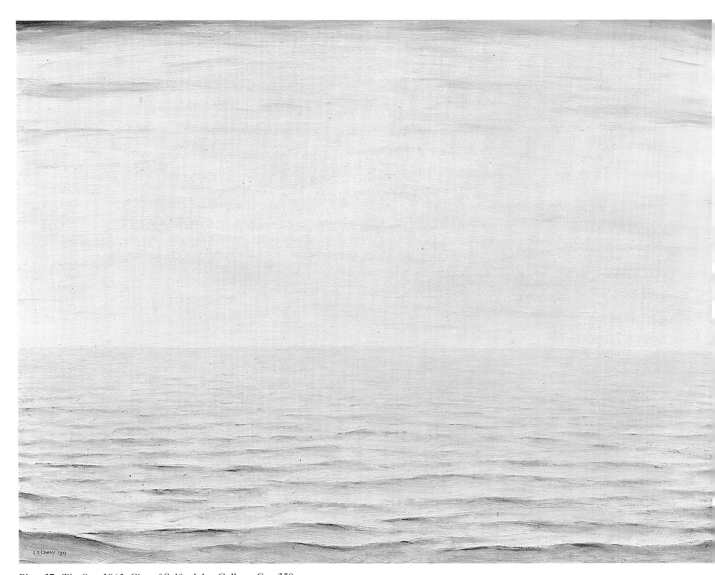

Plate 37 *The Sea*. 1963. City of Salford Art Gallery. Cat. 358

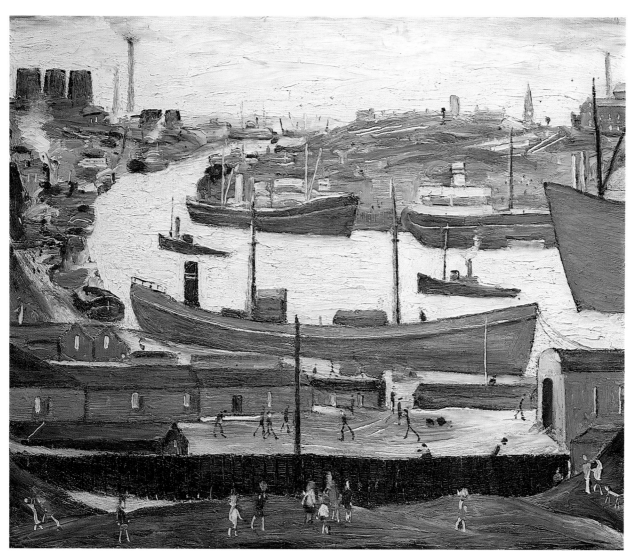

Plate 38 *River Wear at Sunderland*. 1961. Sunderland Museum and Art Gallery. Cat. 434

4

'Will It All Last . . .?'

MARINA VAIZEY

The paintings of L. S. Lowry are probably, almost certainly, the most familiar, the most loved and the most appreciated of all twentieth-century British art. Critically, they are generally ignored, treated as peripheral to the central concerns of advanced, progressive art, their very popularity held against them. They are not part of progress, evolution, development, it seems. Yet the attitude of exhibition organizers, curators, critics and art historians is ambivalent. In the *Oxford Companion to 20th Century Art*, edited by Harold Osborne, there is a sympathetic, succinct entry on Lowry which states the dilemma very well. Osborne, whose own knowledge is encyclopaedic, remarks that critical reaction to the 1976 Retrospective held at the Royal Academy displayed 'considerable divergence of opinion', with some commentators responding to 'an important original vision' while others thought Lowry 'a very minor, or at best competent, artist . . . interesting [only] as a social commentator in the visual field.'

In the two-year part work, *The Great Artists: Their Lives, Works and Inspiration*, published by Marshall Cavendish, 1985–6, Lowry was one of the 95 artists chosen to represent Western art from the Renaissance to the present, and one of 25 'moderns'. Naturally the weekly publication had an eye to the British market; the other British artists chosen for the modern period were Bridget Riley, Gwen John, Edward Burra and Stanley Spencer. In 1976 at the Royal Academy, the art of L. S. Lowry, in an exhibition lasting only 72 days, in six rooms of the main galleries, was seen by a recorded number of 180,216 visitors. Lowry indeed holds the Royal Academy record for any twentieth-century exhibition of the art of an individual. Only Picasso and Stanley Spencer begin to approach Lowry in the twentieth-century top of the pops at the RA. Yet of course Picasso and Spencer have both had a much warmer critical reception than Lowry, who outdistanced both by almost 50,000 visitors. Lowry's art has often been dealt with by art dealers, writers and journalists, rather than art historians. Indeed, the artist whose position is in some ways most analogous to Lowry's—in terms of the divergence between popular and critical appraisal—would currently be the American Andrew Wyeth, whose work has been shown at the Metropolitan, New York, and at Washington's National Gallery, as well as at London's Royal Academy.

The difficulty with Lowry shows up clearly in the literature of art. R. H. Wilenski, an unjustly neglected journalist and historian, responsible for sober, intelligent and vivid appraisals over four decades, does not in his prescient *The Modern Movement in Art*

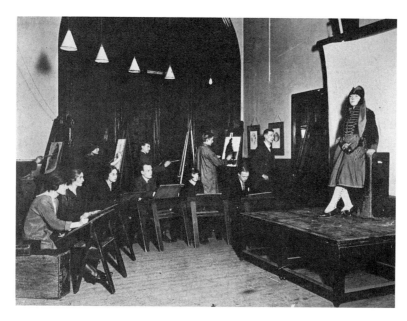

L. S. Lowry (far right) in a
costume class at
Salford School of Art *c*.1927

(reprinted twelve times in four editions from 1927 to 1960) mention Lowry, although
Spencer, Patrick Heron, Victor Pasmore, Epstein and Paul Nash, are all included.

Although Lowry's rather mysterious life has attracted increasing interest, there are
several reasons why his art has not entered even the mainstream of English eccentricity in
the essays of the commentators. He did not live in London, nor even in the Home Counties
or the South. He was not at the metropolitan heart of things; involved in art-school
education as a part timer, he was never on the art-school network, as student or teacher. It is
also difficult to categorize his work; in spite of a long art education and continual
attendance at classes, his work defies most comparisons: it is *sui generis*. Yet Lowry himself
was incensed at being thought a naïve original. As he said, indignantly, he was 'sick' of
being described as self-taught. He went to classes at the Manchester Art School, and in
Salford, for twenty-three years and to life drawing for 'twelve solid years'. It was life
drawing that he regarded as the 'foundation of painting'. His drawings from the life are
academic and accomplished; they give little hint of the individuality that he was to explore,
the Lowry world he invented. Drawings preceded paintings; they provided the building
blocks for the vision—which the artist claimed as reality, though it was often a composite
reality.

What is more, even though few who knew him as an artist in later life were aware of it, he
had a full-time job, and worked until the retirement age of sixty-five. It is exceptionally
difficult to think of any parallel—an artist who had a full-time job totally unconnected with
art—although there are many parallels with writers. Lowry was a maker of myth, perhaps,
but from a perceived reality, and that often harsh. His image is not escapist, however
dreamlike it may be.

Lowry's art was a match of technique and temperament. The striking contrasts between
dark and light mean that Lowrys reproduce very well, but it is salutary to see how
remarkable his paintings are 'in the flesh'. He was conscious of his loneliness. In one
interview, he described how 'every human creature is an island'. His figures were, he
remarked, 'often adrift in areas of lonely whiteness'. Colour was emotional. It has drawn
the admiration of some of the critical, scholarly and curatorial leaders of the art world:
Kenneth Clark, Herbert Read, E. H. Gombrich. Gombrich described Lowry as an artist
who could 'not be labelled or docketed'.

His art is, of course, more wide ranging than the popular view of it. The subject matter is

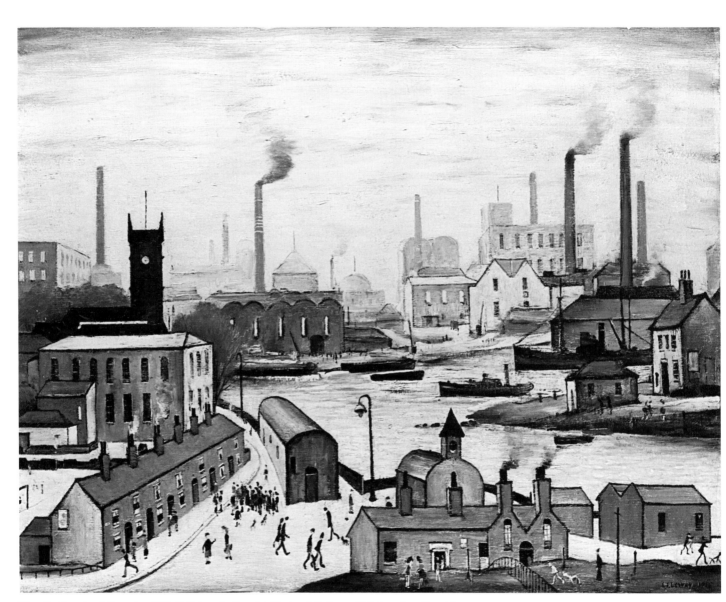

Fig. 42 *Canal and Factories*. 1955. Edinburgh, Scottish National Gallery of Modern Art. Cat. 19

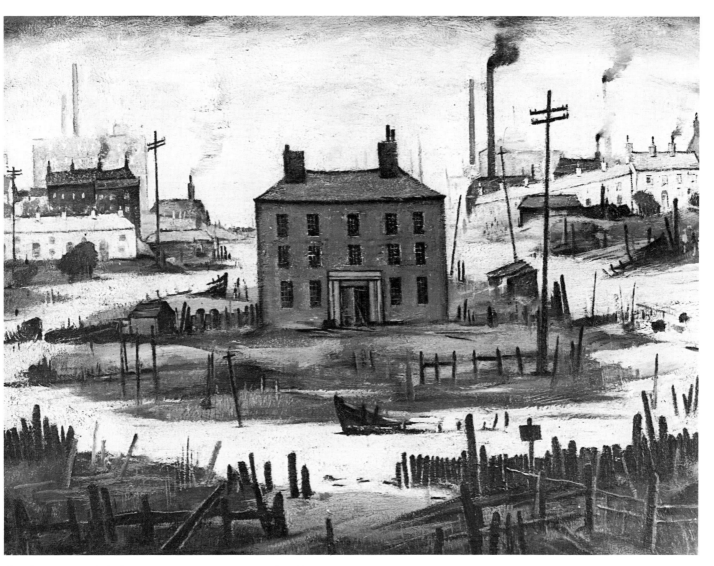

Fig. 43 *An Island*. 1942. City of Manchester Art Galleries. Cat. 78

broad—portraits, landscapes, seascapes, incidents as well as the crowd-filled industrial scenes for which he is most famous. Yet the techniques are similar; the look of a Lowry over decades is markedly consistent compared to many another artist whose work might more easily be divided and subdivided into chapters and phases.

Because Lowry is so much his own invention, owing much to the groundwork of drawing (as he himself emphasized) yet seemingly so little to both the history of art and the art of his own times, the normal method of critical and scholarly assessment—compare and contrast—is more or less voided. The way, too, in which Lowry's art finally made an impact on a London audience was romantic and unconventional. A. J. McNeill Reid, of Reid & Lefevre (now the Lefevre Gallery) chanced on Lowry's paintings at the London framers, Bourlet, in 1938; Lowry was exhibited at the Lefevre the following year and his metropolitan reputation was secure, although he was at first mistaken for a naïve or primitive painter. Moreover, the Tate purchased work from that 1939 exhibition. John Rothenstein, then director of the Tate had come to London from Sheffield only the year before. 'I stood in the gallery (Reid & Lefevre) marvelling at the accuracy of the mirror that this to me unknown painter had held up to the bleakness, the obsolete shabbiness, the grimy fogboundness, the grimness of northern industrial England.' After his fascination with the subject, Rothenstein noted, he began to admire the quality of the painting, and chose to show to the Trustees of the Tate a painting 'that summed up remorselessly yet with tenderness the industrial north I knew so well.'

Yet what is curious is that critics have not been interested, in spite of the laudatory remarks collected from time to time from the mandarins of the art world. In part this is because Lowry never needed championing once he had been 'discovered'; he was never interested in moving to London, was rarely interviewed, worked in an office until the conventional retiring age of sixty-five, and apparently only needed money in order occasionally to buy the Pre-Raphaelites he was interested in. Lowry paid tribute to the Impressionist Adolphe Valette, his teacher, but he never imitated Impressionist techniques, nor School of Paris painting. But some of his seascapes are as minimalist, as 'conceptual', as aspects of constructivism, or abstract expressionism, a reduction of nature to a flow of one or two colours. John Rothenstein described an episode in 1951 when he accompanied Graham Greene to dealers' galleries in London, and the writer bought 'a tiny [Lowry] canvas, divided almost exactly in two by a horizontal line, the upper half stained with a faint grey and the lower with a dusky green'. Lowry has also been paid the ultimate compliment of being forged: the recognizable style and the substantial prices achieved by his painting see to that.

In all the histories of British art, almost without exception, Lowry is dismissed in a line as a 'solitary figure' although invariably there will be a reproduction of his work. William Gaunt, that most elegant and underrated writer, in his *Concise History of English Painting*, notes Lowry under the general rubric of 'painters who have achieved an individual realism without concession to the twentieth-century concern with manner rather than content'. Gaunt underlines Lowry's 'local attachment', and describes him as standing alone (again) 'as a "provincial Brueghel" in his depiction of scurrying crowds against backgrounds of factories, chimneys, dingy canals, and the little terrace houses of the industrial town.'

Lowry of course has one feature that allies him to a significant number of artists; he was obsessive, dependent on his surroundings and his subject matter; as Rothenstein, I believe astutely, observed, he was 'enslaved'. A newspaper article by David Storey, novelist, playwright and, once, art student, coupled Lowry and Spencer when discussing the British Tradition, as together representing 'the reclusive charm of our native art'.

Yet Lowry's paintings, unlike the majority of Stanley Spencer's—or Edward Burra's—rarely tell a story. They may appear as narrative, but they are plotless. The academic drawings show he could be as conventional as any. To choose, to invent, the idiom he did

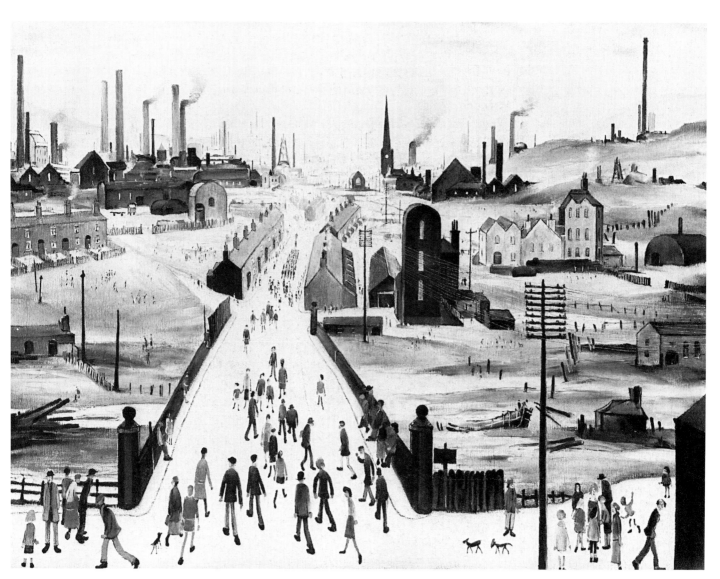

Fig. 44. *The Canal Bridge*. 1949. Southampton Art Gallery. Cat. 428

would seem to make him a natural for critical appraisal. Yet, by his own volition, standing aside from the 'mainstream', appraisal came there none.

No academic commentator has ever wanted to claim Lowry, in spite of the affinities between his art and 'modernism' that actually could be demonstrated. Among these characteristics, which are typical of Lowry but which can be applied to 'modern' artists, are his reductive simplicity, severities of style, unrealistic but convincing and authoritative use of colour, a quite frequent yet not invariable lack of any story (although the art is representational) and the typical but again not invariable lack of individuality in the portraits. Then there is his actual technical skill which could be analysed. But of course, Lowry never needed partisans. He existed, and he was a hard-working artist, and he did not need championing. No critic could make his reputation with Lowry. The public, once they had found his work, never needed convincing. His London gallery, the Lefevre, sold modern masters, Impressionists—and Lowry. But Lowry was outside the art world. He simply never belonged—except to the public which adored, and adores, his art. In some very real way, Lowry, the loner, the outsider, is a quintessential part of English art; our critical ignorance of his work is therefore damaging both to our understanding of English art—and to our understanding of modernism.

The Public Collections

MICHAEL LEBER AND JUDITH SANDLING

It was a frequent complaint, or boast, by L. S. Lowry that he had received little recognition prior to the 1939 Lefevre exhibition. There developed, through unqualified acceptance of his belief, a view of a rejected artist, struggling to sell his pictures and ignored by public galleries and private collectors.

The evidence, however, clearly contradicts this characterization. If he sold little to private collectors, he also exhibited little. He was in competition with a great many accomplished artists, few of whom realized Lowry's eventual success. His work was also far from the accepted norm whether in a contemporary or traditional sense: it could be considered provincial, even parochial. Certainly, prior to 1926, it could be viewed as sombre and dismal. As early as 1927—he was by then forty years of age but had exhibited only irregularly since 1919—the *Eccles Journal* was able to report that a painting by the Pendlebury artist L. S. Lowry had been purchased by the Tate Gallery. The account was somewhat misleading as *Coming out of School* (Cat. 54) had been acquired by the Duveen Paintings Fund specifically for use in loan exhibitions. However, it represented the first official purchase of a Lowry work. The painting was not transferred to the Tate Gallery collections until 1949, a circumstance which did little to contradict Lowry's general dislike for galleries which acquired paintings only to store them for years. Such criticism was not limited to the Tate, nor was it, or is it, limited to Lowry.

If the Tate 'purchase' was a disappointment to the artist, major sales to public collections were soon to follow. In 1930 Manchester City Art Gallery purchased *An Accident*, 1926 (Cat. 69), from the 'Six Manchester Art Clubs' exhibition held at the gallery and, in the same year, a drawing was presented to the city's Rutherston Collection, the latter from a sell-out exhibition of his local drawings held at the Roundhouse. A commission for Manchester was discussed but was not completed, again much to the artist's chagrin.

Through the 1930s other galleries followed Manchester's lead. Salford purchased *A Street Scene – St Simon's Church* (Cat. 247) in 1936; Stockport had bought *A Street in Stockport: Crowther Street* (Cat. 431) from James Bourlet and Sons a year earlier; and Manchester added *An Organ Grinder* (Cat. 74) from the 1936 Manchester Academy of Fine Arts exhibition. *Street Scene* (Cat. 430) was acquired by Southport from the 1939 Spring Exhibition at the town's Atkinson Art Gallery and Salford purchased *The Lake* (Cat. 276) also in 1939.

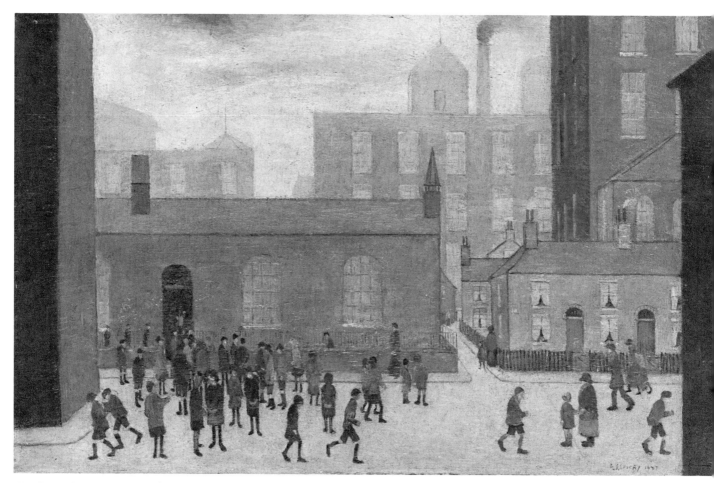

Fig. 45 *Coming out of School.* 1927. London, The Tate Gallery. Cat. 54

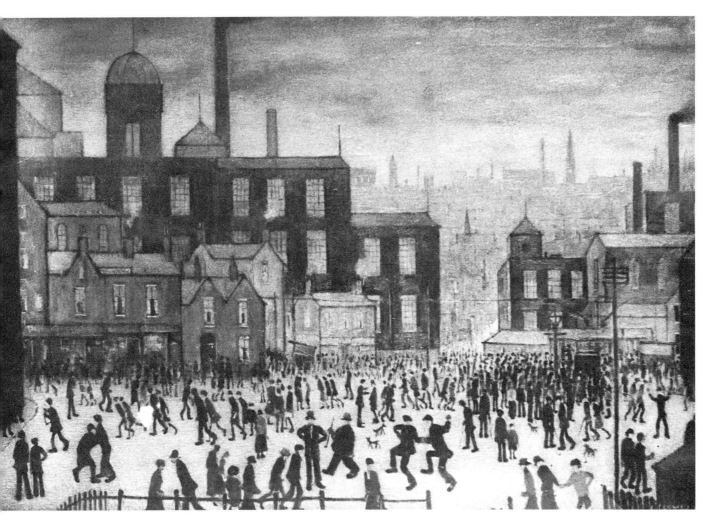

Fig. 46 *Our Town*. 1947. Rochdale Art Gallery. Cat. 99

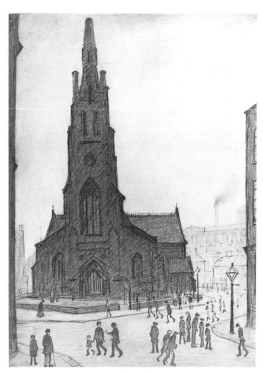

Fig. 47 *St Simon's Church. c.1927.*
City of Salford Art Gallery.
Cat. 245

Fig. 48 *St Simon's Church (A Street Scene – St Simon's Church).* 1927. City of Salford Art Gallery. Cat. 246

The one-man exhibition held at the Lefevre Gallery in 1939 was only a limited success in overall sales but these did include one important and influential acquisition by a public gallery. The Tate Gallery purchased *Dwellings* (Cat. 55) for the permanent exhibition, a forthright signal of national acceptance.

The Tate purchase and enthusiastic reviews for the exhibition resulted in a gradual increase in the number of galleries acquiring Lowry's works. During the 1940s regular exhibitions at the Lefevre Gallery attracted purchases by Glasgow, Aberdeen, Birmingham, Newcastle, Leeds and the British Council. Other galleries—Lincoln, Liverpool, Rochdale and Rugby—and the Arts Council purchased direct from the artist. Manchester added two more important paintings from the Mid-day Studios exhibitions held in the city. Two paintings were bought by the Contemporary Art Society and allocated to Lincoln and Leamington Spa. Swindon, Manchester and the Whitworth Art Gallery had been recipients of private donations. By 1950 there were thirty-seven Lowrys in public collections. In the ten years which followed, this figure increased by 112, largely the result of two exhibitions in the North West.

Salford's 1951 L. S. Lowry Retrospective encouraged the city to add thirteen works by purchase, to which the artist added fourteen by presentation. Until this time, Salford's collection had totalled just four paintings, one of which Lowry had donated. During the 1950s, however, Salford were to assemble the basis of a remarkable collection, through a combination of purchase, commission and the generosity of the artist. At the close of the decade, Manchester City Art Gallery held another major Retrospective exhibition, and virtually all the works available for sale were acquired by either Manchester or Salford. In the intervening years, other important purchases had been made by the Tate Gallery, Southampton, Nottingham and Bradford.

The 1960s saw significant additions to public collections. Salford extended its collection whilst Coventry, Huddersfield, the Tate and Sheffield made important purchases. The period also saw the development of two noteworthy collections at Swinton and Eccles. Recent collecting has been more spasmodic. There was a burst of collecting by galleries in

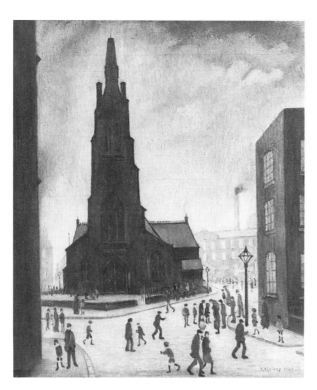

Fig. 49 *A Street Scene – St Simon's Church*. 1928. City of Salford Art Gallery. Cat. 247

the North East which coincided with Lowry's frequent sojourns in the area. The artist's death in 1976 resulted in his bequest of four paintings to Salford's collection which was greatly extended by a major purchase from the artist's estate. Salford apart, less than a dozen works by Lowry have entered public collections since his death.

The chronology of collecting points obviously to the importance of local collecting by galleries prior to 1939 and a great surge of acquisitions during the 1940s and 1950s, when Lowry became known nationally and when his paintings could be purchased at relatively low cost.

It is as well to note, however, that only the Arts Council, Sheffield, Sunderland, the Whitworth, the Tate, Manchester and Salford can boast more than three Lowry works. Yet there are only one or two major public collections without a Lowry. Outside the North West, galleries tended to collect what might be called 'typical' Lowrys, the industrial scenes with figures. Only a quarter of the public holdings outside of Salford do not fit into this category. There is a similarly narrow approach with regard to period. Outside of Salford, only two works are dated before 1920 and over half date from 1925 to 1945.

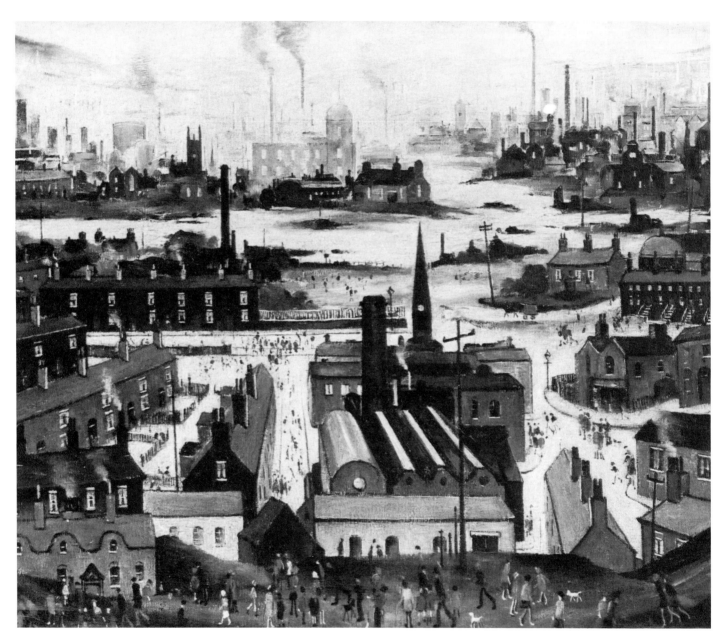

Fig. 50 *Industrial City*. 1945–8. London, The British Council. Cat. 45

Selected List of Exhibitions

Catalogues exist for virtually all the exhibitions listed. However, those marked with an asterisk are particularly valuable to the researcher.

1927　London, Royal Society of British Artists, '*Daily Express* Young Artists Exhibition' (also toured to Leeds)

1930　Manchester, City Art Gallery, 'Six Manchester Art Clubs'

1931　London, New English Art Club
Paris, Salon des Artistes

1931/2　Salford, Art Gallery, 'Works by Local Artists'

1932　London, Royal Academy
Manchester, Academy of Fine Arts

1933　Bradford
London, Royal Academy
London, Royal Society of Arts

1934　Edinburgh, Royal Scottish Academy
London, Arlington Gallery

1936　Manchester, Academy of Fine Arts

1938　Salford, Art Gallery, 'Paintings from the Art Galleries of Lancashire and Cheshire'

1939　London, Lefevre Gallery, 'Paintings of the Midlands by L. S. Lowry'

1940　Manchester, Academy of Fine Arts

1941　London, New English Art Club
Salford, Art Gallery, 'Paintings and Drawings by L. S. Lowry RBA'

1942　Salford, Art Gallery, 'Society of Modern Painters'

1943　Liverpool, Bluecoat Chambers
London, Lefevre Gallery, 'Paintings by Joseph Herman and L. S. Lowry'

1945　London, Lefevre Gallery, 'Paintings by L. S. Lowry'
London, National Gallery, 'Walker Art Gallery, Acquisitions 1935–45'

1946　Derby, Art Gallery, 'Exhibition of Contemporary Art'
Newcastle-upon-Tyne, Laing Art Gallery, 'Northern Counties Exhibition'

1947　Arts Council, 'Paintings from the Rutherston Collection'
London, Lefevre Gallery, 'Sickert to Hodgkins'
Salford, Art Gallery, 'Local Artists Exhibition'

1948　London, Lefevre Gallery, 'Paintings by L. S. Lowry'
Manchester, Mid-day Studios, 'Paintings by L. S. Lowry'
Salford, Art Gallery, 'Local Artists Exhibition'

1948/9　British Council, 'Fine Arts Exhibition'
British Council Canadian Tour, 'Contemporary British Drawings'

1949　Arts Council, 'Picture of the Month'

1950　Accrington, Haworth Art Gallery
London, Whitechapel Art Gallery, 'Painters' Progress'

1951　Arts Council, 'Two Lancashire Painters' (with Theodore Major)
Belfast, Ulster Museum
Lancaster
London Group
London, Lefevre Gallery, 'Recent Paintings by L. S. Lowry'
London, Royal Academy
Salford, Art Gallery, 'Retrospective Exhibition of the Work of L. S. Lowry, MA, RBA'

1951/2　Arts Council, '60 Paintings for '51'

1952　Accrington, Haworth Art Gallery
Scottish Arts Council, '20th Century British Painters from Aberdeen Art Gallery'

1953　Dudley, Public Library, 'Life in Industry 1910–1950'
London, Lefevre Gallery, 'Recent Paintings by L. S. Lowry'
*Salford, Art Gallery, 'Painters' Progress, The Manchester Group'

1954　London, Guildhall Art Gallery, 'Trends – British Art 1900–1954'
London, Whitechapel Art Gallery
Salford, Art Gallery, 'The Lancashire Scene'

1955　Arts Council, 'British Painters of Today'
Arts Council, '10 English Painters 1925–55'
Manchester, Academy of Fine Arts
Manchester, Regional College of Art
Salford, Art Gallery, 'The Lancashire Scene'
*Wakefield, Art Gallery, 'Paintings and Drawings: L. S. Lowry and Josef Herman'

1956　Edinburgh, Royal Scottish Academy
London, Lefevre Gallery, 'Recent Paintings by L. S. Lowry'
London, Royal Academy
Scottish Arts Council, 'Paintings from the Scottish Galleries'
Stalybridge, Astley Cheetham Art Gallery

1957　Altrincham
Ashton-under-Lyne, Heginbottom School of Art
Bradford Spring Exhibition
Geneva, Musée d'Art, 'Art et Travail'
London, Agnew's, 'Loan Exhibition from the City Art Gallery, Birmingham'
London, Royal Academy
Manchester, Academy of Fine Arts
Salford, Art Gallery, 'The Lancashire Scene'

1959　London, Royal Academy
*Manchester, City Art Gallery, 'L. S. Lowry Retrospective Exhibition'

1960　Altrincham, Art Gallery, 'Paintings and Drawings by L. S. Lowry'
Arts Council, 'Northern Artists'
Harrogate, 'Festival of the Visual Arts'
London, Contemporary Art Society, 'First 50 Years'
Manchester, City Art Gallery, 'Works of Art from Private Collections'

1961 *Eccles, Monks Hall Museum, 'L. S. Lowry'
 London, Lefevre Gallery, 'New Paintings by L. S. Lowry'
 *Pendlebury, Public Hall, 'L. S. Lowry'

1962 Bury, Art Gallery, 'Works of L. S. Lowry RA'
 *Sheffield, Graves Art Gallery, 'The Works of L. S. Lowry
 ARA'

1962/3 *Midland Area Service, 'Lowry'

1963 London, Royal Academy, Summer Exhibition
 London, Royal Academy, Winter Exhibition
 North-Western Federation Exhibition

1964 Kendal, Abbot Hall Art Gallery, 'L. S. Lowry'
 London, Lefevre Gallery, 'Recent Paintings by L. S. Lowry'
 *Pendlebury, Public Hall, 'L. S. Lowry'

1965 Bournemouth
 London, Mercury Gallery
 Salford, Art Gallery, 'Frape Memorial Exhibition'

1966 *London, Lefevre Gallery, 'Recent Paintings by L. S. Lowry'
 Pendlebury, Public Hall, 'L. S. Lowry'

1966/7 *Arts Council Tour, Sunderland Art Gallery, Whitworth Art
 Gallery (Manchester), Bristol Art Gallery, Tate Gallery
 (London), 'L. S. Lowry Retrospective Exhibition'

1967 Lytham St Annes, College of Further Education, 'L. S.
 Lowry'
 Newcastle-upon-Tyne, Stone Gallery
 Nottingham, Playhouse

1968 Arts Council
 Dublin, Trinity College, 'Modern Art from the Ulster
 Museum'
 Halifax, Town Hall, 'L. S. Lowry'
 London, Crane Kalman Gallery, 'The Loneliness in L. S.
 Lowry'

1970 Arts Council, 'Decade 1920–1930'
 London, Camden Arts Centre, 'Narrative Painting in Britain
 in the 20th Century'
 North-West Museum and Art Gallery Service, 'The
 Rutherston Loan Scheme 1925–1970' (from the City Art
 Gallery, Manchester)
 Norwich, Castle Museum, 'L. S. Lowry'
 Swinton, Public Library, 'L. S. Lowry'

1971 *Accrington, Haworth Art Gallery, 'L. S. Lowry'
 Belfast, Ulster Museum, 'L. S. Lowry' (Arts Council of
 Northern Ireland)
 Jarrow, '20th-Century British Painting'
 Kirkcaldy, Art Gallery, 'Group of Eight'
 Rochdale, Art Gallery

1972 *Leigh, Turnpike Gallery, 'Paintings and Drawings by L. S.
 Lowry'

1972/3 Arts Council, 'Decade 1940–1950'

1973 *Liverpool, Walker Art Gallery, 'L. S. Lowry'
 Nottingham, University Art Gallery, 'Diploma Works by
 Present RAs'
 Pendlebury, Public Hall

1974 London, Crane Kalman Gallery, 'A Selection of British
 Paintings'
 London, Royal Society of British Artists, 'RBA 150th
 Anniversary'
 *Nottingham, University Art Gallery, 'L. S. Lowry RA'

1975 Arts Council, 'Drawings of People'
 Le Havre, Musée des Beaux Arts

1976 Kirkcaldy, Art Gallery, 'The Arts in Fife'
 *London, Royal Academy, 'L. S. Lowry RA'
 *Manchester, City Art Gallery, 'Adolphe Valette'
 Wigan, Powell Museum

1977 Accrington, Haworth Art Gallery
 London, Agnew's, 'English Watercolours and Drawings from
 Manchester City Art Gallery'
 *Manchester, City Art Gallery, 'A Pre-Raphaelite Passion –
 the Private Collection of L. S. Lowry'
 *Mottram-in-Longdendale, Cheshire, 'L. S. Lowry Memorial
 Exhibition'
 Preston, Polytechnic Arts Centre, 'L. S. Lowry'

1977/8 Arts Council, 'Cityscape'
 Nottingham, Midland Group, 'Towards Another Picture'
 *Scottish Arts Council, 'L. S. Lowry'

1978 London, Colnaghi Gallery
 Sheffield, Graves Art Gallery, '60 Painters for '51 Re-creation'

1979 Bladon Gallery, '30th Anniversary Exhibition'
 Kendal, Abbot Hall Art Gallery, 'Paintings and Drawings by
 L. S. Lowry'
 Sheffield, Graves Art Gallery, 'L. S. Lowry'

1979/80 London, Hayward Gallery, 'British Art and Design of the
 1930s'

1980 Greater Manchester Council, 'Face to Face'
 Stockport, Art Gallery, 'L. S. Lowry'
 Swansea, Glynn Vivian Art Gallery

1981 Accrington, Haworth Art Gallery, '20th Century British
 Painting'
 London, Mayor Gallery, 'A Selection from Middlesbrough
 Art Gallery 20th Century British Collection'

1982 Leicester, Art Gallery, 'RA Diploma Works 1921–1981'
 London, Crane Kalman Gallery

1982/3 Arts Council, 'Coal: British Mining in Art'
 Leicester, Art Gallery, 'L. S. Lowry'

1983 Arts Council, 'Landscape in Britain'
 Arts Council, 'Paintings With Red in Them'
 Bolton, Art Gallery, 'City Visions'
 London, Mayor Gallery, 'Fourteen Modern British Paintings
 from the Whitworth Art Gallery'
 *Stalybridge, Astley Cheetham Art Gallery, 'L. S. Lowry'

1983/4 Arts Council Tour, 'The Nature of Painting II: Rhythm and
 Motion'

1984 Arts Council, 'The Forgotten Fifties'
 London, Artists International Association 1933–1955

1985 Birmingham, Ikon Gallery, 'Summer in the City'
 Chichester, Pallant House Gallery, 'Strands and Shorelines'
 *London, Dulwich Picture Gallery, 'Introducing Sam Rabin'
 Manchester, Cornerhouse, 'Human Interest'
 Nottingham, Castle Museum, 'Train Spotting: Images of the
 Railway in Art'
 Swansea, University College, Taliesin Centre for the Arts,
 'The Drawings of L. S. Lowry'

1986 Arts Council, 'Looking into Painting I: Landscape'
 Lancaster, City Museum, 'The Classic Slum'
 Leigh, Turnpike Gallery, 'Urban Views'
 Manchester, Whitworth Art Gallery, 'Artist and Model'
 Newcastle-upon-Tyne, Laing Art Gallery, 'The Sea'
 Tokyo, Setagaya Art Museum (and Tochigi, Perfectural
 Museum of Fine Art), 'Naivety in Art'
 Warwick University, 'Treasures in Store'

1987 'Lancashire South of the Sands: 2. The Industrial Landscape'
 (touring exhibition)

The catalogue is arranged alphabetically by gallery and chronologically within each collection. Titles are generally those given by Lowry to works exhibited during his lifetime and other accepted titles. Sizes are in centimetres, height × width. The abbreviations t.r./t.l./b.r./b.l. are respectively: top right/top left/bottom right/bottom left. Signatures have been standardized to L. S. Lowry or LSL. Dates are those given by the artist on the works, or are given as *c.* (*circa*) on the best information available. Details of provenance are given in chronological order on information provided by galleries. Exhibitions are selective. The abbreviated exhibition title (see list of exhibitions for more detail) is followed, where applicable, by the number given to the work in the catalogue. Under LIT only major published references are included. Brookes number refers to a mark on the work made by the restorer, James Brookes.

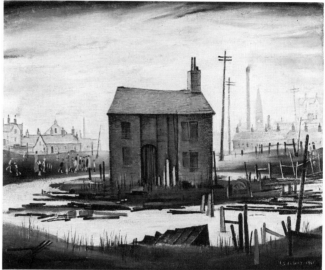

ABERDEEN
Art Gallery and Museums

1. Barges on a Canal 1941
(Pl. 20)
Oil on board. 39.8 × 53.2 cm.
Signed b.l: L. S. Lowry 1941
EXH: Scottish Arts Council 1956 (32); Royal Academy 1976 (128)
PROV: purchased from Alex Reid & Lefevre Ltd., 1945

Almost identical to *Footbridge at Clifton Junction* (65), a pencil drawing in the collection of the City Art Gallery, Manchester. Only the house on the right and the figures have been added. The footbridge crossed the Bolton and Bury Canal.

2. Derelict Building 1941
Oil on canvas. 43.3 × 53.2 cm.
Signed b.r: L. S. Lowry 1941
EXH: Scottish Arts Council 1952 (23); Kirkcaldy 1976; Royal Academy 1976 (163)
PROV: purchased from Alex Reid & Lefevre Ltd., 1945

The isolated, often derelict, house held great appeal for L. S. Lowry. *An Empty House* (432) is one of the earliest; *An Island* (78) dates from 1942.

BEDFORD
Cecil Higgins Art Gallery and Museum

3. Church Street, Kirkham 1925
Pencil on paper. 25.7 × 36.4 cm.
Signed b.l: L. S. Lowry 1925
EXH: Royal Academy 1976 (61) wrongly titled
PROV: purchased from Alex Reid & Lefevre Ltd., 1958

An accurate topographical drawing of a small village near Preston, Lancashire. In 1977, the right-hand side of the street was demolished except for the church. A painting of the same scene, *A Lancashire Village*, dated 1935, shows much the same view except that the church has been replaced by a large house with a plain black spire rising behind.

4. Industrial Landscape 1934
Pencil on paper. 26.9 × 39.5 cm.
Signed b.r: L. S. Lowry 1934
EXH: Royal Academy 1976 (108) repr.
PROV: purchased from the Piccadilly Gallery, 1965

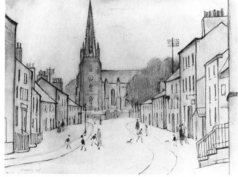

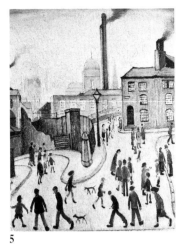

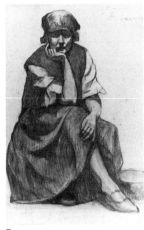

5

7

8

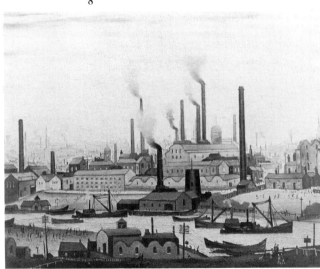

10

BELFAST
Ulster Museum

5. Street Scene 1947
Oil on canvas. 51.2 × 41.2 cm.
Signed b.l: L. S. Lowry 1947
EXH: Dublin 1968; Belfast 1971
(15)
PROV: Alex Reid & Lefevre Ltd.;
T. & R. Annan & Sons,
Glasgow

BIRMINGHAM
City Museums and Art Gallery

6. An Industrial Town 1944
(Fig. 32)
Oil on canvas. 45.8 × 60.9 cm.
Signed b.r: L. S. Lowry 1944
EXH: Lefevre Gallery 1945 (4);
Agnew's 1957 (67); Geneva
1957 (260); Midland Area
Service 1962/3 (12) repr.
PROV: purchased from Alex Reid
& Lefevre Ltd., 1946

Compare *The Pond* (58).

BOLTON
Museum and Art Gallery

7. A Girl Seated 1920
Pencil on card. 53.6 × 36.2 cm.
Signed b.r: L. S. Lowry 1920
Inscribed t.r: To P. Warburton
from L. S. Lowry
Inscribed b.l: 2 hrs
EXH: Stalybridge 1983 (1)
PROV: presented by the artist to his
friend and teacher, Percy
Warburton, by whom be-
queathed to his daughter, Mrs
E. M. Taylor; purchased from
Sotheby's, 16 March 1977

From Lowry's time at Salford
School of Art. Percy Warburton
was one of the lecturers at Salford
and it is possible that this drawing
was executed in one of his classes.
It seems likely that the drawing
was signed in 1920 and the in-
scription added when it was
presented.
　Lowry visited the Warburton
family in Bolton for many years
and was walking with his old tea-
cher when Warburton collapsed
with a fatal heart attack.

8. Worsley 1921
Pencil on paper. 12.4 × 17.5 cm.
Signed b.r: L. S. Lowry 1921
EXH: Stalybridge 1983 (2)

PROV: presented by the artist to his
friend and teacher, Percy
Warburton; purchased from
Warburton's daughter, Mrs
E. M. Taylor, 1976

Some doubt has to be raised con-
cerning the date on this drawing.
The subject and method of work
are more consistent with Lowry's
drawing around 1930 and the
figures may have been added later.
See 211, 212, 213.

BRADFORD
Art Galleries and Museums,
Cartwright Hall

**9. Industrial Landscape
Ashton-under-Lyne)** 1952
(Pl. 29)
Oil on canvas. 115 × 152.5 cm.
Signed b.r: L. S. Lowry 1952
EXH: Lefevre Gallery 1953 (1);
Lefevre Gallery 1956 (1);
Bradford 1957 (53);
Manchester 1959 (54);
Sheffield 1962 (62); Kendal
1964 (20); Arts Council 1966/7
(70); Royal Academy 1976
(197); Bolton 1983 (13)
PROV: purchased from Alex Reid
& Lefevre Ltd., 1957

The scene is based on Ashton-
under-Lyne, Lancashire. The art
critic, Eric Newton, assessed this
painting thus: '. . . As an organi-
sation from foreground to distant
horizon it is a masterpiece'
(*Guardian*, 3 June 1959).

BURY
Art Gallery

10. A River Bank 1947
Oil on canvas. 69.5 × 90 cm.
Signed b.r: L. S. Lowry 1947
EXH: British Council Fine Arts
Exhibition 1948/9; Wakefield
1955 (17); Bury 1962 (35);
Sheffield 1962 (44); Kendal
1964 (21); Arts Council 1966/7
(56); Swinton 1970 (20);
Accrington 1971 (55); Leigh
1972 (50); Stalybridge 1983 (3)
PROV: purchased from Alex Reid
& Lefevre Ltd., 1951

A composite view based on fac-
tories by the River Irwell. See 201.
Bury formerly also owned a pencil
drawing, *Industrial Scene*, 1959,
which was exhibited at Accrington
1971 (70) and Leigh 1972 (56).

BUXTON
Museum (Derbyshire Museums Service)

11. Ironworks 1947 (Fig. 31)
Oil on canvas. 51 × 61.5 cm.
Signed b.r: L. S. Lowry 1947
EXH: Whitechapel Art Gallery 1950; Royal Academy 1976 (171)
PROV: purchased by Derby Education Committee from the Whitechapel Art Gallery, 1950

The rather lozenge-shaped building on the left is probably based on All Saints Church, Pendlebury.

CARLISLE
Museum and Art Gallery

12. Street Scene Undated
Pencil on paper. 27.9 × 38.2 cm.
Signed b.r: L. S. Lowry
PROV: Carel Weight Purchase, 1958

A painting, *The Steps*, 1944, based on this view is reproduced in Levy, 1975, Pl. 121.

COVENTRY
Herbert Art Gallery

13. Ebbw Vale 1960 (Pl. 35)
Oil on canvas. 114 × 152 cm.
Signed b.r: L. S. Lowry 1960
EXH: Lefevre Gallery 1961 (1) repr.; Midland Area Service 1962/3 (17); Accrington 1971 (71); Leigh 1972 (57); Royal Academy 1976 (252)
PROV: purchased from Alex Reid & Lefevre Ltd., 1961

Lowry was introduced to the South Wales mining valleys by his friend and collector Monty Bloom. Their visits to Wales re-awakened Lowry's interest in the industrial scene, and the unusual combination of rugged landscape and densely-packed towns inspired a collection of works which though small in number were some of the most important of the artist's later paintings. See 61, 361.

In the *Guardian* of 13 October 1961, Eric Newton wrote: 'The largest painting in the show is a crowded panorama of the hillside that rises behind Ebbw Vale. It is the most densely packed and the most highly organised picture he has ever attempted, and for once he has sacrificed detail to breadth.

The inferno of cottages and streets that covers the landscape is seen with an all-embracing eye through an industrial haze and the mood becomes almost noble.'

DARLINGTON
Durham County Council Museum Education Service

14. Seascape 1960 (Fig. 21)
Pencil on paper. 25 × 35.5 cm.
Signed b.l: L. S. Lowry 1960
PROV: purchased from the artist, 1965

The desolate seascapes which captivated Lowry during his visits to the North East are, perhaps, most powerful as drawings. The cold, grey North Sea with an overcast sky needs no colouring to portray its mood. See 43, 358.

15. Industrial Scene 1962
Pencil on paper. 35.5 × 25 cm.
Signed b.l: L. S. Lowry 1962
PROV: purchased from the artist, 1965

Hardly an industrial scene at all, this drawing has more connections with *The Tollbooth, Glasgow* (438). This particular drawing shows considerable reworking, the building on the right being drawn over the outline of a church.

DERBY
Art Gallery

16. Houses near a Mill 1941
Oil on canvas. 50.8 × 40.7 cm.
Signed b.l: L. S. Lowry 1941
EXH: Derby 1946 (5); Midland Area Service 1962/3 (13)
PROV: purchased from Alex Reid & Lefevre Ltd., 1946, after the exhibition of Contemporary Art at Derby Art Gallery

DERBY
Derbyshire County Council, Museums Loans Service

17. Row of Children 1968
Pencil on paper. 20.3 × 22.4 cm.
Signed b.r: L. S. Lowry 1968
PROV: purchased from Mr V. P. Myerson, Ganymed Press, London, 1968

Probably drawn on the north-east coast. The children have been added after the sea view has been lined in.

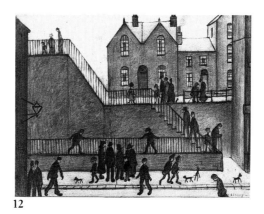
12

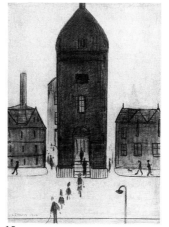
15

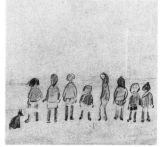
17

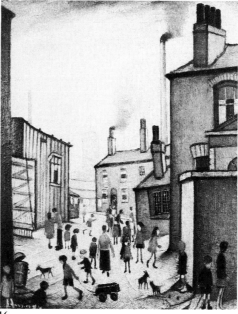
16

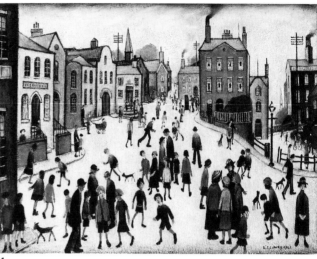

21

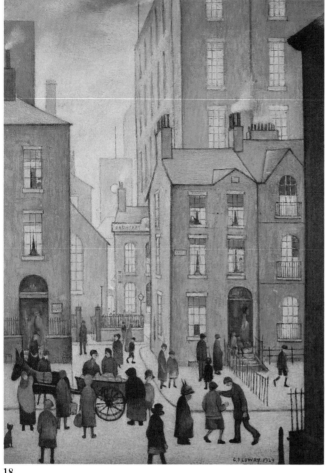

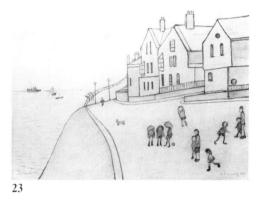

18

23

EDINBURGH
Royal Scottish Academy

18. Hawker's Cart 1929
Oil on board. 114.3 × 101.6 cm.
Signed b.r: L. S. Lowry 1929
EXH: Royal Scottish Academy
1934 (229)
PROV: purchased from the artist,
1934

EDINBURGH
Scottish National Gallery of
Modern Art

19. Canal and Factories 1955
(Fig. 42)
Oil on canvas. 60.9 × 76.2 cm.
Signed b.r: L. S. Lowry, 1955
EXH: Lefevre Gallery 1956 (4);
Crane Kalman Gallery 1974
(41) Pl. XXIII
PROV: Christie's auction, 11 May
1973, lot 108; Crane Kalman
Gallery, 1974

Based on the River Mersey at
Runcorn and Widnes.

GLASGOW
Art Gallery

20. River Scene 1942 (Pl. 21)
Oil on plywood. 45.5 × 63.4 cm.
Signed b.r: L. S. Lowry 1942
EXH: Lefevre Gallery 1943 (20);
Sheffield 1962 (35); Arts
Council 1966/7 (40) repr.;
Royal Academy 1976 (133)
LIT: Collis, 1951, Pl. 2; Rothen-
stein, 1962, p. 175, Pl. 50
PROV: purchased from Alex Reid
& Lefevre Ltd., 1943

21. A Village Square 1943
Oil on canvas. 45.7 × 61 cm.
Signed b.r: L. S. Lowry 1943
EXH: Royal Academy 1976 (136)
repr.; Scottish Arts Council
1977/8 (29)
PROV: purchased from T. & R.
Annan & Sons, Glasgow, by
Mrs George Singleton, 1943/4;
presented to Glasgow Art
Gallery by Mr George
Singleton in memory of his
wife, 1965

In a letter to the gallery, Lowry
wrote: 'I remember doing it quite
well. It was based on a much
earlier painting of mine of
Longnor, a village in Derbyshire
which I did about 40–45 years ago
at least.'

22. VE Day 1945 (Fig. 34)
Oil on canvas. 76.6 × 102 cm.
Signed b.l: L. S. Lowry 1945
EXH: Arts Council 1966/7 (48);
Camden Arts Centre 1970 (30);
Royal Academy 1976 (159)
repr. on cover
PROV: purchased from an exhi-
bition of the artist's work at T.
& R. Annan & Sons, Glasgow,
1946

A narrative painting portraying
the celebrations to mark the end of
the Second World War in Europe.
See 31 for another use of the
central court of houses.

HARTLEPOOL
Gray Art Gallery and Museum

23. The Front, Hartlepool 1969
Pencil on paper. 29.5 × 42 cm.
Signed b.r: L. S. Lowry 1969
Inscribed b.l: Hartlepool 1969
EXH: Colnaghi Gallery 1978 (38)
PROV: purchased from Colnaghi
Ltd., London, 1978

HUDDERSFIELD
Art Gallery

24. Level-crossing 1961
Oil on canvas. 54 × 75 cm.
Signed b.r: L. S. Lowry 1961
EXH: Halifax 1968; Accrington
1971 (75); Kirkcaldy 1971 (16);
Leigh 1972 (59); Accrington
1981
PROV: purchased from Alex Reid
& Lefevre Ltd., 1961

The artist undertook several
works based on a level-crossing in
Burton-on-Trent. See 288.

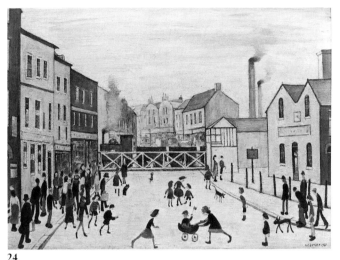

24

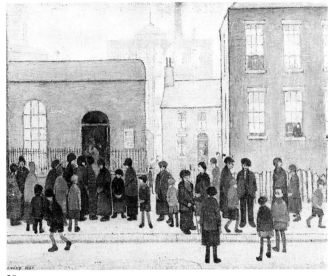

29

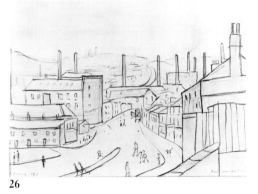

26

27

30

25. Huddersfield 1965 (Fig. 37)
Oil on canvas. 59.5 × 75 cm.
Signed b.r: L. S. Lowry 1965
EXH: Halifax 1968; Accrington
 1971 (83); Kirkcaldy 1971 (15);
 Leigh 1972 (70); Accrington
 1981
PROV: commissioned by
 Huddersfield Corporation,
 1965

One of the few official commissions accepted by the artist. See 26.

**26. View from Chapel Hill,
 Huddersfield** 1965
Pencil on paper. 25 × 34 cm.
(sight)
Signed b.l: L. S. Lowry 1965
Inscribed b.r: View from Chapel
Hill
PROV: purchased from Fitzgerald,
 London, 1982

This drawing relates to the painting of *Huddersfield* by Lowry which was commissioned by the Huddersfield Corporation in 1965 (25).

KENDAL
Abbot Hall Art Gallery

27. Canal Scene 1929
Pencil on paper. 28 × 37 cm.
(sight)
Signed b.r: L. S. Lowry 1929
EXH: 'Lancashire South of the
 Sands' 1987 (25)
PROV: probably purchased from
 the 1930 Roundhouse
 Exhibition at Manchester in
 support of the University
 Settlement; bequeathed to
 Abbot Hall, 1987

See 71, 72, 73, 254, 256.

KIRKCALDY
Art Gallery

28. An Old Street 1937 (Frontis.)
Oil on panel. 51.5 × 36.5 cm.
Signed b.l: L. S. Lowry 1937
PROV: Alex Reid & Lefevre Ltd.;
 J. W. Blyth, by whom bequeathed to Kirkcaldy Art
 Gallery, 1964

LEAMINGTON SPA
Warwick District Council Art
Gallery and Museum

29. The Mission Room 1937
Oil on board. 36.8 × 50.8 cm.
Signed b.l: L. S. Lowry 1937
EXH: British Council Exhibition
 1940s (precise date unknown);
 London, Guildhall Art Gallery
 1954; Midland Area Service
 1962/3 (6)
PROV: gift of the Contemporary
 Art Society, 1940

Compare *Waiting for the Shop to
Open* (79).

LEEDS
City Art Gallery

**30. A Lancashire Cotton
 Worker** 1944
Oil on wood panel. 53.2 × 41.9 cm.
Signed b.r: L. S. Lowry 1944
EXH: Liverpool 1973 (46); Royal
 Academy 1976 (154)

PROV: Alex Reid & Lefevre Ltd.;
 Mrs Edmund Arnold, 1961

One of a very few portraits set against an industrial scene. *An Old Lady* in the Maitland Collection is comparable.

**31. Industrial Landscape:
 The Canal** 1945 (Fig. 33)
Oil on canvas. 60.9 × 76.2 cm.
Signed b.r: L. S. Lowry 1945
EXH: Lefevre Gallery 1948;
 Salford 1951 (32); Wakefield
 1955 (15); Liverpool 1973 (47);
 Royal Academy 1976 (161)
PROV: purchased from Alex Reid
 & Lefevre Ltd., 1948

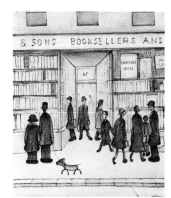

32

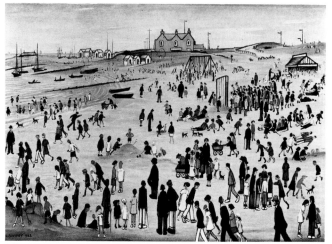

33

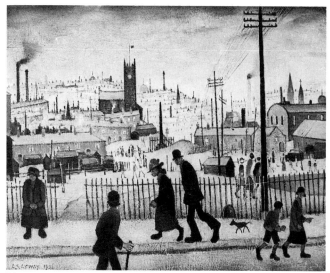

34

37

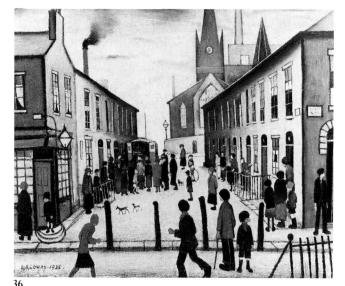

36

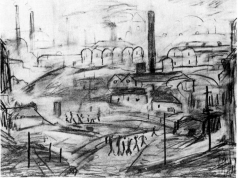

38

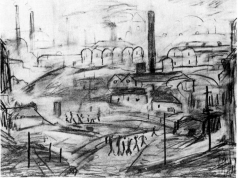

40

LEICESTER
Leicestershire Museums, Art Galleries and Records Service

32. The Booksellers c.1930
Pencil on paper. 34.3 × 28 cm.
Signed b.r: L. S. Lowry
PROV: purchased from Gillian Jason, 1981

Undated, this drawing may be later than suggested. It is one of the very few seasonal works by Lowry.

33. Industrial Landscape: River Scene 1950
Oil on canvas. 110.2 × 148.3 cm.
Signed b.l: L. S. Lowry 1950
EXH: Arts Council 1951/2 (31); Dudley 1953 (43); Wakefield 1955 (27); Arts Council 1955; Edinburgh 1956 (11); Sheffield 1962 (59); Midland Area Service 1962/3 (15); Nottingham 1974 (11) Pl. VI; Royal Academy 1976 (182) repr.; Sheffield 1978
LIT: Rohde, 1979, p. xxi
PROV: the artist; commissioned by the Arts Council of Great Britain for the Festival of Britain Exhibition, 1951 '60 Paintings for '51'; purchased by Leicester, 1952

Lowry was selected to paint a large work, not less than 45 × 60 in. (114 × 152 cm.) on a subject of his own choice. Canvas and stretchers were provided by the Arts Council. A highly detailed painting which was regarded by Lowry as one of his best works.

LINCOLN
Usher Gallery

34. View of a Town 1936
Oil on canvas. 40.6 × 50.8 cm.
Signed b.l: L. S. Lowry 1936
EXH: Arts Council 1949
PROV: purchased from the artist, 1942

One of many paintings in which the foreground is divided from the main part of the picture by a fence; possibly strengthening the detachment of the artist.

35. Britain at Play 1943 (Pl. 23)
Oil on canvas. 45.7 × 61 cm.
Signed b.l: L. S. Lowry 1943
EXH: Lefevre Gallery 1943 (31); Contemporary Art Society 1960; Royal Academy 1976 (138); Artists International Association 1984
PROV: presented by the Contemporary Art Society, 1943

The scene depicts Angel Fields, Manchester, and has elements based on Peel Park, Salford. See 207, 248. Sketches for the swings are in the Salford Collection (283). Parks were, for many years, centres for community activity drawing vast numbers of people at weekends and bank holidays.

LIVERPOOL
Walker Art Gallery

36. The Fever Van 1935
Oil on canvas. 43.1 × 53.3 cm.
Signed b.l: L. S. Lowry 1935
EXH: Salford 1941 (6); Bluecoat Chambers 1943 (13); National Gallery 1945 (111) repr.; Sheffield 1962 (18); Kendal 1964 (22); Liverpool 1973 (35) Pl. 8; Royal Academy 1976 (112)
LIT: Ingham, 1977, cover, Pl. 6
PROV: purchased from the artist, 1943

A once familiar sight on the streets of most large industrial towns. Lowry often recorded such incidents. See 69, 96, 272.

LONDON
Arts Council of Great Britain

37. Rhyl 1926
Chalk on paper. 24 × 38 cm.
Signed b.r: L. S. Lowry 1926
PROV: purchased from Alex Reid & Lefevre Ltd., 1962

The artist spent several holidays at Rhyl in the mid-1920s. See 221, 222.

38. July, the Seaside 1943
Oil on canvas. 66.6 × 92.7 cm.
Signed b.r: L. S. Lowry 1943
EXH: Arts Council Coll. 'A Selection from the Oil Paintings. Part I' 1955; Arts Council Coll. of Paintings and Drawings. Part 4 'Since the

War' 1958; London, Artists Market 1976; Royal Academy 1976 (143); Scottish Arts Council 1977/8 (32); Birmingham, Ikon Gallery 1985; Manchester, Cornerhouse 1985
PROV: purchased from the artist, 1943

There are elements of the earlier seaside studies and the scene is almost certainly from the North Wales coast. The title and the well wrapped-up people may well be a comment on holidays in Britain.

39. The Park 1946 (Pl. 25)
Oil on canvas. 38 × 80 cm.
Signed b.r: L. S. Lowry 1946
EXH: London Group 1951; Arts Council Coll. Part II 1952; Arts Council Coll. 'A Selection from the Oil Paintings. Part II' 1955; Arts Council Coll. of Paintings and Drawings. Part 4 'Since the War' 1958; Arts Council Coll. 'British Painting 40–49' 1966; Arts Council 1966/7 (52); Hayward Gallery 1980; Leigh 1986
PROV: purchased from the London Group exhibition, 1951

A reworking of the Peel Park theme, the crowd massing around the bandstand. See 207.

40. Steelworks 1960
Black chalk on paper. 25 × 35 cm.
Signed b.l: L. S. Lowry 1960
EXH: Arts Council 1966/7 (155); Leigh 1986
PROV: purchased from Alex Reid & Lefevre Ltd., 1960

Probably drawn in South Wales.

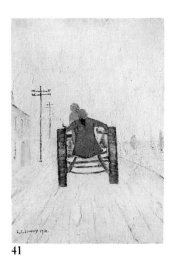

41

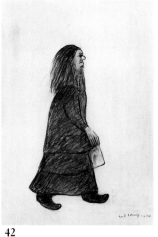

42

41. Woman Riding on a Tractor 1961
Oil on canvas. 35.5 × 25.3 cm.
Signed b.l: L. S. Lowry 1961
PROV: acquired from the estate of Sir William Williams, 1983

The artist was not happy depicting motor transport. Side views of vehicles, see 25, are often complete failures. But Lowry did enjoy portraying vehicles moving away from him.

42. Woman with Long Hair 1964
Pencil on paper. 34.2 × 24.5 cm.
Signed b.r: L. S. Lowry 1964
EXH: Arts Council 1975; Hayward Gallery 1980
PROV: purchased from Alex Reid & Lefevre Ltd., 1975

One of Lowry's later portraits of odd-looking individuals.

43. Seascape 1965
Oil on panel. 26.7 × 77.8 cm.
Signed b.r: L. S. Lowry 1965
EXH: Lefevre Gallery 1967 (7); Arts Council 1966/7 (108) repr. Pl. 33; Earl's Barton Exhibition 1970; London, Artists Market 1976; Hayward Gallery 1980; Newcastle 1986
PROV: purchased from Alex Reid & Lefevre Ltd., 1967

The chill North Sea, viewed by Lowry from his room at the Seaburn Hotel, Sunderland, inspired several such seascapes which have a parallel in the 'lonely' landscapes. See 14, 358, 87.

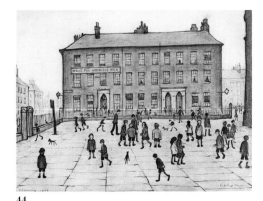

44

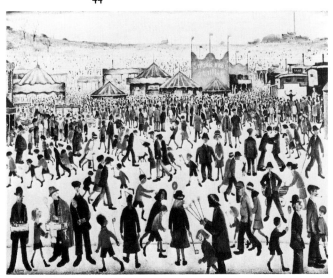

46

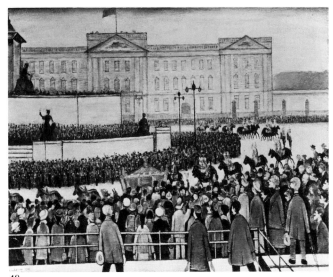

48

LONDON
The British Council

44. City Scene: St John's Parade 1929
Pencil on paper. 28 × 38 cm.
Signed b.l: L. S. Lowry 1929
EXH: British Council Canadian Tour 1948/9
PROV: purchased from Alex Reid & Lefevre Ltd., 1948

A subject which appealed to the artist's interest in architecture. St John's Parade was off Deansgate, Manchester.

45. Industrial City 1945–8 (Fig. 50)
Oil on canvas. 63.5 × 76.2 cm.
Signed b.r: L. S. Lowry 45[?]
EXH: British Council Exhibitions Overseas, National Art Gallery, Wellington, New Zealand 1984
PROV: purchased from Alex Reid & Lefevre Ltd., 1948

Probably based on Manchester and the River Irwell.

LONDON
Government Art Collection

46. Lancashire Fair: Good Friday, Daisy Nook 1946
Oil on canvas. 72.5 × 91.5 cm.
Signed b.l: L. S. Lowry 1946
PROV: purchased from Leicester Galleries, 1947

Slightly smaller version of subject exhibited at the Tate, 1966.

47. Grantley Hall, near Ripon 1952
Oil on canvas. 49.5 × 75 cm.
Signed b.r: L. S. Lowry 1952
PROV: purchased from Alex Reid & Lefevre Ltd., 1953

48. Coronation Procession Passing Queen Victoria Memorial 1953
Oil on canvas. 50 × 63 cm.
Signed b.l: L. S. Lowry 1953
PROV: purchased from the artist, 1954

Lowry was one of a number of artists commissioned to portray the Coronation of Queen Elizabeth II.

LONDON
Imperial War Museum

49. Going to Work 1943 (Fig. 15)
Oil on canvas. 45.8 × 61 cm.

Signed b.l: L. S. Lowry 1943
EXH: Royal Academy 1976 (141)
PROV: commissioned in 1942 by the War Artists' Advisory Committee of the Ministry of Information and allocated to the Imperial War Museum

Britain at work in 1943 (compare *Britain at Play* (35)). Only the barrage balloons and the buses make this anything other than a typical Lowry scene. The buildings depicted are the Mather & Platt Park Works, Newton Heath, Manchester.

LONDON
National Maritime Museum

50. Greenwich Reach towards Deptford Power Station 1959 (Fig. 38)
Oil on canvas. 51 × 76 cm.
Signed b.l: L. S. Lowry 1959
EXH: Liverpool 1973 (66)
PROV: Alex Reid & Lefevre Ltd.; Mr G. R. Kennerley; purchased from the Crane Kalman Gallery, London, 1976

Lowry made regular visits to London for over thirty years but he found little inspiration in the capital city. He was, however, continually intrigued by rivers, and the ships and barges in this picture provide as much interest as the impressive 'battleship' of the power station.

LONDON
Royal Academy of Arts

51. Woman with a Shopping Bag 1956
Oil on board. 40 × 12.1 cm.
Signed b.r: L. S. Lowry 1956
EXH: Royal Academy 1976 (249); Bladon Gallery 1979
PROV: bequest of Miss Helen Kapp, 1978

Once the mills had begun to close, Lowry diverted his attention from the town and the crowds to individual figures.

52. Station Approach 1962
Oil on board. 41.9 × 50.8 cm.
Signed b.r: L. S. Lowry 1962
EXH: Royal Academy, Winter Exhibition 1963 (10); Bournemouth 1965 (43); Nottingham 1973 (35); Royal Society of British Artists 1974; Royal

Academy 1976 (276); Leicester 1982 (57) repro.

PROV: presented by the artist to the Royal Academy as his Diploma Work on his election as a full member, 1962

Based on Central Station, Manchester. By 1962, the artist's power of concentration was waning and the myriad figures became blurred (compare *VE Day* (22)).

When he was elected to the Royal Academy, Lowry said: 'I've done it and I'm pleased. I know I shouldn't say so, but I am. Signing on after people like Reynolds and Gainsborough, Constable and Turner.' He was in his 74th year and, as the upper age limit for election is 75 years, his acceptance came just in time.

LONDON
The Science Museum

53. A Manufacturing Town 1922

Oil on panel. 43.2 × 53.3 cm.
Signed b.l: L. S. Lowry 1922
EXH: Royal Academy 1976 (43) repr. p. 8; Crane Kalman Gallery 1982 (3) repr.
LIT: Levy, 1975, Pl. 26; Levy, 1976, Pl. 26; McLean, 1978, p. 3; Woods, 1981, p. 13; Great Artists, 1986, p. 2280
PROV: Alex Reid & Lefevre Ltd.; Crane Kalman Gallery; purchased by the Science Museum, 1982

One of the early industrial scenes painted before Bernard D. Taylor encouraged Lowry to lighten the sky. See 99.

LONDON
The Tate Gallery

54. Coming out of School 1927 (Fig. 45)

Oil on plywood. 34.5 × 54 cm.
Signed b.r: L. S. Lowry 1927
EXH: RBA Galleries 1927 (359); Arts Council 1966/7 (17); Royal Academy 1976 (76) repr.
LIT: Spalding, 1979, Pl. 11
PROV: purchased by the Duveen Paintings Fund at the '*Daily Express* Young Artists Exhibition', 1927; presented by the Duveen Paintings Fund, 1949

Letter from the artist, 21 January 1956: 'This is not a depiction of a particular place but is based on recollections of a school seen in Lancashire.'

The Duveen Scheme was inaugurated by Lord Duveen to purchase works by contemporary British artists for presentation to museums and to furnish touring exhibitions.

The painting was reproduced on a stamp by the Post Office in 1967. 'Was very nice of them', commented the artist, but James Fitton RA thought it: 'crazy—I am a great admirer of Lowry but with the international kind of publicity these stamps . . . bring do we really, in this age of automation . . . want to advertise the slums and smoking chimneys of Salford.'

51

55. Dwellings, Ordsall Lane, Salford 1927 (Fig. 36)

Oil on plywood. 43 × 53.5 cm.
Signed b.l: L. S. Lowry 1927
EXH: Lefevre Gallery 1939 (19); Royal Academy 1939 (39); Sheffield 1962 (10); Arts Council 1966/7 (15); Royal Academy 1976 (74) repr.
LIT: Levy, 1975, Pl. 100; Spalding, 1979, Pl. 15
PROV: purchased from the artist through Alex Reid & Lefevre Ltd., 1939

Exhibited at the Lefevre Gallery as *Dwellings*, the location was added later. Despite incontrovertible evidence provided by maps and history, the site has consistently and wrongly been given as Ordsall Lane. In fact, the tenements stood close to the top of Oldfield Road near to Salford Royal Hospital and Chapel Street. Sadly, the Tate and others refuse to accept the error of geography. See 56 and 252.

56. Study for Dwellings, Ordsall Lane, Salford 1927

Pencil on paper. 28.3 × 39.4 cm.
Signed b.r: LSL 1927
EXH: Sheffield 1962 (134); Arts Council 1966/7 (137); Royal Academy 1976 (79)
LIT: Levy, 1963, Pl. 33
PROV: presented by the artist, 1951

Lowry made at least two drawings of this view (see 252). The oil painting is also in the Tate Gallery (see 55).

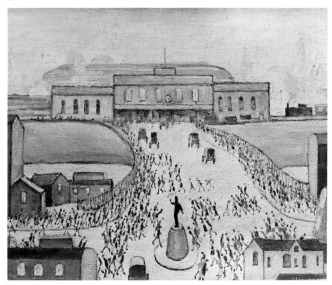

52

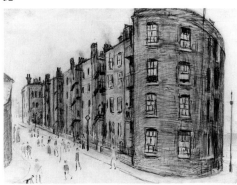

56

57

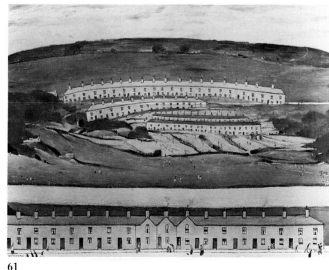

61

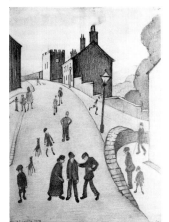

63

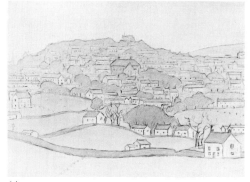

64

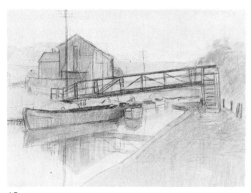

65

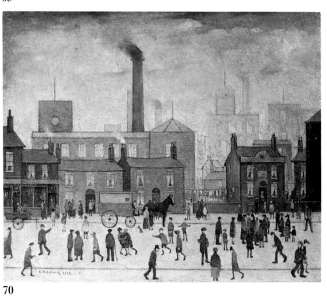

70

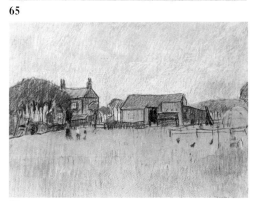

66

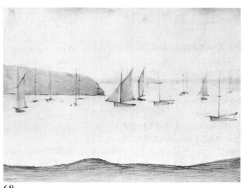

68

57. The Old House, Grove Street, Salford 1948
Oil on canvas. 45.7 × 61 cm.
Signed b.l: L. S. Lowry 1948
EXH: Lefevre Gallery 1951 (37) as *The Old House*
LIT: Levy, 1975, Pl. 99
PROV: purchased from the artist through Alex Reid & Lefevre Ltd., 1951

The gallery has a letter from the artist describing how this was 'based on a careful pencil drawing made in 1927, the picture is as like the drawing as I could make it in 1948.' The house has since been demolished but the street, in Lower Broughton, remains.

58. The Pond 1950 (Pl. 27)
Oil on canvas. 114.5 × 152.5 cm.
Signed b.r: L. S. Lowry 1950
EXH: Lefevre Gallery 1951 (1); Royal Academy 1951 (564); Arts Council 1966/7 (66) Pl. 19; Royal Academy 1976 (184); Royal Academy 1981 (18)
LIT: Collis, 1951, Pl. 23; Levy, 1960, facing p. 65; Levy, 1961, Pl. 14; Levy, 1975, Pl. 126; Ingham, 1977, Pl. 2; McLean, 1978, p. 11; Spalding, 1979, Pl. 34; Great Artists, 1986, pp. 2284–5, 2290–1
PROV: Chantrey Purchase from the artist through Alex Reid & Lefevre Ltd., 1951

Lowry wrote to the gallery in 1956: 'This is a composite picture built up from a blank canvas. I hadn't the slightest idea of what I was going to put in the picture but it eventually came out as you see it.'
Stockport Viaduct, a familiar image in Lowry's industrial pictures, appears on the right. 'It fascinates me; dominates my imagination. . . . into [the] composite pieces . . . Stockport Viaduct so often creeps, like some recurring subject in a dream' (to Mervyn Levy, *Studio*, March 1963).
The artist could be easily influenced by people who viewed a painting during its execution. Here, the pair of trousers, hanging to dry from a window of a house near the lower centre, and the washing lines were suggested by Charles Roscoe who called on Lowry to read his gas meters! The painting was considered by Lowry to be his very finest industrial landscape.

59. Industrial Landscape 1955 (Fig. 16)
Oil on canvas. 114.5 × 152 cm.
Signed b.r: L. S. Lowry 1955
EXH: Royal Academy 1956 (83) repr.
LIT: Levy, 1975, Pl. 124; Great Artists, 1986, pp. 2282–3
PROV: Chantrey Purchase from the artist, 1956

Letter of 19 October 1956: 'The picture is of no particular place. When I started in on the plain canvas I hadn't the slightest idea as to what sort of Industrial scene would result. But by making a start by putting say a church or chimney near the middle this picture seemed to come bit by bit.'

60. A Young Man 1955 (Pl. 32)
Oil on canvas. 51 × 60.5 cm.
Signed b.r: L. S. Lowry 1955
EXH: Royal Academy 1957 (485)
PROV: purchased from the artist, 1957

Letter from the artist, 4 July 1957: 'The head was done from my recollection of a young man I saw once in a Manchester park—a good while ago. He interested me very much at the time and stayed in my mind in a vague sort of way ever since. He gave me the impression that something had very badly gone wrong in his life tho' he gave no inkling of what it was in a fairly long conversation. He was totally disinterested in anything at all and yet was, to me, most interesting—he was a peculiar young gentleman and I would have liked to come across him again. I am sure I am right about him.'

61. Hillside in Wales 1962
Oil on canvas. 76 × 101.5 cm.
Signed b.l: L. S. Lowry 1962
EXH: Royal Academy 1963 (87)
LIT: Levy, 1975, Pl. 111
PROV: Chantrey Purchase from the artist, 1963

Letter from the artist, 15 June 1963: 'Painted from notes and sketches made on the spot near Abertillery.' See 13, 361.

LONDON
Victoria and Albert Museum

62. Burford Church 1929 [?]
Pencil on paper. 39 × 28 cm.
Signed b.r: L. S. Lowry 1929
PROV: purchased from Alex Reid & Lefevre Ltd., 1958

63. Over the Hill 1930
Pencil on paper. 38.4 × 28 cm.
Signed b.r: L. S. Lowry 1930
PROV: purchased from Alex Reid & Lefevre Ltd., 1958

MANCHESTER
City Art Gallery

64. View of Denbigh 1913
Pencil and chalk on grey paper. 25.2 × 35.9 cm.
Signed b.r: LSL 24/9/13
Inscribed b.l: Denbigh
Inscribed on reverse: Denbigh/1913
EXH: Manchester 1959 (73); Altrincham 1960 (5); Manchester 1977 (11); Kendal 1979 (22)
PROV: purchased from Alex Reid & Lefevre Ltd., 1959

65. Footbridge at Clifton Junction 1920
Pencil and pastel over chalk on grey/green paper. 28 × 38.3 cm.
Signed b.r: L. S. Lowry 1920
EXH: Manchester 1977 (12); Kendal 1979 (23)
PROV: presented by the artist, 1959

The drawing was the inspiration for *Barges on a Canal* (1).

66. Farm near Pendlebury 1920
Pastel on grey paper. 28.2 × 38.1 cm.
Signed b.r: L. S. Lowry 1920
Inscribed on reverse: Farm near Pendlebury
EXH: Manchester 1977 (13); Kendal 1979 (25)
PROV: presented by the artist, 1959

Lowry often used pastel in producing landscapes before 1920.

67. The Result of the Race 1922 (Fig. 27)
Pencil on paper. 36.8 × 27.1 cm.
Signed and inscribed b.l: LSL 1922/The Result of the Race
Inscribed on reverse: Racing Special/1922
EXH: Manchester 1959 (78); Altrincham 1960 (12); Sheffield 1962 (115); Manchester 1977 (14) repr.; Stalybridge 1983 (4)
PROV: purchased from Alex Reid & Lefevre Ltd., 1959

See *The Mid-day Special*, 1926, in the Salford Art Gallery Collection (236).

68. Sea with Boats 19–5 (probably 1925)
Pencil on paper. 25.6 × 35.7 cm.
Signed b.l: L. S. Lowry 19–5
EXH: Manchester 1959 (81); Accrington 1971 (26); Manchester 1977 (15) repr.; Kendal 1979 (29); Stalybridge 1983 (5)
PROV: purchased from Alex Reid & Lefevre Ltd., 1959

Almost certainly drawn in North Wales.

69. An Accident 1926 (Pl. 10)
Oil on panel. 36.3 × 61 cm.
Signed b.l: L. S. Lowry 1926
EXH: Manchester 1930 (252); Arts Council 1947 (18); Whitechapel Art Gallery 1950 (17); Arts Council 1951 (39); Edinburgh 1956 (9); Manchester 1959 (16); Arts Council 1966/7 (14) Pl. 8; Leigh 1972 (27); Liverpool 1973 (21); Royal Academy 1976 (68); Manchester 1977 (1) repr.
LIT: Levy, 1961, Pl. 4; Levy, 1975, Pl. 129; Andrews, 1977, pp. 54, 59, 62, 68, 73; Spalding, 1979, Pl. 13; Rohde, 1979, pp. 122–3, Pl. X
PROV: purchased from the 'Six Manchester Art Clubs' exhibition, 1930

Letter from the artist, 20 September 1930: 'About the paint—It was done on wood on a white ground—laid in solidly at one shot—then the roughness scraped off and the whole gradually worked up in detail to the end. No oil used, or varnish—I do not use either. Have not varnished a picture for a long time. I somehow prefer not to. . . . As to the subject. It was a case of a woman found drowned (suicide) some years ago in Pendlebury—a large crowd seemed to come absolutely from nowhere in no time. The incident rather got hold of me.'
Manchester's first purchase of a Lowry.

70. Coming Home from the Mill 1928
Oil on canvas. 43 × 53.3 cm.
Signed b.l: L. S. Lowry 1928
EXH: New English Art Club 1931 (74); Manchester Academy of Fine Arts 1932 (158); Whitechapel Art Gallery 1950 (18); Salford 1951 (34); Arts Council 1951 (3); Manchester

71

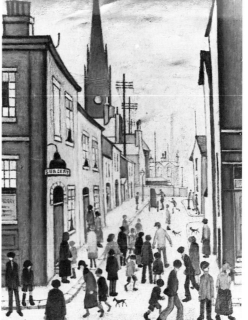

74

77

72

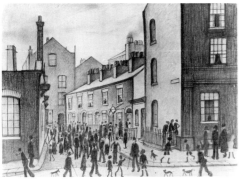

73

75

1960 (205); Sheffield 1962 (12); Kendal 1964 (24); Manchester 1976 (151); Manchester 1977 (2) repr.

LIT: Andrews, 1977, Pl. XVI (back of painting)

PROV: bequeathed by George Spiegelberg, Esq., 1961

On the reverse of this picture is an oil sketch, obscured by labels and dirt, of two men in an interior sitting at desks while a queue passes before them. See 140, 426.

71. Junction Street, Stony Brow, Ancoats 1929

Pencil on paper. 27 × 37.5 cm. (sight)

Signed b.r: L. S. Lowry 1929

EXH: Manchester 1959 (92); Agnew's 1977 (58) Pl. 12; Manchester 1977 (16) repr.

LIT: Andrews, 1977, p. 67

PROV: presented by Miss Margaret Pilkington to the Rutherston Collection, 1930

Junction Street, off Store Street, was renamed Jutland Street in 1939. Stony Brow appears to be a local name for it, possibly the original one.

This was the first acquisition of Lowry's work made by Manchester. The drawing was exhibited by Lowry at the Roundhouse, Manchester, in 1930. The City Art Gallery, pos-

sibly confident that the work would not sell, arrived too late to secure their choice of picture but persuaded Miss Pilkington, a good friend of the Gallery, to present it to the collection.

'A strange *tour de force* is *Stony Brow*, a steep empty cobbled road' unsigned review in the *Manchester Guardian*, 1930. See 27, 72, 73, 254, 256.

72. Ancoats 1929

Pencil on paper. 27.8 × 38.3 cm.

Signed b.r: Lowry 1929

EXH: Manchester 1959 (94); Altrincham 1960 (1); Sheffield 1962 (136); Accrington 1971 (38); Agnew's 1977 (57); Manchester 1977 (18); Kendal 1979 (34)

PROV: A. P. Simon, Manchester; Miss Isabel Simon, Cambridge, from whom Manchester purchased, 1955

The street is Fairburn's Buildings, off Store Street, a cul-de-sac but with a passage leading to Great Ancoats Street. It was probably known as Fairburn's Buildings Passage. The lodging house and tenement block on the right have been demolished.

The drawing was probably executed for the Roundhouse Exhibition in 1930. See 27, 71, 73, 254, 256.

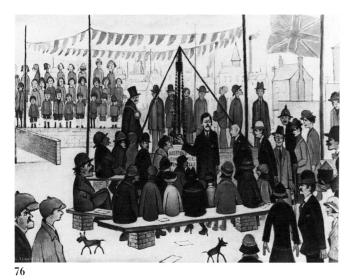

76

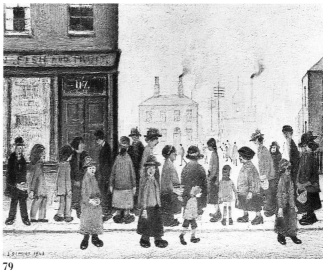

79

73. The Viaduct, Store Street, Manchester 1929
Pencil on paper. 27.2 × 37.6 cm. (sight)
Signed b.l: L. S. Lowry 1929
EXH: Lefevre Gallery 1947; Manchester 1959 (93); Sheffield 1962 (138); Manchester 1977 (17) repr.; Kendal 1979 (32); Stalybridge 1983 (6)
PROV: A. P. Simon, Manchester; Miss Isabel Simon, Cambridge, from whom Manchester purchased, 1955

A view in Ancoats, close to Piccadilly Station. The viaduct still stands, as does one of the telegraph poles, but the chimney and factory have gone. The drawing was probably exhibited at the Roundhouse Exhibition in 1930. See 27, 71, 72, 254, 256.

74. An Organ Grinder 1934
Oil on canvas. 53.5 × 39.5 cm.
Signed b.l: L. S. Lowry 1934
EXH: Manchester Academy of Fine Arts 1936 (218); Manchester 1959 (25); Altrincham 1960 (27); Kendal 1964 (23); Kendal 1979 (5); Manchester 1977 (3)
LIT: Levy, 1975, Pl. 17; Levy, 1978, Pl. 17
PROV: purchased from the Manchester Academy of Fine Arts, 1936

Lowry often composed his street pictures around a person selling his wares (236), an incident (69) or in this case a street performer. The organ grinder toured the streets with his barrel organ, entertaining

the residents and making a small living.

75. Farm in Clifton, Lancashire 1934
Pencil on paper. 27.5 × 38.1 cm.
Signed b.r: L. S. Lowry 1934
Inscribed on reverse: Farm in Clifton/Lancs.
EXH: Manchester 1959 (100); Sheffield 1962 (148); Pendlebury 1964 (7); Manchester 1977 (19)
PROV: purchased from Alex Reid & Lefevre Ltd., 1959

In the Pendlebury exhibition catalogue, the farm was identified as Hilton's or Manor Farm, lying near the junction of Moss and Riders Lane, just over the Kearsley border from Clifton.

76. Laying a Foundation Stone 1936
Oil on canvas. 45.7 × 61 cm.
Signed b.l: L. S. Lowry 1936
EXH: Lefevre Gallery 1939 (15); Manchester Academy of Fine Arts 1940 (170); Belfast 1971 (10); Manchester 1977 (4); Kendal 1979 (6)
LIT: Levy, 1975, Pl. 61; Rohde, 1979, p. 213
PROV: presented by the Royal Manchester Institution to the Rutherston Collection, 1940

The incident shows the Mayor of Swinton and Pendlebury, Alderman William S. Mycock, laying a foundation stone in Clifton near Pendlebury. Only the mayor appeared to like the picture, one guest accusing Lowry of not being a gentleman 'for portraying us so' (Rohde, p. 213).

77. Outside a Lodging House 1938
Pencil on paper. 38 × 28.4 cm.
Signed b.r: L. S. Lowry 1938
EXH: Lefevre Gallery 1939 (21); Manchester 1959 (105); Altrincham 1960 (11); Agnew's 1977 (59); Manchester 1977 (20) repr.; Stalybridge 1983 (7)
PROV: purchased from Alex Reid & Lefevre Ltd., 1959

See *A Fight*, *c*.1935, Salford Art Gallery (272).

78. An Island 1942 (Fig. 43)
Oil on canvas. 45.6 × 60.9 cm.
Signed b.l: L. S. Lowry 1942
EXH: probably Lefevre Gallery 1943 (6); Mid-day Studios 1948 (4); Salford 1951 (27); Arts Council 1951/2 (10); Wakefield 1955 (11); Manchester 1959 (37); Arts Council 1966/7 (39) Pl. 13; Arts Council 1972/3 (14); Manchester 1977 (5)
LIT: Collis, 1951, Pl. 10; Levy, 1961, Pl. 10; Levy, 1975, Pl. 130; Andrews, 1977, pp. 82–3; Ingham, 1977, Pl. 3; Spalding, 1979, Pl. 29; Rohde, 1979, pp. xviii, xxii, Pl. XII
PROV: purchased from the Midday Studios, Manchester, 1948

Letter from the artist, 24 November 1948: '*An Island* is an old house long uninhabited, falling further and further into decay. . . . I seem to have a strong leaning towards decayed houses in deteriorated areas. . . . [it is] heavily painted at first, on a heavy white ground and afterwards overpainted—no oil or any medium employed.'

Probably viewed in the Oldham Road area. Lowry commented: 'I have learned much from that house.' See 2, 432.

79. Waiting for the Shop to Open 1943
Oil on canvas. 43.3 × 53.3 cm.
Signed b.l: L. S. Lowry 1943
EXH: Mid-day Studios 1948 (17); Wakefield 1955 (13); Manchester 1959 (40); Sheffield 1962 (37); Arts Council 1966/7 (42); Norwich 1970 (11); Belfast 1971 (12); Leigh 1972 (45); Arts Council 1972/3 (15); Manchester 1977 (6); Kendal 1979 (7)
LIT: Levy, 1961, Pl. 11; Levy, 1975, frontispiece; Andrews, 1977, p. 82; Levy, 1978, Pl. 42
PROV: purchased from the Midday Studios Manchester, 1948

Compare with *Waiting for the Shop to Open* (86), Whitworth Art Gallery, Manchester, which was drawn a year or two earlier and also features a fish and fruit shop.

Letter from the artist, 24 November 1948: '*Waiting for the Shop to Open* is simply a queue outside a shop, waiting for the proprietor to open the door. We saw a lot of these queues during the War Time, and even now quite a fair amount of it is still going on.'

Note the 117 on the door of the shop; this is a reference to his own address, which was 117 Station Road, Pendlebury.

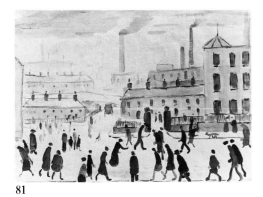

81

83

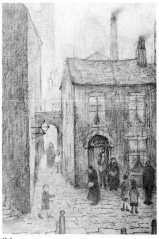

84

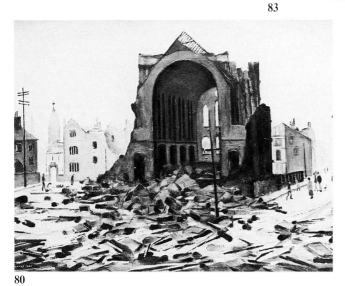

80

82

80. St Augustine's Church, Manchester 1945
Oil on canvas. 46 × 61.3 cm.
Signed b.l: L. S. Lowry 1945
EXH: NWMAGS 1970 (14); Royal Academy 1976 (160) repr.; Manchester 1977 (7) repr.; Scottish Arts Council 1977/8 (35)
LIT: McLean, 1978, p. 8, repr.
PROV: presented by H. M. Government, 1947

Study for this painting is in Salford Art Gallery (286). St Augustine's was built in York Street, Chorlton-upon-Medlock in 1908 to replace the church in Granby Row. It was blitzed in 1940 and the area cleared in 1966. See *Going to Work* (49).

81. Industrial Landscape 1955
Watercolour and gouache on paper. 28 × 39.1 cm.
Unsigned
Inscribed on reverse: Landscape 1955
EXH: Manchester 1959 (112); Altrincham 1960 (9); Manchester 1977 (21)
LIT: Levy, 1975, p. 11, Pl. 118
PROV: Alex Reid & Lefevre Ltd., 1959

'Watercolours I've only used occasionally, they don't really suit me; dry too quickly. They're not flexible enough. I like a medium you can work into over a period of time.' Lowry to Levy, 1975.

82. Piccadilly Gardens (Manchester) 1954
Oil on canvas. 76.2 × 101.6 cm.
Signed b.r: L. S. Lowry 1954

EXH: Whitechapel Art Gallery 1954 (38); Wakefield 1955 (40); Manchester Academy of Fine Arts 1955 (129); Manchester 1959 (60); Accrington 1971 (66) Pl. 7; Manchester 1977 (8) repr.
LIT: Levy, 1975, Pl. 110; Great Artists, 1986, pp. 2294–5
PROV: commissioned by Henry's Stores Ltd., Market Street, Manchester in 1954 and presented in January 1956, on the occasion of the 80th birthday of Mrs Henry Cohen, co-founder of the company

Lowry first sketched in Piccadilly in 1930 at the request of the Director of Manchester City Art Gallery who asked: 'I wonder if you will . . . make one or two studies of Piccadilly as it is today with the sunken garden, the loafers, the rains and all the rest of the mess and muddle.' Although Lowry did exactly what the Director asked it was not acceptable. The same drawings were probably used to make this painting.

83. Group of People with Two Dogs 1959
Pencil on paper. 38.5 × 50.3 cm.
Signed b.r: L. S. Lowry 1959
Inscribed on reverse: Group of People/Design for catalogue cover L. S. Lowry Retrospective Exhibition 1959/L. S. Lowry
EXH: Altrincham 1960 (7); Manchester 1977 (22)
PROV: presented by the artist, 1959

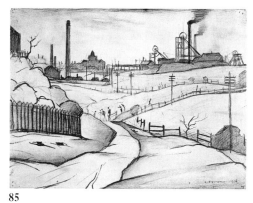

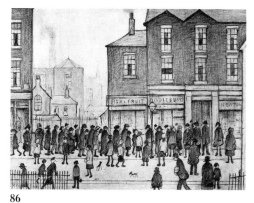

85 86

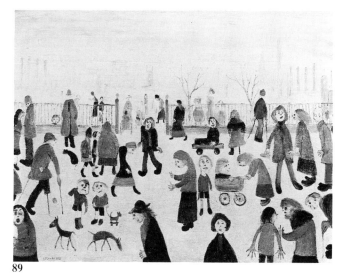

87 89

MANCHESTER
Whitworth Art Gallery

84. Lancashire Street Scene
1925
Pencil on paper. 35.7 × 25.5 cm.
Signed b.l: L. S. Lowry 1925
EXH: Accrington 1971 (27);
Nottingham 1974 (27); Royal
Academy 1976 (63); Mottram
1977 (18)
PROV: presented by the Friends of
the Whitworth Art Gallery,
1954

Based on a little alley in
Pendlebury.

85. View in Pendlebury 1936
28.2 × 38.1 cm.
RECTO: Pencil on paper
Signed b.r: L. S. Lowry 1936
EXH: Lancaster 1951; Manchester
Regional College of Art 1955;
Stalybridge 1956; Ashton-
under-Lyne 1957; NW
Federation Exhibition 1963
(11); Accrington 1971 (44);
Nottingham 1974 (33);
Mottram 1977; Kendal 1979

(39); Stalybridge 1983 (34)

Showing Newtown Colliery, now
closed, from Rake Lane looking
towards Manchester Road.
VERSO: *Three-quarter-length Study
of a Girl*
Pencil
Signed t.r: L. S. Lowry
PROV: presented by K. Russell
Brady, 1949

86. Waiting for the Shop to
Open 1941
Pencil on paper. 28 × 38 cm.
Signed b.l: L. S. Lowry 1941 (the
last digit has been altered from a 2)
Inscribed on reverse: Waiting for
the Shop to Open/1942
EXH: Accrington 1952;
Stalybridge 1954; Manchester
Regional College of Art 1955;
Altrincham 1957; Nottingham
1974 (34); Royal Academy 1976
(131); Kendal 1979 (41);
Stalybridge 1983 (35)
PROV: presented by Miss
Margaret Pilkington, 1949

Compare *Waiting for the Shop to*

Open in the Manchester
Collection (79).

87. Lake Landscape 1950
Oil on canvas. 71 × 91.5 cm.
Signed b.r: L. S. Lowry 1950
EXH: Lefevre Gallery 1951 (3);
Salford 1951 (59); Wakefield
1955 (25); Manchester 1959
(49); Sheffield 1962 (58); Arts
Council 1966/7 (65) Pl. 18;
Nottingham 1974 (10) Pl. V;
Royal Academy 1976 (187);
Kendal 1979 (11); Arts Council
1983 (146)
LIT: Collis, 1951, Pl. 22; Levy,
1961, Pl. 15; Spalding, 1979, p.
13, Pl. 35; Clements, 1985, p. 20
PROV: presented to the University
of Manchester by the family of
Mary Logan Cowan, BA, MB
(Toronto), 1893–1972, in her
memory. Mary Logan Cowan
was the wife of H. B. Maitland,
MD, Professor of Bacteriology
at Manchester, 1927–1962.

Originally called *Lakeland*.
Hugh Maitland was one of the
artist's earliest patrons and be-
came a close friend. See 295, 296.

88. Ancoats Hospital Out-
patients' Hall 1952 (Pl. 28)
Oil on canvas. 59.3 × 90 cm.
(sight)
Signed b.l: L. S. Lowry 1952
EXH: Sheffield 1962 (61) Pl. III;
Accrington 1971 (62) Pl. 10;
Royal Academy 1976 (194)
repr.; Midland Group,
Nottingham 1977/8; Mayor
Gallery 1983; Arts Council
1984
LIT: Levy, 1975, Pl. 60
PROV: commissioned by the
Hospital Medical Committee
from the artist in memory of
P. G. McEvedy, FRICS; pre-
sented to the gallery, 1975

89. In a Park 1963
Oil on canvas. 76.5 × 101.9 cm.
Signed b.l: L. S. Lowry 1963
Inscribed in ballpoint pen on can-
vas folded over stretcher at top:
Park Scene
EXH: Lefevre Gallery 1964 (4)
repr. p. 8; Royal Academy 1976
(285) repr.; Kendal 1979 (16);
Arts Council Tour 1983/4

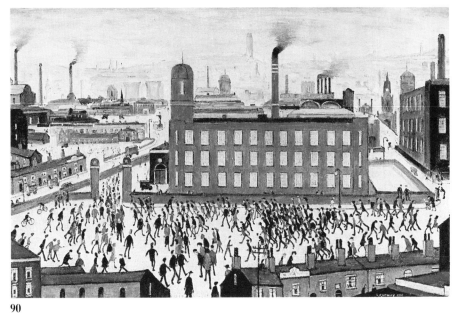

90

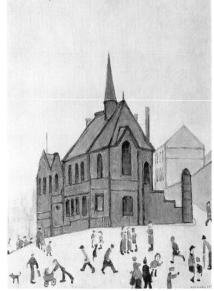

93

94

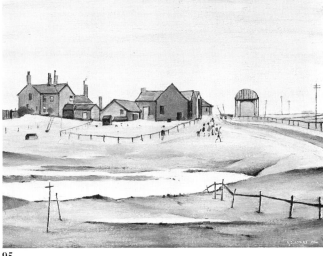

95

LIT: Spalding, 1979, Pl. 42
PROV: purchased from Alex Reid & Lefevre Ltd. by Mr & Mrs Jonathan Dudley, 1964; presented to gallery, 1974

Lowry was not an artist to waste a good idea and, particularly in his final years, he would often repeat a painting making subtle alterations. This is a reworking of *The Cripples* theme (see 291).

90. Industrial Scene 1965
Oil on canvas. 56 × 86.3 cm.
Signed b.r: L. S. Lowry 1965
Signed and inscribed on back of stretcher: L. S. Lowry, 23 Stalybridge Road, Mottram in Longdendale Cheshire [and] Not for Sale [twice]

EXH: Nottingham 1974 (16) Pl. VII; Royal Academy 1976 (301); Manchester, Cornerhouse 1985
PROV: presented by the artist, 1973

MIDDLESBROUGH
Art Gallery

91. The Old Town Hall and St Hilda's Church, Middlesbrough 1959 (Fig. 13)
Oil on canvas. 41 × 31 cm.
Signed b.r: L. S. Lowry 1959
EXH: Mayor Gallery 1981
PROV: commissioned from the artist by the Friends of the Middlesbrough Art Gallery and presented by them, 1960.

Lowry was invited to Middlesbrough to make some sketches for this work. He stayed with the art critic, Bill Johnson, who was greatly surprised when Lowry took only twenty minutes to complete his studies.

The Friends suffered long delays before they finally collected the painting 'still wet on the canvas'. It emerged that Lowry had painted and sold two other versions of the same scene whilst telling the Friends that the painting had not been finished. As the Friends had paid only £60 for their painting, they could scarcely complain. The church has since been demolished but the Town Hall survives.

NEWCASTLE-UPON-TYNE
Laing Art Gallery

92. River Scene or **Industrial Landscape** 1935 (Pl. 16)
Oil on plywood. 37.5 × 51.4 cm.
Signed b.r: L. S. Lowry 1935
EXH: possibly Lefevre Gallery 1939 (8); Newcastle 1946 (82); Newcastle, 1957 (190); Jarrow 1971 (37); Royal Academy 1976 (110); Scottish Arts Council 1977/8 (19) repr.; Arts Council 1982/3 (13) pp. 58–9, repr.
PROV: purchased from Alex Reid & Lefevre Ltd., 1946

A pencil drawing of the same subject, dated 1964, is in a private collection. The North East became a refuge for Lowry in his

later life. Little known in the area, he could relax away from the pressures of Mottram. Adopted by Micky and Tilly Marshall, who ran the Stone Gallery in Newcastle, Lowry was revitalized.

93. Old Chapel, Newcastle-upon-Tyne 1965
Oil on canvas. 60.8 × 45.7 cm.
Signed b.r: L. S. Lowry 1965
PROV: purchased from the Stone Gallery, Newcastle-upon-Tyne, 1966

Label on back of canvas reads: 'Stone Gallery/Old Chapel, Newcastle-upon-Tyne/Oil/L. S. Lowry'. This chapel is on the corner of Tyne Street and Horatio Street off City Road, Newcastle-upon-Tyne.

NEWPORT, Gwent
Museum and Art Gallery

94. Francis Street, Salford 1957
Oil on canvas. 40 × 50.5 cm.
Signed b.l: L. S. Lowry 1957
EXH: Salford 1957 (109) as *Francis Terrace, Salford*; Royal Academy 1976 (235)
PROV: purchased from the 'Lancashire Scene' Exhibition, Salford Art Gallery, 1957

See *Francis Terrace, Salford* (307). In 1956/7, Lowry undertook many works in Salford at the request of the city's Art Gallery. One of the subjects he chose was Francis Terrace.

NORWICH
Castle Museum

95. Landscape with Farm Buildings 1954
Oil on canvas board. 40.4 × 50.2 cm.
Signed b.r: L. S. Lowry 1954
EXH: Royal Academy 1976 (208)
PROV: presented by David Carr and friends, 1955

A label on the reverse reads: '*A Lancashire Farm* L. S. Lowry. L. S. Lowry was chosen by the following people to represent good painting, and the picture was selected by the artist. Edward Barker, Ruth Barker, Jeffery Camp, David Carr, Ronald Courteney, Leslie Davenport, Joe Fairhurst, Willis Feast, Hubert Forward, Barbara Gilligan,

William Hartwell, Cavendish Morton, Hamilton Wood, 22 October 1955.'

David Carr, the artist son of a wealthy manufacturer, became good friends with Lowry after writing to him. They corresponded for several years and Lowry visited Carr on regular occasions. It has been suggested that the farm portrayed here was near to the artist's home in Mottram.

NOTTINGHAM
Castle Museum

96. The Arrest 1927
Oil on canvas. 53.3 × 43.2 cm.
Signed and dated b.r: L. S. Lowry 1927
EXH: Sheffield 1962 (9); Midland Area Service 1962/3 (4); Accrington 1971 (34) Pl. 4; Leigh 1972 (29); Nottingham 1974 (1) Pl. 1; Royal Academy 1976 (72); Arts Council 1977/8 (88)
LIT: Levy, 1975, Pl. 53; Spalding, 1979, Pl. 19
PROV: purchased from the artist by Mr D. Carr, c.1944; Alex Reid & Lefevre Ltd.; purchased by Nottingham, 1952

Probably witnessed by Lowry in Manchester, although the street name 'Police Street' is undoubtedly a Lowry joke.

97. Industrial Panorama 1953 (Pl. 30)
Oil on canvas. 58.4 × 81.3 cm.
Signed b.l: L. S. Lowry 1953
EXH: Lefevre Gallery 1953 (15); Manchester 1959 (57); Sheffield 1962 (169); Midland Area Service 1962/3 (16); Accrington 1971 (65) Pl. 11; Leigh 1972 (54) repr.; Nottingham 1974 (13); Royal Academy 1976 (202) repr.; Scottish Arts Council 1977/8 (45); Arts Council 1986 (24)
LIT: Levy, 1975, Pl. 127; McLean, 1978, p. 15; Great Artists, 1986, pp. 2292–3, repr.
PROV: purchased from Alex Reid & Lefevre Ltd., 1953

This appears to be a reworking of *The Canal Bridge* (428). The foreground has marked similarities to *Industrial Landscape* (9) and the middle ground is occupied by an obelisk on a rounded hill reminiscent of *A Landmark* (274).

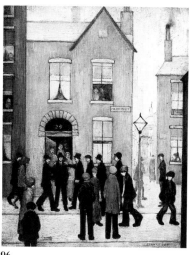

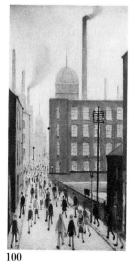

96 **100**

OLDHAM
Art Gallery

98. The Procession 1927 (Pl. 12)
Oil on canvas. 39.5 × 59 cm.
Signed b.r: L. S. Lowry 1927
EXH: Paris 1931; Royal Academy 1932; Royal Society of Arts 1933; Arlington Gallery 1934 (13); Arts Council (North West Region) 1951 (2); Salford 1951 (63); Altrincham 1960 (28); Swinton 1970 (4); Accrington 1971 (33); Leigh 1972 (30); Royal Academy 1976 (78); Scottish Arts Council 1977/8 (13); Stalybridge 1983 (8); Leigh 1986
PROV: Arlington Gallery, London, 1934

Based on a scene at Swinton Market and probably showing a Whit Walk. The theme occurs in many of the artist's drawings and paintings.

ROCHDALE
Art Gallery

99. Our Town 1947 (Fig. 46)
Oil on canvas. 43 × 62 cm.
Signed b.r: L. S. Lowry 1947
EXH: Accrington 1950; Salford 1951 (61); Altrincham 1960 (26); Sheffield 1962 (30); Swinton 1970 (22); Royal Academy 1976 (129); Scottish Arts Council 1977/8 (49); Stalybridge 1983 (9)
LIT: Levy, 1975, cover, Pl. 2; Levy, 1978, cover, Pl. 2; Woods, 1981, p. 4; Great

Artists, 1986, cover (detail), pp. 2288–9
PROV: purchased from the artist, 1949

RUGBY
Library, Museum and Art Gallery

100. Monday Morning 1946
Oil on panel. 50.8 × 26.7 cm.
Signed b.r: L. S. Lowry 1946
EXH: Lefevre Gallery 1948 (48); Arts Council 1960 (45); Midland Area Service 1962/3 (14); University of Warwick 1986
PROV: purchased from Alex Reid & Lefevre Ltd., 1948

Lowry made regular visits to Rugby to stay with Argent Brierley and his wife Jean. Brierley had been a lecturer at Manchester School of Art.

SALFORD
Museum and Art Gallery

101. Nude Boy Seated 1906
Pencil on paper. 37.8 × 56.2 cm.
Signed t.r: L. S. Lowry 1906
EXH: Leicester 1982/3
LIT: Levy, 1976, Pl. 5; Salford Lowry Collection, 1977 (1)
PROV: purchased from the artist, 1961

This drawing, together with 103 and 104, is more likely to have been undertaken after 1908. Lowry did not begin to take art classes at Manchester until 1905

and he was to recall: 'I took Preparatory Antique, Light and Shade, and then, after a time, the Antique Class, and when they thought I was sufficiently advanced in Antique I went into the Life Class.'

It is known that the artist frequently added a date to a work many years after it was completed. Such datings seem to have depended on his own recollection, which may have been suspect, or on the advice of a friend. He would, for instance, ask a buyer: 'When do you think I did this, Sir?'

102. Still Life *c*.1906 (Pl. 1)
Oil on canvas board. 23.5 × 33.5 cm.
Unsigned
EXH: Salford 1953 (106); Manchester 1959 (1); Harrogate 1960 (118); Arts Council 1966/7 (1); Liverpool 1973 (1); Royal Academy 1976 (2)
LIT: Salford Lowry Collection, 1977 (2); (Leber and Sandling), 1983, repr.
PROV: purchased from Alex Reid & Lefevre Ltd., 1959

Probably painted when the artist took private lessons with William Fitz, an American who had a studio in Manchester. Recalling his early teacher, Lowry said that Fitz was 'a competent painter, but I don't think he was very distinguished. That doesn't matter. A teacher doesn't have to be distinguished.' Lowry attended his classes for about ten years from 1905. Examples of Fitz's own work may be found in the collections of Salford Art Gallery.

Speaking of this picture, the artist said: 'I used to draw little ships when I was about eight. Didn't start painting until I went to art school. I think I did my first painting about 1906, it's in the Art Gallery at Salford.'

103. Reclining Nude *c*.1906
Pencil on paper. 35.1 × 52.8 cm.
Signed t.l: L. S. Lowry
LIT: Levy, 1976, Pl. 4; Salford Lowry Collection, 1977 (3)
PROV: purchased from the artist, 1961

104. Seated Woman with a Book *c*.1906
Pencil on paper. 53.8 × 36.3 cm.
Signed t.l: L. S. Lowry

EXH: Preston 1977 (4)
LIT: Levy, 1976, Pl. 3; Salford Lowry Collection, 1977 (4)
PROV: presented by the artist, 1971

105. Study of Head from the Antique *c*.1907
41 × 34.5 cm.
RECTO: Pencil on paper
Signed t.l: L. S. Lowry
EXH: Wigan 1976
LIT: Levy, 1976, Pl. 6; Salford Lowry Collection, 1977 (5)
VERSO: Study of Two Hands
Pencil
Unsigned
LIT: Salford Lowry Collection, 1977 (6)
PROV: purchased from the artist, 1961

When he enrolled at Manchester School of Art around 1905, Lowry entered the antique drawing class. It was only when students were able to produce adequate likenesses of the plaster casts that they were allowed to enrol in the life class.

106. Portrait of a Man 1908
Pencil on paper. 40.2 × 27.7 cm.
Signed b.r: L. S. Lowry 1908
EXH: Salford 1953 (107); Manchester 1959 (71); Harrogate 1960 (108); Arts Council 1966/7 (113); Nottingham 1967; Royal Academy 1976 (6)
LIT: Levy, 1963, Pl. 4; Levy, 1976, Pl. 9; Salford Lowry Collection, 1977 (7)
PROV: presented by the artist, 1952

The catalogue for the 1959 Manchester exhibition states that this 'is the first life drawing executed by the artist whilst at Manchester School of Art'. It seems unlikely that he would have undertaken any life drawing before this date. Lowry recounted, 'I did the life drawing for twelve solid years [at Manchester] as well as I could and that, I think, is the foundation of painting.'

107. Near Blackpool 1908
Pencil on a page of an autograph album. 11.5 × 18.4 cm.
Signed b.r: L. Lowry 17/5/08
Inscribed below drawing: Nr. Blackpool. An original drawing
LIT: Salford Lowry Collection, 1977 (8)
PROV: purchased from Mr N. O. Nicholl, 1976

It was a customary childhood practice that, on leaving school, pupils would collect, in an autograph album, contributions of notes, poetry or drawings from their classmates. The vendor's aunt attended the same school as Lowry.

Several of the artist's earliest surviving works are coastal scenes either sketched at, or recalled from, Lancashire holiday resorts. The theme was to recur throughout his life.

108. Head from the Antique *c*.1908 (Fig. 3)
Pencil on paper. 52 × 33.7 cm.
Signed and inscribed t.r: L. S. Lowry 10 hrs
EXH: Royal Academy 1976 (7)
LIT: Levy, 1963, Pl. 1; Levy, 1976, Pl. 8; Salford Lowry Collection, 1977 (9)
PROV: purchased from the artist, 1961

'If you draw from life, whatever you do, you can say it was like that when I drew it, but it moved. You can't say that about the antique,' commented the artist.

109. Seated Nude (facing left) *c*.1908
Pencil on paper. 53 × 34.5 cm.
Signed t.r: L. S. Lowry
EXH: Arts Council 1966/7 (112); Preston 1977 (20); Stalybridge 1983 (10); Dulwich Picture Gallery 1985 (2)
LIT: Levy, 1963, Pl. 3; Levy, 1976, Pl. 10; Salford Lowry Collection, 1977 (10)
PROV: purchased from the artist, 1961

110. Arden's Farm, Swinton *c*.1909
Oil on board. 17.5 × 25.5 cm.
Signed b.l: L. Lowry 19[]
EXH: Arts Council 1966/7 (3); Swinton 1970 (10); Accrington 1971 (1); Royal Academy 1976 (5)
LIT: Salford Lowry Collection, 1977 (12)
PROV: presented by the artist, 1966 (Swinton Collection)

The Lowry family moved to Pendlebury in 1909 and this is one of the artist's earliest local views. Arden's Farm, or Moss Farm, stood near the northern end of Moss Lane, Wardley.

111. Clifton Junction – Morning 1910 (Pl. 2)
Oil on board. 20.2 × 34.8 cm.
Signed b.l: L. S. Lowry 1910
EXH: Swinton 1970 (2); Accrington 1971 (2); Leigh 1972 (1)
LIT: Martin, 1977, p. 28; Salford Lowry Collection, 1977 (13); Rohde, 1979, pp. 53, 304
PROV: presented by the artist, 1970 (Swinton Collection)

This and 112 are a pair of pictures painted on Easter Monday. Lowry stated that they were the last paintings he undertook outdoors. He also explained: 'There are no figures in them—I was only turning from landscape to pure factories: 1910 to 1920 was the period of genesis.' The church in the distance is St Anne's, Clifton, which still survives.

112. Clifton Junction – Evening 1910
Oil on board. 19 × 35.5 cm.
Signed b.l: L. S. Lowry 1910
EXH: Swinton 1970 (3); Accrington 1971 (3); Leigh 1972 (2); Royal Academy 1976 (10)
LIT: Martin, 1977, p. 28; Salford Lowry Collection, 1977 (14); Rohde, 1979, pp. 53, 304
PROV: presented by the artist, 1970 (Swinton Collection)

See 111.

113. Portrait of the Artist's Father 1910
Oil on canvas. 41 × 31 cm.
Signed b.r: L. S. Lowry 1910
EXH: Manchester 1959 (3); Arts Council 1966/7 (4) Pl. 3; Royal Academy 1976 (9) repr.
LIT: Collis, 1951, p. 24; Levy, 1961, Pl. 1; Levy, 1975, p. 16, Pl. 49; Salford Lowry Collection, 1977 (15), repr.; Levy, 1978, Pl. 32; Rohde, 1979, pp. xxiv, 48; Spalding, 1979, p. 10, Pl. 1
PROV: bequeathed by the artist, 1976

The artist bequeathed this painting, together with *Portrait of the Artist's Mother* (115) and two other pictures. He allowed the gallery to exhibit the other pictures but he retained the two portraits, which hung in his living room, until his death.

Showing this painting to Robert Robinson, Lowry made

the intriguing comment: 'There's father, oh, how they carried on, they said it was wicked. Well, I didn't do what I might have done with father, but I did what I wanted.' See 147, 177.

114. Male Nude from the Antique *c*.1911
54.2 × 35 cm.
RECTO: Pencil on paper
 Signed b.r: L. S. Lowry
EXH: Arts Council 1966/7 (111); Manchester 1976 (41); Preston 1977 (2); Stockport 1980
LIT: Levy, 1963, Pl. 2; Levy, 1976, Pl. 13; Salford Lowry Collection, 1977 (17)
VERSO: *Male Nude from the Antique*
 Pencil
 Unsigned
LIT: Salford Lowry Collection, 1977 (16)

PROV: purchased from the artist, 1961

115. Portrait of the Artist's Mother 1912 (Fig. 29)
Oil on canvas. 46.1 × 35.9 cm.
Signed b.r: L. S. Lowry 1912
EXH: probably Salford 1951 (16); Manchester 1959 (4); Arts Council 1966/7 (5) Pl. 2; Royal Academy 1976 (8) repr.
LIT: Collis, 1951, pp. 24–5; Levy, 1961, Pl. 2; Levy, 1975, p. 16, Pl. 48; Salford Lowry Collection, 1977 (18), repr.; Levy, 1978, Pl. 33; Rohde, 1979, pp. xxiv, 48; Great Artists, 1986, p. 2274, repr.
PROV: bequeathed by the artist, 1976

Restoration work on this painting prior to the Royal Academy exhibition revealed evidence of three other pictures beneath the portrait each covered with a layer of filler (probably lead white). See 113, 181.

116. St Martin's, Canterbury 1912
Pencil, black and white crayon on grey paper. 25.8 × 18.9 cm.
Signed and inscribed b.r: LSL 1912 'St. Martins' Canterbury
PROV: purchased from the artist's estate, 1981

A rare interior view of a church and one of many drawings of the time made in black and white crayon.

117. Boy in a School Cap 1912
Pencil and white chalk on paper. 42.5 × 24.5 cm.
Signed b.l: L. S. Lowry 1912
EXH: Manchester 1959 (72); Nottingham 1967; Norwich 1970; Royal Academy 1976 (14); Sheffield 1979
LIT: Levy, 1963, Pl. 5; Levy, 1976, Pl. 16; Salford Lowry Collection, 1977 (20)
PROV: purchased from Alex Reid & Lefevre Ltd., 1959

The sitter was a family friend who is believed to have died in action in the First World War. See 123.

118. Landscape *c*.1912 (Fig. 30)
Oil on canvas. 33.5 × 23.5 cm.
Unsigned
EXH: Manchester 1959 (6); Harrogate 1960 (119); Liverpool 1973 (5)
LIT: Levy, 1975, Pl. 32; Salford Lowry Collection, 1977 (19)
PROV: purchased from Alex Reid & Lefevre Ltd., 1959

Speaking of his work as a whole, Lowry denied any direct influences. Yet his early works are affected by a traditional approach or, in the case of this painting and 125, by the Impressionism he associated with Adolphe Valette.

119. Girl with Bouffant Hair *c*.1912
Pencil on paper. 41.8 × 34.8 cm.
Signed on reverse: L. S. Lowry
EXH: Mottram 1977 (20) repr.
LIT: Levy, 1976, Pl. 17; Salford Lowry Collection, 1977 (21)
PROV: purchased from the artist, 1961

120. Head of a Young Man in Cap *c*.1912
Pencil on paper. 45.5 × 33.7 cm.
Signed t.r: L. S. Lowry
EXH: Liverpool 1973 (2); Preston 1977 (3); Stockport 1980; Swansea 1985 (3)
LIT: Levy, 1976, Pl. 18; Salford Lowry Collection, 1977 (22)
PROV: purchased from the artist, 1961

121. St Mary's Church, Swinton 1913
Pencil on paper. 20.3 × 11.7 cm.
Signed in black ink b.l: L. S. Lowry; dated b.r: 1913
EXH: Bury 1962 (25); Pendlebury 1966 (14); Swinton 1970 (26); Leigh 1972 (3); Royal Academy 1976 (16)

LIT: Levy, 1976, Pl 19; Salford Lowry Collection, 1977 (23)
PROV: purchased from the artist by Gerald Cotton; presented, 1966 (Swinton Collection)

St Mary's Church stood on Swinton Hall Road close to the Acme Mill. The view appealed to the artist and was repeated several times in later paintings. See 327, 437. After bomb damage in the Second World War the spire was removed and the church was demolished in 1964.

122. Lancashire Landscape 1913
Pastel on grey paper. 26.7 × 48 cm.
Signed in blue ballpoint pen b.r: L. S. Lowry 1913
EXH: Stalybridge 1983 (12)
PROV: purchased from the artist's estate, 1981

The Lowry family holidayed regularly in and around Lytham St Annes giving the young artist an introduction to the landscape of the Fylde. There are a number of drawings made in pastel which have survived. Lowry was to return to the Fylde for inspiration throughout his life and regularly used pastels in his drawing.

123. Portrait of a Boy *c*.1913–14
Oil on panel. 37.3 × 26.4 cm.
Unsigned
EXH: possibly Salford 1953 (108); Manchester 1959 (7); Nottingham 1967; Liverpool 1973 (6)
LIT: Levy, 1975, Pl. 51; Salford Lowry Collection, 1977 (24)
PROV: purchased from Alex Reid & Lefevre Ltd., 1959

Compare 117.

124. Head of a Bald Man *c*.1913–14
Oil on panel. 28.7 × 18.2 cm.
Unsigned
EXH: Manchester 1959 (8); Harrogate 1960 (120); Kendal 1964 (30)
LIT: Levy, 1975, Pl. 33; Salford Lowry Collection, 1977 (25)
PROV: purchased from Alex Reid & Lefevre Ltd., 1959

125. Country Lane 1914 (Pl. 3)
Oil on panel. 23.6 × 15.6 cm.
Signed b.r: L. S. Lowry
Signed on reverse: L. S. Lowry 1914

116

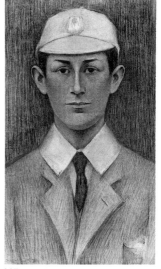

117

121

LIT: Levy, 1975, Pl. 8; Levy, 1978, Pl. 8; Salford Lowry Collection, 1977 (28), repr.
PROV: purchased from the artist by Prof. H. B. Maitland; purchased from his daughter, 1976

Previously titled *Horse and Cart*. See 116.

126. A Farm 1914
Pastel on grey/blue paper. 18.2 × 35.8 cm.
Signed b.r: L. S. Lowry 1914
EXH: Stalybridge 1983 (13); Swansea 1985 (9)
PROV: purchased from the artist's estate, 1981
Brookes number

Probably a Lancashire landscape.

127. Study of a Woman's Head 1914
Pencil on paper. 44.1 × 35.5 cm.
Signed b.r: L. S. Lowry 1914
EXH: Manchester 1959 (76); Altrincham 1960 (15); Sheffield 1962 (101); Sheffield 1979; Stockport 1980
LIT: Levy, 1976, Pl. 21; Salford Lowry Collection, 1977 (26)
PROV: presented by the artist, 1952

128. Head of a Man 1914
Pencil and white crayon on grey paper. 45 × 32.3 cm.
Signed b.l: LSL 14
EXH: Arts Council 1966/7 (115); Nottingham 1967; Belfast 1971 (1); Stockport 1980
LIT: Levy, 1963, Pl. 7; Salford Lowry Collection, 1977 (27)
PROV: purchased from Alex Reid & Lefevre Ltd. 1959

129. Female Nude (Nude Girl Holding Apple) *c*.1914
54.1 × 36.3 cm.
RECTO: Pencil on paper
Signed t.r: L. S. Lowry
EXH: Stalybridge 1983 (11)
LIT: Levy, 1976, Pl. 2; Salford Lowry Collection, 1977 (29)
Lowry also did an oil painting of *Female Nude* (see Rohde, 1979, Pl. IV).
VERSO: Study of a Statue from the Antique *c*.1910
Pencil
Unsigned
PROV: purchased from the artist, 1961

130. Seated Woman *c*.1914
Pencil on paper. 51.7 × 33.8 cm.
Signed and inscribed t.r: L. S.

Lowry 45 minutes
EXH: Scottish Arts Council 1977/8 (1)
LIT: Levy, 1976, Pl. 20; Salford Lowry Collection, 1977 (30)
PROV: purchased from the artist, 1961

131. Seated Male Nude *c*.1914 (Fig. 4)
Pencil on paper. 54.8 × 34.9 cm.
Signed and inscribed t.r: L. S. Lowry 8 hrs
EXH: Manchester 1959 (75); Harrogate 1960 (109); Royal Academy 1976 (19); Stockport 1980
LIT: Levy, 1963, Pl. 6, p. 10; Levy, 1976, Pl. 22; Salford Lowry Collection, 1977 (31), repr.; (Leber and Sandling), 1983, repr.
PROV: presented by the artist, 1952

James Fitton RA, a younger contemporary of Lowry at Manchester School of Art, summarized Lowry's life class work thus: 'He used to sit in front of the nude model and by the time he had finished—he made a swipe from the neck to the ankle more or less—it looked as if it had been carved with a meat axe.'

132. Study of a Female Head *c*.1914
Pencil on paper. 33.2 × 27.5 cm.
Signed in ink (possibly later) b.r: L. S. Lowry
EXH: Wigan 1976; Preston 1977 (1)
LIT: Salford Lowry Collection, 1977 (32)
PROV: presented by the artist, 1971

133. Man Wearing Smock *c*.1916
Pencil on paper. 54 × 36 cm.
Signed and inscribed t.r: L. S. Lowry 1 hr
EXH: Mottram 1977 (19); Sheffield 1979; Swansea 1985 (4)
LIT: Levy, 1976, Pl. 26; Salford Lowry Collection, 1977 (33)
PROV: presented by the artist, 1971

134. Head of a Man 1917
Pencil on paper. 44.4 × 35.3 cm.
Signed b.r: LSL 17
LIT: Levy, 1976, Pl. 32; Salford Lowry Collection, 1977 (34)
PROV: presented by the artist, 1952

135. Head of a Man with Moustache 1917
Pencil on paper. 44.3 × 35.4 cm.

Signed b.r: L. S. Lowry 1917
EXH: Scottish Arts Council 1977/8 (2); Stockport 1980
LIT: Levy, 1976, Pl. 33; Salford Lowry Collection, 1977 (35)
PROV: presented by the artist, 1952

136. Girl with Necklace *c*.1917
Pencil on paper. 52.8 × 34.5 cm.
Signed t.r: L. S. Lowry
LIT: Levy, 1976, Pl. 28; Salford Lowry Collection, 1977 (36)
PROV: purchased from the artist, 1961

137. Model in Dutch Costume *c*.1917
Pencil on paper. 53 × 35.5 cm.
Signed and inscribed t.r: L. S. Lowry 1 hr
EXH: Stockport 1980
LIT: Levy, 1976, Pl. 30; Salford Lowry Collection, 1977 (37)
PROV: presented by the artist, 1952

A photograph in the Salford University Archives (p. 85) shows Lowry in a costume class at the Salford School of Art around 1919.

138. Seated Girl in Cap *c*.1917
Pencil on paper. 55.6 × 38.2 cm.
Signed t.l: L. S. Lowry
EXH: Preston 1977 (19); Stockport 1980; Swansea 1985 (2)
LIT: Levy, 1976, Pl. 29; Salford Lowry Collection, 1977 (38)
PROV: purchased from the artist, 1961

139. Study of a Girl in Peasant Dress *c*.1917
Pencil on paper. 51 × 33.8 cm.
Signed t.r: L. S. Lowry
EXH: Accrington 1971 (9); Liverpool 1973 (3); Wigan 1976
LIT: Levy, 1976, Pl. 31; Salford Lowry Collection, 1977 (39)
PROV: purchased from the artist, 1961

140. Coming from the Mill *c*.1917–18 (Pl. 4)
Pastel on paper. 43.7 × 56.1 cm.
Signed b.r: L. S. Lowry
Inscribed in pencil on reverse: about 1917 or 1918
EXH: Nottingham 1967; Norwich 1970; Belfast 1971 (2); Nottingham 1974 (20); Royal Academy 1976 (24) repr.; Sheffield 1979
LIT: Salford Lowry Collection, 1977 (41), repr.; Spalding, 1979, p. 24, Pl. 6; (Leber and Sandling), 1983, repr.
PROV: presented by the artist, 1958

One of Lowry's earliest composite industrial scenes drawn before the artist decided to use a white background. The composition was repeated in *Coming from the Mill*, 1930 (255), where the white ground was used. The horse-drawn vehicles can be compared to similar studies made by Adolphe Valette, Lowry's tutor at the Manchester School of Art.

141. A Fylde Farm 1918
Wax crayon and pencil on paper. 34.7 × 54.6 cm.
Signed b.l: L. S. Lowry 1918
EXH: Sheffield 1979
LIT: Salford Lowry Collection, 1977 (42), repr.
PROV: presented by the artist, 1971

See 122, 126.

142. Model with Head-dress 1918
Pencil on paper. 52.8 × 37.1 cm.
Signed b.r: L. S. Lowry 1918; t.l: L. S. Lowry
EXH: Harrogate 1960 (110); Accrington 1971 (10); Royal Academy 1976 (25); Swansea 1985 (1)
LIT: Levy, 1963, Pl. 11; Levy, 1976, Pl. 34; Salford Lowry Collection, 1977 (43), repr.
PROV: presented by the artist, 1952

143. Frank Jopling Fletcher 1919 (Pl. 5)
Oil on canvas. 48.7 × 38.7 cm.
Signed b.r: L. S. Lowry 1919
EXH: Salford 1965 (25); Liverpool 1973 (7)
LIT: Levy, 1975, Pl. 50; Andrews, 1977, p. 45; Salford Lowry Collection, 1977 (44); Rohde, 1979, pp. 73–4; (Leber and Sandling), 1983, repr.
PROV: presented by Philip Fletcher, the sitter's son, 1965

Fletcher was a friend of Lowry and they regularly attended concerts and the theatre together. The portrait was painted as 'a special surprise' (Lowry to Professor Maitland) and presented on his birthday. Fletcher disliked it intensely and, although he owned other Lowry works, he kept it hidden away from public view. The rejection of the painting convinced Lowry that he was not a portrait painter. 'I cannot make people look cheerful,' he commented.

141

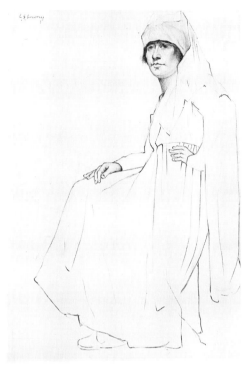

142

144. Notes on Anatomy and Figure Studies (a–c) 1919
Pencil on lined paper. 22.7 × 17.2 cm.
Unsigned
(a) notes on anatomy dated Oct 17 1919
(b) notes on anatomy
(c) recto: notes on anatomy
 verso: figure studies
PROV: purchased from the artist's estate, 1981

These pages had been inserted in the Anatomical Sketchbook (148).

145. Peel Park Sketch 1919
Pencil on paper. 19.4 × 10.7 cm.
Signed b.l: L. S. Lowry 1919
EXH: Altrincham 1960 (14); Liverpool 1973 (9); Scottish Arts Council 1977/8 (5)
LIT: Levy, 1963, Pl. 15; Levy, 1976, Pl. 35, p. 23; Salford Lowry Collection, 1977 (45)
PROV: presented by the artist, 1960

In the period 1919 to 1928, whilst he was a student at the Salford School of Art, the artist sketched many views in and around Peel Park and sometimes composed paintings of the area.

146. Peel Park Sketch 1919
Pencil on paper. 19.4 × 10.7 cm.
Signed b.l: L. S. Lowry 1919
EXH: Altrincham 1960 (14); Liverpool 1973 (9); Scottish Arts Council 1977/8 (5)
LIT: Levy, 1963, Pl. 15; Levy, 1976, Pl. 35, p. 23; Salford Lowry Collection, 1977 (46)
PROV: presented by the artist, 1960

147. Robert Lowry (The Artist's Father) c.1919 (Fig. 2)
20 × 14.5 cm.
RECTO: Coloured pencils on paper
 Unsigned
LIT: (Leber and Sandling), 1983, repr.
VERSO: *Flexed Arm*
 Pencil
 Unsigned
PROV: purchased from the artist's estate, 1981.

Lowry seldom spoke at any length about his father. Robert Lowry did not understand his son's work—'My father would look at an odd picture of mine and say "Ee, you're a rum 'un. I can't see you selling anything,"' the artist recalled. Yet it was his father who recommended that he drew St Simon's Church and who encouraged him in his experiment with white backgrounds (Lowry painted small panels with flake white and sealed them up. When they were reopened, the white had mellowed, much to the artist's liking). See 113, 177.

148. Anatomical Sketchbook c.1919–20 (Fig. 24)
Pencil, coloured pencils, black ink on paper. 25.5 × 20.5 cm. (cover)
Unsigned pages all bound in a grey linen-covered cardboard. 56 pages
PROV: purchased from the artist's estate, 1981

The sketchbook includes: anatomical studies with notations, studies of models, figure sketches, scenes from city life.

149. Wet Earth, Swinton 1920
Pastel on paper. 27.7 × 39 cm.
Signed b.l: L. S. Lowry 1920
EXH: Eccles 1961 (19); Pendlebury 1961 (1); Bury 1962 (22); Pendlebury 1964 (17) repr.; Pendlebury 1966 (2); Lytham St Annes 1967 (2); Swinton 1970 (24); Accrington 1971 (11); Royal Academy 1976 (35)
LIT: Salford Lowry Collection, 1977 (50)
PROV: purchased from the artist, 1961 (Swinton Collection)

The colliery at Dixon Fold in Clifton was the work of the noted mining engineer, Matthew Fletcher, and problems with flooding—indicated by the name—were ingeniously solved by James Brindley, 1752. The mine closed in 1928. The two drawings and a pastel by Lowry are the only record of the complete colliery to survive. See 216, 217.

150. Yachts 1920 (Pl. 6)
Pastel on paper. 28.4 × 38.2 cm.
Signed b.l: L. S. Lowry 1920
EXH: Arts Council 1966/7 (122); Nottingham 1967; Royal Academy 1976 (33); Sheffield 1979; Swansea 1980
LIT: Salford Lowry Collection, 1977 (51), repr. on cover
PROV: purchased from Alex Reid & Lefevre Ltd., 1959

The subject was one which the artist returned to time and again in his work. Evoking memories of family holidays, it was the only theme which attracted the interest of his mother.

151. Peel Park Sketch 1920
Pencil on paper. 11.4 × 19 cm.
Signed b.l: L. S. Lowry 1920
EXH: Altrincham 1960 (14); Liverpool 1973 (9); Scottish Arts Council 1977/8 (5); Swansea 1985 (17)
LIT: Levy, 1963, Pl. 15; Levy, 1976, Pl. 35, p. 23; Salford Lowry Collection, 1977 (47)
PROV: presented by the artist, 1960

Showing the portico of Lark Hill Mansion. This house was opened in 1850 as Salford Museum. In the 1930s it had deteriorated beyond reprieve and was demolished and replaced by the final wing of the present museum and art gallery.

152. Peel Park Sketch 1920
Pencil on paper. 11.4 × 19 cm.
Signed b.l: L. S. Lowry 1920
EXH: Altrincham 1960 (14); Liverpool 1973 (9); Scottish Arts Council 1977/8 (5); Swansea 1985 (18)
LIT: Levy, 1963, Pl. 15; Levy, 1976, Pl. 35, p. 23; Salford Lowry Collection, 1977 (48)
PROV: presented by the artist, 1960

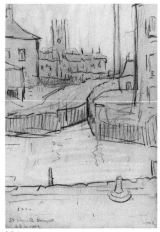

154

153. Peel Park Sketch 1920
Pencil on paper. 11.5 × 19.6 cm.
Signed b.l: L. S. Lowry 1920
EXH: Altrincham 1960 (14);
Liverpool 1973 (9); Scottish
Arts Council 1977/8 (5)
LIT: Levy, 1963, Pl. 15; Levy,
1976, Pl. 35, p. 23; Salford
Lowry Collection, 1977 (49)
PROV: presented by the artist, 1960

**154. St John's Church,
Deansgate** 1920
Pencil and white crayon on pale
green paper. 18 × 12.8 cm.
Signed and inscribed b.l: LSL
1920 St Johns Ch Deansgate
Signed on reverse: LSL 1920
PROV: purchased from the artist's
estate, 1981

St John's Church, Byrom Street,
was demolished in 1931. Lowry
did a large drawing and an oil
painting of this subject. See 185.

155. Head of a Man (profile
facing left) 1920
Pen and black ink on paper.
21 × 20.8 cm.
Signed in blue ballpoint pen b.r:
LSL 1920
PROV: purchased from the artist's
estate, 1981

Nos. 155 to 169 are a series of
drawings of visitors and colleagues
at the Pall Mall Property
Company treated in a variety of
manners and techniques. Frank
Whalley, a Manchester journalist
who knew the artist well, has dated
the drawings as between 1918 and
1920.

**156. Head of a Man with Dark
Hair** (profile facing right) c.1920
Pencil on paper. 20.6 × 19.7 cm.
Signed b.r: LSL
PROV: purchased from the artist's
estate, 1981

157. Head of a Man (full frontal)
c.1920
Pencil on paper. 21.1 × 21 cm.
Signed b.r: LSL
PROV: purchased from the artist's
estate, 1981

158. Head of a Man (full frontal)
c.1920
Pencil on paper. 21.1 × 20.5 cm.
Signed b.r: LSL
PROV: purchased from the artist's
estate, 1981

159. Head of a Man (profile
facing right) c.1920
Pencil on paper. 21.1 × 21 cm.
Signed b.r: LSL
PROV: purchased from the artist's
estate, 1981

160. Head of a Man (profile
facing left) c.1920 (Fig. 6)
Pen and black ink on paper.
20.5 × 20.7 cm.
Signed in pencil b.l: LSL
PROV: purchased from the artist's
estate, 1981

161. Head of a Man (profile
facing left) c.1920
Pen and black ink on paper.
21.3 × 20.7 cm.
Signed in blue ballpoint pen b.l:
LSL
PROV: purchased from the artist's
estate, 1981

**162. Head of a Man with
Bowler Hat** (profile facing left)
c.1920
Pen and black ink on paper.
21.1 × 20.9 cm.
Signed in blue ballpoint pen b.r:
LSL
PROV: purchased from the artist's
estate, 1981

163. Head of a Man (profile
facing left) c.1920
Pen and black ink on paper.
20 × 20.8 cm.
Signed in pencil b.l: LSL
PROV: purchased from the artist's
estate, 1981

164. Head of a Man (facing
three-quarters right) c.1920
Pencil on paper. 21 × 21 cm.
Signed b.r: LSL
EXH: Stalybridge 1983 (31)
PROV: purchased from the artist's
estate, 1981

165. Head of a Man (profile
facing left) c.1920
Pencil on paper. 21.2 × 20.8 cm.
Signed b.l: LSL
EXH: Stalybridge 1983 (30)
PROV: purchased from the artist's
estate, 1981

166. Head of a Bearded Man
(facing three-quarters left)
c.1920
Pencil on paper. 20.6 × 20 cm.
Signed b.l: LSL
PROV: purchased from the artist's
estate, 1981

167. Head of a Man (profile
facing left) c.1920
Pencil on paper. 20 × 20.1 cm.
Signed in blue ballpoint pen b.l:
LSL
PROV: purchased from the artist's
estate, 1981

168. Head of a Man (profile
facing left) c.1920
Pencil on paper. 21 × 20 cm.
Signed b.r: LSL
PROV: purchased from the artist's
estate, 1981

**169. Head of a Man with
Staring Eyes** (full frontal)
c.1920
Pencil on paper. 21.6 × 21.5 cm.
Signed b.r: LSL
PROV: purchased from the artist's
estate, 1981

170. Standing Woman c.1920
Pencil on paper. 38.5 × 27.7 cm.
Signed t.r: L. S. Lowry
PROV: purchased from the artist's
estate, 1981

171. Study of Crossed Legs
c.1920
Pencil on paper. 28.2 × 19.2 cm.
Unsigned
PROV: purchased from the artist's
estate, 1981

172. Art School Studies c.1920
Pencil on paper. 25.2 × 20.2 cm.
Unsigned
PROV: purchased from the artist's
estate, 1981

173. Art School Studies c.1920
Pencil on paper. 25 × 20.3 cm.
Unsigned
PROV: purchased from the artist's
estate, 1981

174. Figure Studies c.1920
24.5 × 37 cm.
RECTO and VERSO: Pencil on paper
Unsigned
PROV: purchased from the artist's
estate, 1981

The figures sketched in these
studies were frequently used in
later drawings and paintings. 'To
begin with I did a lot of studies of
little figures, drawing them as well
as I could.' (Lowry to Edwin
Mullins.)

175. Figure Studies c.1920
24.5 × 36.8 cm.
RECTO and VERSO: Pencil on paper
Unsigned
PROV: purchased from the artist's
estate, 1981

The figures which appear in the
industrial landscapes have fre-
quently been criticized, yet these
sketches demonstrate the compre-
hensive manner of Lowry's
research.

176. Figure Studies c.1920
(Fig. 23)
24.5 × 37 cm.
RECTO and VERSO: Pencil on paper
Unsigned
PROV: purchased from the artist's
estate, 1981

177. Figure Studies c.1920
15.5 × 11.7 cm.
RECTO: Light grey and black
pencils on card
Unsigned
VERSO: Two Heads and a Figure
Light grey and black pencils
Unsigned
PROV: purchased from the artist's
estate, 1981.

One of the heads is probably a
sketch of the artist's father.

178. Figure Studies c.1920
37.2 × 24.7 cm.
RECTO and VERSO: Pencil on paper
Unsigned
PROV: purchased from the artist's
estate, 1981

179. Three Figures *c.*1920
11.6 × 15.5 cm.
RECTO: Pencil on paper
 Unsigned
VERSO: Figure Group and Single
 Figure
 Pencil
 Unsigned
PROV: purchased from the artist's
 estate, 1981

180. Three Figures *c.*1920
15.6 × 11.6 cm.
RECTO: Light grey pencil on card
 Unsigned
VERSO: Heads and Dogs
 Light grey pencil
 Unsigned
PROV: purchased from the artist's
 estate, 1981

181. The Artist's Mother
*c.*1920 (Fig. 1)
24.5 × 37 cm.
RECTO: Pencil on paper
 Unsigned
LIT: Rohde, 1979, Pl. VI; (Leber
 and Sandling), 1983, repr.
VERSO: Studies of Groups of
 Figures
 Pencil
 Unsigned
PROV: purchased from the artist's
 estate, 1981

Lowry's mother, Elizabeth, was
rarely in good health and, follow-
ing the family move to Pendlebury
in 1909, she seldom went out. For
the last six years of her life, she was
bedfast. 'She didn't understand
my work but she understood me
and that was enough,' remem-
bered L. S. Lowry. See 115.

**182. The Milton Picture
House** *c.*1920
27.2 × 36.7 cm.
RECTO: Pencil on paper
 Unsigned
VERSO: Figure Studies
 Pencil
 Unsigned
PROV: purchased from the artist's
 estate, 1981

183. The Restaurant *c.*1920
Pencil on paper. 37.2 × 24.5 cm.
Unsigned
PROV: purchased from the artist's
 estate, 1981

There were few Manchester res-
taurants Lowry did not patronize
at some time. He was a plain eater
with simple gastronomic tastes
but an enormous appetite.

184

184. The Boardroom *c.*1920
Pencil on paper. 20.2 × 25.2 cm.
Unsigned
PROV: purchased from the artist's
 estate, 1981

A scene which Lowry probably
witnessed at the Pall Mall
Property Company.

**185. Sketch of St John's
Church, Deansgate** (detail)
*c.*1920
Pencil on paper. 12.2 × 17.7 cm.
Unsigned
PROV: purchased from the artist's
 estate, 1981

See 154.

186. A Street Scene *c.*1920
Pencil on paper. 27.2 × 14.1 cm.
Unsigned
EXH: Swansea 1985 (28)
PROV: purchased from the artist's
 estate, 1981

187. The Spinners Arms *c.*1920
Pencil on paper. 27.2 × 20.2 cm.
Unsigned
PROV: purchased from the artist's
 estate, 1981

188. Restaurant Scene *c.*1920
Pencil on paper. 37.2 × 24.5 cm.
Unsigned
PROV: purchased from the artist's
 estate, 1981

189. Street Market *c.*1920
Pencil on paper. 36.8 × 27.1 cm.
Unsigned
Inscribed on building:
 []cturers
PROV: purchased from the artist's
 estate, 1981

190. The Waiting Room *c.*1920
Pencil on paper. 26 × 35.2 cm.
Unsigned
PROV: purchased from the artist's
 estate, 1981

191. A Doctor's Waiting Room
*c.*1920
Oil on board. 27.3 × 40.9 cm.
Unsigned
EXH: Manchester 1959 (10);
 Harrogate 1960 (121); Eccles
 1961 (21); Norwich 1970;
 Liverpool 1973 (11)
LIT: Levy, 1975, Pl. 14; Salford
 Lowry Collection, 1977 (52),
 repr.; Levy, 1978, Pl. 14;
 Rohde, 1979, p. 100; Woods,
 1981, pp. 8, 15; (Leber and
 Sandling), 1983, repr.
PROV: purchased from Alex Reid
 & Lefevre Ltd., 1959

192. On the Sands *c.*1920
26 × 30.7 cm.
RECTO: Pencil on paper
 Unsigned
VERSO: Figure Studies for *On the
 Sands*
 Pencil
 Unsigned
PROV: purchased from the artist's
 estate, 1981

People on beaches were recorded
by the artist throughout his life.
These studies were made for *On
the Sands*, 1921 (195), but the
same subject occurs in the 1960s.
See 193, 194, 387.

187

193. Girl with a Plait (and
 Other Studies) *c.*1920
20.8 × 14 cm.
RECTO: Pencil on paper
 Unsigned
LIT: Rohde, 1979, chapter head-
 ing, p. 176
VERSO: Study of a Plait
 Pencil
 Unsigned
PROV: purchased from the artist's
 estate, 1981

Studies for *On the Sands* (195).
See 192, 194, 387.

194. On the Sands *c.*1920
Pencil on paper. 20.5 × 12.7 cm.
Unsigned
LIT: (Leber and Sandling), 1983,
 repr.
PROV: purchased from the artist's
 estate, 1981

See 192, 193, 195, 387.

195. On the Sands 1921
 (Fig. 17)
Pencil on paper. 27.3 × 36.7 cm.
Signed b.r: L. S. Lowry 1921
EXH: Manchester 1959 (77);
 Harrogate 1960 (112);
 Nottingham 1967; Norwich
 1970; Leigh 1972 (10);
 Liverpool 1973 (12); Royal
 Academy 1976 (42); Scottish
 Arts Council 1977/8 (6);
 Sheffield 1979
LIT: Levy, 1976, Pl. 52; Salford
 Lowry Collection, 1977 (54),
 repr.; Rohde, 1979, inside front
 and back covers; (Leber and
 Sandling), 1983, repr.
PROV: purchased from Alex Reid
 & Lefevre Ltd., 1959

The artist completed a number of
studies for this drawing. See
192–4, 387.

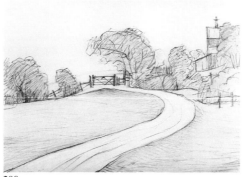

200

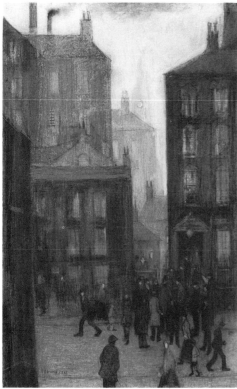

196

203

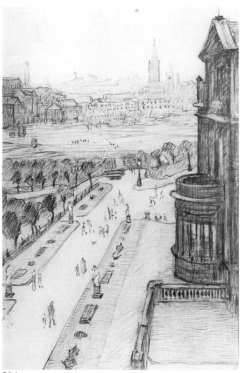

204

206

196. The Lodging House 1921
Pastel on paper. 50.1 × 32.6 cm.
Signed b.l: L. S. Lowry 1921
EXH: probably Bradford 1933;
 Kendal 1964 (39); Nottingham
 1967; Norwich 1970;
 Accrington 1971 (15); Leigh
 1972 (11); Liverpool 1973 (13);
 Royal Academy 1976 (40) repr.;
 Sheffield 1979; Leigh 1986
LIT: Salford Lowry Collection,
 1977 (53), repr.; Rohde, 1979,
 p. 100, Pl. IV; Spalding, 1979,
 Pl. 8
PROV: bequeathed by Mr G. H.
 Aldred, 1963

In 1921, Lowry exhibited eight
works in an exhibition at the
offices of an architect, Roland
Thomasson, in Manchester. The
exhibition was reviewed by
Bernard D. Taylor in the
Manchester Guardian who noted
that he 'has a very interesting and
individual outlook.... His portrait
of Lancashire is more grimly like
than a caricature because it is done
with the intimacy of affection. . . .
Mr Lowry has refused all comfor-
table delusions.... His Lancashire
is grey.' Although Lowry did not
sell any pictures at the exhibition
he did recall later that *The Lodging
House* was the first picture he sold.
'It was to a friend of my father's.
. . . He gave me £5 for it.' As the
donor was related to Thomas
Aldred, for whom Lowry had
worked around 1904, it seems that
Aldred saw the picture at the 1921
exhibition but purchased it later.

197. Woman in a Chair
 1921–56
Oil on panel. 41.8 × 34 cm.
Unsigned
EXH: Manchester 1959 (11);
 Liverpool 1973 (14)
LIT: Salford Lowry Collection,
 1977 (55)
PROV: purchased from Alex Reid
 & Lefevre Ltd., 1959

The subject was painted from life
in 1921. The artist repainted the
background in 1956.

198. Regent Street, Lytham
 1922 (Pl. 8)
Oil on board. 25.6 × 35.6 cm.
Signed b.r: L. S. Lowry 1922
LIT: Salford Lowry Collection,
 1977 (56), repr.
PROV: bequeathed by the artist,
 1976

A Fylde landscape which the artist
repeated several times.

199. Swinton Moss *c*.1922
Oil on board. 14 × 19.5 cm.
Signed b.r: L. S. Lowry
EXH: Accrington 1971 (50); Leigh
1972 (80); Royal Academy 1976
(44)
LIT: Salford Lowry Collection,
1977 (57); (Leber and
Sandling), 1983, repr.
PROV: presented by the artist, 1971
(Swinton Collection)

The artist enjoyed walking with
friends and he made many sket-
ches on the mossland farms
around Swinton during the 1920s.
Some of the sketches were later
used for paintings. Harold Riley
accompanied Lowry on a senti-
mental return to the moss in the
1960s and noted that 'it was a place
to him of sacred memories very
close to his heart'.

200. On the Moss 1923
Pencil on paper. 26.5 × 37.5 cm.
Signed b.l: L. S. Lowry 1923
EXH: Pendlebury 1961 (4);
Sheffield 1962 (116); Bury 1962
(12); Pendlebury 1964 (1);
Pendlebury 1966 (11); Lytham
St Annes 1967 (11); Leigh 1972
(14)
LIT: Levy, 1976, Pl. 63; Salford
Lowry Collection, 1977 (58)
PROV: purchased from the artist,
1961 (Swinton Collection)

A Swinton view.

**201. River Irwell at the
Adelphi** 1924 (Fig. 8)
Pencil on paper. 35.5 × 52.3 cm.
Signed b.l: L. S. Lowry 1924
EXH: Altrincham 1960 (13); Arts
Council 1966/7 (129);
Nottingham 1967; Royal
Academy 1976 (53) repr.;
Scottish Arts Council 1977/8
(8); Sheffield 1979
LIT: Levy, 1963, Pl. 42; Levy,
1976, Pl. 67; Salford Lowry
Collection, 1977 (59)
PROV: presented by the artist, 1958

In the far distance is Kersal Ridge
and St Paul's Church spire. The
River Irwell takes a rather tor-
tuous route through Salford and
there is a very large bend at the
Adelphi, which lies near to Peel
Park. The artist sketched regu-
larly in this area and made several
drawings and paintings of the river
and the factories which lined its
banks. Flooding of the river was
quite common and the scene re-
produced in this drawing almost

certainly inspired the artist's later
industrial lake scenes. See 20, 92,
276.

202. Bandstand, Peel Park 1924
Pencil on paper. 17.1 × 24.5 cm.
Signed b.l: L. S. Lowry 1924
EXH: possibly Salford 1931/2 (97);
Salford 1947; Nottingham
1967; Sheffield 1979; Stockport
1980
LIT: Levy, 1963, pp. 13, 17, Pl. 23;
Levy, 1976, p. 24, Pl. 66;
Salford Lowry Collection, 1977
(59)
PROV: purchased from the artist,
1952

Peel Park was a popular attraction
for the townspeople of Salford and
Manchester and the bandstand
was the focus of much activity.
The subject was drawn and pain-
ted many times by the artist. See
207, 248, 439. The bandstand was
later demolished.

**203. View from a Window of
the Royal Technical College,
Salford** 1924
Pencil on paper. 54.4 × 37.5 cm.
Signed b.l: L. S. Lowry 1924
EXH: Salford 1951 (2);
Manchester 1959 (79);
Harrogate 1960 (111); Arts
Council 1966/7 (125) Pl. 1;
Norwich 1970; Nottingham
1974 (24); Royal Academy 1976
(52) repr.; Sheffield 1979
LIT: Levy, 1963, pp. 10, 13, 24, Pl.
24; Levy, 1976, p. 23, Pl. 68;
Salford Lowry Collection, 1977
(62), repr.
PROV: presented by the artist, 1951

The view is from the Art School
balcony of what is now the Peel
Building of the University of Sal-
ford, looking towards the centre of
Salford with its closely packed
streets and factories. The chimney
has since been demolished.
 Described by Mervyn Levy as
'at the pinnacle of the artist's
achievement with the pencil'.
Edwin Mullins noted Lowry's
varied use of the pencil 'to suit the
different surfaces he is describing:
a heavy criss-crossing for the dark
brick-work on the left, compact
vertical lines from top to bottom
for the smooth chimney in the
centre, little disconnected strokes
for the figures down below, a
general fuzz for the smog over the
city, the lightest of cat's-whisker
strokes for the drifting smoke
above.'

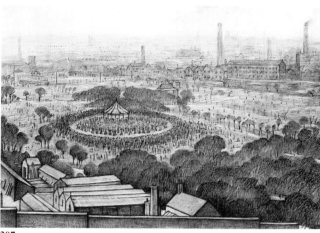

207

**204. View from a Window of
the Royal Technical College,
Salford, Looking Towards
Manchester** 1924
Pencil on paper. 55.5 × 37.5 cm.
Signed b.r: L. S. Lowry 1924
EXH: Norwich 1970; Accrington
1971 (29) repr. on cover;
Nottingham 1974 (23);
Sheffield 1979; Stockport 1980
LIT: Levy, 1976, Pl. 69; Salford
Lowry Collection, 1977 (61)
PROV: purchased from the artist,
1952

When he was attending Salford
School of Art, Lowry took advan-
tage of the fine views from the Peel
Building which housed the art
school. This view shows the rear of
Salford Art Gallery, the terrace
above Peel Park and, in the back-
ground, St Simon's Church and
the factories along the River Irwell.

205. Self-Portrait 1925 (Pl. 9)
Oil on board. 57.2 × 47.2 cm.
Signed b.l: L. S. Lowry 1925
EXH: Manchester 1959 (14);
Harrogate 1960 (122); Arts
Council 1966/7 (12) Pl. 4;
Nottingham 1967; Arts
Council 1970; Liverpool 1973
(17) Pl. 1; Royal Academy 1976
(55) repr.; Greater Manchester
Council 1980
LIT: Levy, 1961, p. 14, Pl. 3; Levy,
1975, Pl. 1; Andrews, 1977,
pp. 58, 66; Ingham, 1977, Pl. 1;
Salford Lowry Collection, 1977
(65), repr.; Levy, 1978, Pl. 1;
McLean, 1978, p. 8, Pl. 1 (title
page); Spalding, 1979, p. 5,
Pl. 18; Rohde, 1979, p. 232;
Woods, 1981, p. 15; Sieja, 1983,
p. 32; (Leber and Sandling),

1983, repr.; Great Artists,
1986, p. 2273, repr.
PROV: purchased from Alex Reid
& Lefevre Ltd., 1959

Painted when the artist was thirty-
seven years old. Lowry later re-
called: 'I had a great tussle with it,
and when it was done I said,
"Never again, thank you." I think
it was very good when I did it, but
it was damaged by damp and after
twenty years I sent it to the re-
storers. He did what he could but
he apologised for not having done
more. The colours have gone.'

**206. View from a Window of
the Royal Technical College,
Salford, Looking Towards
Broughton** 1925
Pencil on paper. 26.5 × 36.5 cm.
Signed b.r: L. S. Lowry 1925
EXH: Wakefield 1955 (52); Arts
Council 1966/7 (133); Norwich
1970; Liverpool 1973 (20);
Nottingham 1974 (25); Royal
Academy 1976 (59) repr.
LIT: Levy, 1963 pp. 13, 78, Pl. 27;
Levy, 1976, Pl. 78; Salford
Lowry Collection, 1977 (64)
PROV: purchased from the artist,
1952

A view over Peel Park with the
industrial suburb of Lower
Broughton in the distance.

**207. Bandstand, Peel Park,
Salford** 1925
Pencil on paper. 36.7 × 54.6 cm.
Signed b.l: L. S. Lowry 1925
EXH: Salford 1951 (3); Wakefield
1955 (44); Manchester 1959
(82); Kendal 1964 (50); Arts
Council 1966/7 (32);
Accrington 1971 (28); Leigh

1972 (17); Liverpool 1973 (19) Pl. 6; Nottingham 1974 (26); Scottish Arts Council 1977/8 (10); Sheffield 1979
LIT: Levy, 1976, Pl. 79; Salford Lowry Collection, 1977 (74), repr.
PROV: presented by the artist, 1951

This drawing was used as a study for an oil painting, dated 1931, in the City Art Gallery, York (439). See 202, 248.

208. Belle Vue House, Leaf Square, Salford 1925 (Fig. 9)
Pencil on paper. 24 × 34.7 cm.
Signed b.r: L. S. Lowry 1925
EXH: Manchester 1959 (87); Norwich 1970; Swansea 1985 (31)
LIT: Levy, 1976, Pl. 76; Salford Lowry Collection, 1977 (76)
PROV: presented by the artist, 1951

This building stood at the end of Leaf Square parallel to Broad Street. It is notable that the Salford views undertaken by Lowry tend to concentrate on churches, Peel Park and the Georgian parts of the city. Leaf Square was a particularly fine period development which was demolished in the early 1960s to make way for the new College of Technology. See 209–10, 229–30.

209. Behind Leaf Square (2) 1925
Pencil on paper. 24.5 × 35 cm.
Signed b.r: L. S. Lowry 1925
EXH: Altrincham 1960 (3); Sheffield 1962 (130); Bury 1962 (3); Preston 1977 (13); Stalybridge 1983 (14); Swansea 1985 (6); Leigh 1986; Lancaster 1986; 'Lancashire South of the Sands' 1987 (24)
LIT: Levy, 1976, Pl. 75; Salford Lowry Collection, 1977 (77)
PROV: purchased from the artist, 1952

See 208, 210, 229–30, 231.

210. Behind Leaf Square (3) 1925
Pencil on paper. 24.5 × 34.8 cm.
Signed b.r: L. S. Lowry 1925
EXH: Accrington 1971 (31); Swansea 1985 (27)
LIT: Levy, 1976, Pl. 74; Salford Lowry Collection, 1977 (78)
PROV: purchased from the artist, 1952

See 208–9, 229–30, 231.

211. Canal at Worsley 1925
Pencil on paper. 24.2 × 34.5 cm.
Signed b.r: L. S. Lowry 1925; b.l: LSL 1925
EXH: Eccles 1961 (2); Pendlebury 1961 (11); Bury 1962 (1); Pendlebury 1966 (10); Lytham St Annes 1967 (10); Accrington 1971 (21); Leigh 1972 (22); Preston 1977 (15); Sheffield 1979
LIT: Levy, 1976, Pl. 71; Salford Lowry Collection, 1977 (66), repr.
PROV: purchased from the artist, 1961 (Swinton Collection)

Worsley, a small village to the west of Salford, is a popular area for visitors. The Bridgewater Canal opened in 1761 and runs from Worsley to Manchester and Runcorn. See 8, 212, 213.

212. Worsley – Canal Scene (View of Packet House) 1925 (Fig. 26)
Pencil on paper. 24.5 × 34.5 cm.
Signed b.r: LSL 1925
EXH: Eccles 1961 (25); Pendlebury 1961 (10 or 12); Sheffield 1962 (128); Bury 1962 (5); Pendlebury 1966 (9); Lytham St Annes 1967 (9); Swinton 1970 (27); Accrington 1971 (24); Leigh 1972 (20)
LIT: Levy, 1976, Pl. 73; Salford Lowry Collection, 1977 (67); (Leber and Sandling), 1983, repr.
PROV: purchased from the artist, 1961 (Swinton Collection)

See 8, 211, 213.

213. Worsley (Iron Bridge) 1925
Pencil on paper. 24.6 × 34.7 cm.
Signed b.r: LSL 1925
Inscribed b.l: Worsley
EXH: Eccles 1961 (10); Pendlebury 1961 (10 or 12); Bury 1962 (27); Pendlebury 1966 (8); Lytham St Annes 1967 (8); Leigh 1972 (21)
LIT: Levy, 1976, Pl. 81; Salford Lowry Collection, 1977 (68)
PROV: purchased from the artist, 1961 (Swinton Collection)

See 8, 211, 212.

214. Old Farm in Pendlebury 1925
Pencil on paper. 24 × 33.5 cm.
Signed b.l: L. S. Lowry 1925
EXH: Eccles 1961 (26); Pendlebury 1961 (8); Sheffield 1962 (129); Bury 1962 (30); Pendlebury 1964 (28); Pendlebury 1966 (6); Lytham St Annes 1967 (6); Swinton 1970 (39); Accrington 1971 (22); Leigh 1972 (23); Royal Academy 1976 (62)
LIT: Levy, 1976, Pl. 83; Salford Lowry Collection, 1977 (71)
PROV: purchased from the artist, 1961 (Swinton Collection)

This was Fildes Fold Farm, which stood in Hospital Road facing the Royal Manchester Children's Hospital.

215. Dixon Fold 1925
Pencil on paper. 24.5 × 34.8 cm.
Signed b.r: L. S. Lowry 1925
EXH: Eccles 1961 (23); Pendlebury 1961 (7); Bury 1962 (7); Sheffield 1962 (127); Pendlebury 1964 (16) repr.; Pendlebury 1966 (5) repr.; Lytham St Annes 1967 (5)
LIT: Levy, 1976, Pl. 72; Salford Lowry Collection, 1977 (69)
PROV: purchased from the artist, 1961 (Swinton Collection)

A view of Top Farm from Dixon Fold, Swinton.

216. Pit-head Scene, Wet Earth 1925
Pencil on paper. 21.6 × 34.8 cm.
Signed b.l: L. S. Lowry 1925
EXH: Eccles 1961 (20); Pendlebury 1961 (9); Bury 1962 (4); Sheffield 1962 (120); Pendlebury 1964 (18); Pendlebury 1966 (7); Lytham St Annes 1967 (7); Swinton 1970 (48); Accrington 1971 (25) Pl. 3; Leigh 1972 (19) repr.
LIT: Levy, 1976, Pl. 106; Salford Lowry Collection, 1977 (70)
PROV: purchased from the artist, 1961 (Swinton Collection)

See 149, 217.

217. Wet Earth Colliery, Dixon Fold 1925
Pencil on paper. 24.3 × 34.5 cm.
Signed b.r: L. S. Lowry 1925
EXH: Manchester 1959 (85); Sheffield 1962 (126); Norwich 1970; Leigh 1972 (8); Liverpool 1973 (27); Preston 1977 (17); Sheffield 1979; Arts Council 1982 (40)
LIT: Levy, 1963, p. 19; Salford Lowry Collection, 1977 (106)
PROV: purchased from the artist, 1952

Wet Earth Colliery closed in late 1928. The only remaining part is the chimney known as 'Fletcher's Folly'. See 149, 216.

218. Country Road 1925
Pencil on paper. 24.5 × 34.7 cm.
Signed b.r: LSL 1925
EXH: Manchester 1959 (84); Arts Council 1966/7 (131); Nottingham 1967; Preston 1977 (10); Norwich 1970; Stockport 1980
LIT: Levy, 1976, Pl. 77; Salford Lowry Collection, 1977 (72); (Leber and Sandling), 1983, repr.
PROV: purchased from Alex Reid & Lefevre Ltd., 1959

A view near Lytham St Annes, Lancashire. See 219.

219. Country Road near Lytham 1925
Pencil on paper. 25.6 × 35.6 cm.
Signed and inscribed b.l: L. S. Lowry '25 St Annes
EXH: Stalybridge 1983 (15); Swansea 1985 (33)
LIT: Levy, 1976, Pl. 80; Salford Lowry Collection, 1977 (73), repr.
PROV: presented by Mr V. G. Funduklian, 1974

220. Old Houses, Flint 1925
Pencil on paper. 25.6 × 35.8 cm.
Signed b.l: L. S. Lowry 1925
EXH: Manchester 1959 (86); Nottingham 1967; Norwich 1970; Preston 1977 (7)
LIT: Levy, 1976, Pl. 84; Salford Lowry Collection, 1977 (75), repr.
PROV: purchased from Alex Reid & Lefevre Ltd., 1959

Lowry never travelled abroad but claimed to have visited all parts of the British Isles.

221. Rhyl Harbour 1925
Pencil on paper. 12.8 × 18.2 cm.
Signed b.l: LSL 25
Inscribed b.r: Rhyl
Inscribed on reverse: Ryhl (sic) Harbour '25
PROV: purchased from the artist's estate, 1981

See 37, 222.

222. Rhyl Harbour c.1925
Pencil on paper. 21.6 × 36.6 cm.
Unsigned
EXH: Sheffield 1979

216

218

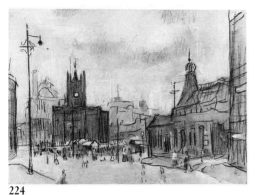

224

232

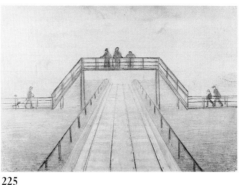

225

LIT: Levy, 1976, Pl. 82; Salford Lowry Collection, 1977 (81); (Leber and Sandling), 1983, repr.
PROV: presented by Mr V. G. Funduklian, 1974

See 37, 221.

223. The Bandstand *c*.1925
Pencil on paper. 27.2 × 36.7 cm.
Unsigned
EXH: Swansea 1985 (26)
PROV: purchased from the artist's estate, 1981

224. The Flat-iron Market *c*.1925
Charcoal, pencil and white chalk on grey paper. 28.3 × 38.3 cm.
Signed b.r: L. S. Lowry
EXH: Wakefield 1955 (45); Kendal 1964 (52); Norwich 1970; Accrington 1971 (30); Leigh 1972 (18); Royal Academy 1976 (64); Scottish Arts Council 1977/8 (9); Sheffield 1979
LIT: Levy, 1963, p. 13, Pl. 25; Salford Lowry Collection, 1977 (79), repr.
PROV: presented by the artist, 1951

The market was held on land adjacent to Sacred Trinity Church bordered by Chapel Street, Blackfriars Street and Gravel Lane. The triangular plot gave the market its name. The church still stands and the building on the right, formerly a police station, is now a workshop. The market closed in 1939.

225. Bridge with Figures over Colliery Railway *c*.1925
Pencil on paper. 37 × 55 cm.
Unsigned
EXH: Pendlebury 1964 (10); Swinton 1970 (42); Royal Academy 1976 (66)
LIT: Pendlebury Catalogue, 1964; Levy, 1976, Pl. 177; Salford Lowry Collection, 1977 (80)
PROV: presented by the artist, 1970

A view on Swinton Moss. The bridge has been demolished.

226. Ardwick Cemetery Entrance *c*.1925
Pencil on paper. 13.7 × 22.5 cm.
Unsigned
Inscribed b.r: Ardwick Cemetery Entrance
PROV: purchased from the artist's estate, 1981

227. Village Road *c*.1925
Pencil on paper. 8.9 × 12.4 cm.
Unsigned
PROV: purchased from the artist's estate, 1981

228. Georgian Terrace *c*.1925
Pencil on paper. 22.7 × 29.2 cm.
Unsigned
EXH: Swansea 1985 (29)
PROV: purchased from the artist's estate, 1981

229. Behind Leaf Square (1) 1926
Pencil on paper. 25 × 35.5 cm.
Signed b.r: L. S. Lowry 1926
EXH: Manchester 1959 (90); Altrincham 1960 (2); Preston 1977 (9)
LIT: Levy, 1976, Pl. 92; Salford Lowry Collection, 1977 (82)
PROV: purchased from the artist, 1952

See 208–10, 230, 231.

230. An Old Lamp: Behind Leaf Square (4) 1926
Pencil on paper. 35.3 × 26.1 cm.
Signed b.r: LSL 1926
Inscribed b.l: An Old Lamp
LIT: Levy, 1976, Pl. 91; Salford Lowry Collection, 1977 (83)
PROV: purchased from the artist, 1952

See 208–10, 229, 231.

231. The Tower 1926
Pencil on paper. 35.5 × 25.3 cm.
Signed b.r: LSL 1926
EXH: Manchester 1959 (89); Altrincham 1960 (16); Norwich 1970; Wigan 1976; Preston 1977 (6); Leicester 1982/3
LIT: Levy, 1976, Pl. 93; Salford Lowry Collection, 1977 (88)
PROV: purchased from Alex Reid & Lefevre Ltd., 1959

An accurate view of Leaf Square, Salford, to which the artist has added an imaginary black church tower. See 209, 210, 229, 230.

232. By Christ Church, Salford 1926
Pencil on paper. 35.5 × 25.3 cm.
Signed b.l: L. S. Lowry 1926
EXH: Manchester 1959 (91); Wigan 1976; Preston 1977 (14); Leicester 1982/3
LIT: Levy, 1963, Pl. 29, p. 19; Levy, 1976, Pl. 96; Salford Lowry Collection, 1977 (85)
PROV: presented by the artist, 1951

The church stood at the end of Acton Square almost directly opposite Salford Art Gallery. See 302, 303 for later drawings.

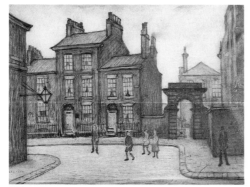

233

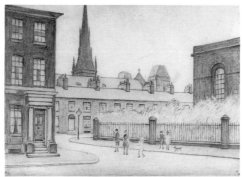

234

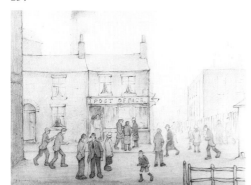

237

249

250

251

One of several drawings of the subject which was the home provided for the manager of Botany Bay Pit.

236. The Mid-day Special 1926
Pencil on paper. 38.4 × 27.8 cm.
Signed b.r: L. S. Lowry 1926
Inscribed b.l: The Mid-day Special
EXH: Altrincham 1960 (10); Nottingham 1967; Norwich 1970; Leigh 1972 (26); Manchester 1977; Sheffield 1979; Stockport 1980
LIT: Levy, 1976, Pl. 89; Salford Lowry Collection, 1977 (84), repr.
PROV: presented by the artist, 1959

Similar in composition to *The Result of the Race*, 1922, City Art Gallery, Manchester (67).

237. The Post Office 1926
Pencil on paper. 27 × 37.3 cm.
Signed b.l: L. S. Lowry 1926
EXH: Manchester 1959 (88); Nottingham 1967; Norwich 1970; Royal Academy 1976 (69); Sheffield 1979; Stockport 1980
LIT: Levy, 1976, Pl. 114; Salford Lowry Collection, 1977 (87)
PROV: purchased from Alex Reid & Lefevre Ltd., 1959

238. Peel Park, Salford 1927 (Pl. 11)
Oil on board. 35 × 50 cm.
Signed b.l: L.S. Lowry 1927
EXH: Salford 1951 (50); Wakefield 1955 (2); Harrogate 1960 (123); Pendlebury 1961 (17); Arts Council 1966/7 (18) Pl. 9; Nottingham 1967; Arts Council 1970; Liverpool 1973 (23) Pl. 17; Nottingham 1974 (2); Royal Academy 1976 (71); Sheffield 1979
LIT: Levy, 1961, p. 15, Pl. 5; Rothenstein, 1962, p. 84; Levy, 1975, Pl. 4; Salford Lowry Collection, 1977 (91); Levy, 1978, Pl. 4; Spalding, 1979, p. 8, Pl. 4; Rohde, 1979, p. xx
PROV: purchased from the Mid-day Studios, Manchester, 1951

A side view of the library entrance taken from the steps of the Peel Building and looking towards the present Maxwell Building of Salford University. The artist made several sketches for this painting. See 239, 240, 241.

233. By the County Court, Salford 1926
Pencil on paper. 24.6 × 34.9 cm.
Signed b.l: L. S. Lowry 1926
EXH: Pendlebury 1961 (13); Kendal 1964 (51); Nottingham 1967; Norwich 1970; Leigh 1972 (28); Preston 1977 (5); Sheffield 1979; Stockport 1980
LIT: Levy, 1976, Pl. 94; Andrews, 1977, p. 63; Salford Lowry Collection, 1977 (90); (Leber and Sandling), 1983, repr.
PROV: presented by the artist, 1951

The County Court, now used as a magistrates' court, stands at the junction of Upper Cleminson Street and Encombe Place. The view, of the rear of the building, is

taken from Wilton Place and is largely unchanged.

234. By St Philip's Church, Salford 1926
Pencil on paper. 25.2 × 35.3 cm.
Signed b.l: L. S. Lowry 1926
EXH: Salford 1953 (112); Norwich 1970; Liverpool 1973 (22)
LIT: Levy, 1976, Pl. 95; Salford Lowry Collection, 1977 (89)
PROV: purchased from the artist, 1952

One of the few Salford churches depicted by Lowry which still survive. The view is looking along Bank Place.

235. House on Botany, Clifton 1926 (Fig. 10)
Pencil on paper. 22 × 35.5 cm.
Signed b.r: L. S. Lowry 1926
EXH: Eccles 1961 (18); Pendlebury 1961 (14); Bury 1962 (6); Sheffield 1962 (131); Pendlebury 1964 (19) repr.; Pendlebury 1966 (12) repr.; Lytham St Annes 1967 (12); Swinton 1970 (49); Accrington 1971 (32) Pl. 5; Leigh 1972 (28) repr. on cover
LIT: Levy, 1976, Pl. 90; Salford Lowry Collection, 1977 (86)
PROV: purchased from the artist, 1961 (Swinton Collection)

239. Peel Park Sketch *c*.1927
Pencil on paper. 20 × 12 cm.
Unsigned
LIT: Levy, 1976, Pl. 100; Salford
 Lowry Collection, 1977 (94)
PROV: presented by the artist, 1957

This and the following two sketches are studies for painting *Peel Park, Salford*, 1927, Salford Art Gallery (238).

240. Peel Park Sketch *c*.1927
Pencil on paper. 20 × 12 cm.
Unsigned
LIT: Levy, 1976, Pl. 100; Salford
 Lowry Collection, 1977 (95)
PROV: presented by the artist, 1957

241. Peel Park Sketch *c*.1927
Pencil on paper. 20 × 12 cm.
Unsigned
LIT: Levy, 1976, Pl. 100; Salford
 Lowry Collection, 1977 (96)
PROV: presented by the artist, 1957

242. Peel Park Sketch *c*.1927
Pencil on paper. 19.4 × 11.5 cm.
Unsigned
LIT: Levy, 1976, Pl. 99; Salford
 Lowry Collection, 1977 (98)
PROV: presented by the artist, 1957

243. Peel Park Sketch *c*.1927
Pencil on paper. 11.3 × 19.7 cm.
Unsigned
LIT: Levy, 1976, Pl. 99; Salford
 Lowry Collection, 1977 (99)
PROV: presented by the artist, 1957

244. The Terrace, Peel Park
1927
Pencil on paper. 26 × 35.8 cm.
Signed b.r: L. S. Lowry 1927
Inscribed on reverse: Presented to me by L. S. Lowry on 30 May 1951 on occasion of my visit to Manchester. The scene is from the Terrace of the Salford Art Gallery, often painted by Lowry. Maurice Collis
EXH: Pendlebury 1961 (16); Arts
 Council 1966/7 (136);
 Nottingham 1967; Norwich
 1970; Royal Academy 1976 (77)
 repr.; Scottish Arts Council
 1977/8 (12)
LIT: Collis, 1951, p. 15; Levy,
 1963, Pl. 31, p. 15; Levy, 1976,
 Pl. 97; Salford Lowry
 Collection, 1977 (93), repr.
PROV: purchased from Alex Reid
 & Lefevre Ltd., 1960

The terrace was a formal feature at the rear of Salford Art Gallery. It survives but is very much altered.

Standing on the terrace, Lowry commented to Collis that: 'From the start I have been fond of this view and have put it in many paintings. You know that I never paint in this spot, but look for a long time, make drawings and think. Many early drawings were made from [here].'

245. St Simon's Church *c*.1927
(Fig. 47)
Pencil on paper. 10.2 × 10.8 cm.
Unsigned
PROV: purchased from the artist's
 estate, 1981

A preparatory sketch of the church on the reverse of an envelope. See 246, 247.

**246. St Simon's Church (A
 Street Scene – St Simon's
 Church)** 1927 (Fig. 48)
Pencil on paper. 38.4 × 29.3 cm.
Signed b.r: L. S. Lowry 1927
EXH: Pendlebury 1961 (18);
 Nottingham 1967; Norwich
 1970; Belfast 1971 (4);
 Liverpool 1973 (24);
 Nottingham 1974 (28) Pl. II;
 Sheffield 1979
LIT: Levy, 1963, pp. 15, 20, 24, Pl.
 32; Levy, 1976, p. 24, Pl. 98;
 Salford Lowry Collection, 1977
 (92), repr.
PROV: presented by the artist, 1951

St Simon's Church, Lower Broughton, Salford. Lowry's father seems to have taken little interest in his son's art, but he did recommend him to draw this view as 'a piece of particular dereliction in a thickly populated area.' The artist took his advice making the briefest of sketches, see 245. When Lowry returned to the scene a month later the church had been demolished. In 1928, he painted the same subject. See 247.

**247. A Street Scene – St
 Simon's Church** 1928 (Fig.
 49)
Oil on board. 43.8 × 38 cm.
Signed b.r: L. S. Lowry 1928
EXH: Salford 1951 (60);
 Manchester 1959 (18);
 Harrogate 1960 (124); Arts
 Council 1966/7 (22) Pl. 11;
 Nottingham 1967; Arts
 Council 1970; Belfast 1971 (6);
 Liverpool 1973 (25) Pl. 15;
 Nottingham 1974 (3) Pl. III

LIT: Collis, 1951, Pl. 5, p. 16;
 Levy, 1961, Pl. 6; Levy, 1975,
 Pl. 96; Levy, 1976, p. 24;
 Andrews, 1977, p. 69; Salford
 Lowry Collection, 1977 (102);
 Spalding, 1979, Pl. 30; Rohde,
 1979, pp. xxii, 124, 135; (Leber
 and Sandling), 1983, repr.
PROV: purchased from the Spring
 Exhibition of the Manchester
 Academy of Fine Arts, 1936

This was the first Lowry picture to be acquired by Salford Art Gallery and laid the foundation for the long association between the artist and the gallery. See 245, 246.

248. Bandstand, Peel Park
1928
Oil on board. 29.2 × 39.2 cm.
Signed b.l: L. S. Lowry 1928
EXH: Sheffield 1962 (13); Swinton
 1970 (19); Accrington 1971
 (35); Leigh 1972 (31);
 Liverpool 1973; Scottish Arts
 Council 1977/8 (14); Sheffield
 1980; Leigh 1986
LIT: Salford Lowry Collection,
 1977 (100); Spalding, 1979,
 p. 10, Pl. 3
PROV: Oliver Jelly, 1962; pur-
 chased from Tib Lane Gallery,
 1963 (Monks Hall Collection)

In a copy of the 1962 Sheffield catalogue, a member of staff of the Salford Art Gallery noted: 'Salford should have this'. Purchased for the Monks Hall Collection the following year, the painting became part of the Salford Collection eleven years later. See 202, 207, 439.

249. Ringley 1928
Pencil on paper. 26.4 × 38.5 cm.
Signed b.l: L. S. Lowry 1928
EXH: Eccles 1961 (15); Pendlebury
 1961 (19); Bury 1962 (13);
 Sheffield 1962 (135); Pendle-
 bury 1964 (21); Pendlebury
 1966 (1); Lytham St Annes
 1967 (1); Swinton 1970 (28);
 Accrington 1971 (36); Leigh
 1972 (32)
LIT: Levy, 1976, Pl. 103; Salford
 Lowry Collection, 1977 (101)
PROV: purchased from the artist,
 1961 (Swinton Collection)

The village lies in the Irwell Valley between Salford and Bolton.

250. View from Morton Moss
c.1928
Pencil on paper. 10.2 × 13 cm.
Signed b.r: LSL
EXH: Pendlebury 1966 (15);
 Lytham St Annes 1967 (15);
 Leigh 1972 (81)
LIT: Levy, 1976, Pl. 110; Salford
 Lowry Collection, 1977 (103)
PROV: purchased from the artist by
 Gerald Cotton, 1966; presen-
 ted, 1966 (Swinton Collection)

The view to the north from Morton Moss Farm. The church spire in the distance is probably that of Kearsley Church. The drawing was completed before Kearsley Power Station was opened, in 1929, as no cooling towers may be seen.

**251. Newtown Mill and Bowl-
 ing Green** *c*.1928
Pencil on paper. 24.6 × 35 cm.
Signed b.r: L. S. Lowry
EXH: Pendlebury 1964 (23);
 Lytham St Annes 1967 (18);
 Accrington 1971 (45); Leigh
 1972 (79)
LIT: Salford Lowry Collection,
 1977 (104)
PROV: purchased from the artist by
 Gerald Cotton, 1965; presen-
 ted, 1966 (Swinton Collection)

A Pendlebury scene familiar to Lowry. He commented: 'My sub-jects were all around me. In those days there were mills and collieries all around Pendlebury. The peo-ple who worked there were passing morning and night. All my ma-terial was on my doorstep.' The mill stands on the corner of Lees Street and Station Road, and part of the bowling green survives.

252. Oldfield Road Dwellings
1929
Pencil on paper. 41.2 × 43.8 cm.
Signed b.r. and on reverse: L. S.
Lowry 1929
EXH: Harrogate 1960 (113);
 Pendlebury 1961 (20); Arts
 Council 1966/7 (138); Norwich
 1970; Nottingham 1974 (29);
 Sheffield 1979
LIT: Levy, 1976, Pl. 107; Salford
 Lowry Collection, 1977 (105),
 repr. (Leber and Sandling),
 1983, repr.
PROV: presented by the artist, 1957

View of the back of workmen's flats which stood near the junction of Oldfield Road and Chapel Street. See 55, 56.

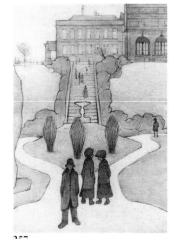

256

257

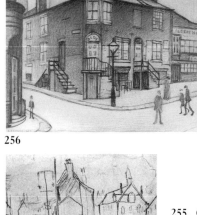

265

253. Clifton Moss Farm 1929
Pencil on paper. 17 × 12 cm.
Signed b.l: LSL 1929
LIT: Salford Lowry Collection,
 1977 (107)
PROV: purchased by the Friends of
 Salford Museums Association
 from an anonymous collector,
 and presented to the gallery,
 1976

Hilton's, or Manor Farm, lies off
Moss Colliery Road just over the
Kearsley border from Clifton.

254. Great Ancoats Street (pre-
 liminary sketch) *c*.1929
Pencil on paper. 11.3 × 19.7 cm.
Unsigned
LIT: Levy, 1976, Pl. 99; Salford
 Lowry Collection, 1977 (97)
PROV: presented by the artist, 1957

A preparatory sketch for the draw-
ing of the same title (256). See also
27, 71, 72, 73.

255. Coming from the Mill
1930 (Pl. 13)
Oil on canvas. 42 × 52 cm.
Signed b.l: L. S. Lowry 1930
EXH: Salford 1941; Salford 1951
 (5); Salford 1955 (63);
 Wakefield 1955 (3);
 Manchester 1959 (20);
 Altrincham 1960 (19); Kendal
 1964 (29); Nottingham 1967;
 Norwich 1970; Leigh 1972
 (34); Nottingham 1974 (4);
 Royal Academy 1976 (88) repr.;
 Hayward Gallery 1979/80
LIT: Levy, 1961, Pl. 7; Levy, 1963,
 p. 15; Levy, 1975, Pl. 119;
 Andrews, 1977, p. 63; Salford
 Lowry Collection, 1977 (108),
 repr.; Levy, 1978, Pl. 34;
 Spalding, 1979, p. 8, Pl. 7;
 (Leber and Sandling), 1983,
 repr.
PROV: purchased from the artist,
 1941

Based on a much earlier pastel
drawing (140) and showing a mark-
ed contrast in style. In a letter to
the gallery, Lowry wrote: 'It gives
me great pleasure that Salford
have bought [this] picture—for I
have always thought it was my
most characteristic mill scene.'
See 70, 426.

**256. Great Ancoats Street,
Manchester** 1930
Pencil on paper. 28 × 38.4 cm.
Signed b.l: L. S. Lowry 1930
EXH: Salford 1951 (6);
 Nottingham 1967; Norwich
 1970; Belfast 1971 (19);
 Nottingham 1974 (30);
 Leicester 1982/3
LIT: Levy, 1976, Pl. 115; Salford
 Lowry Collection, 1977 (112),
 repr.

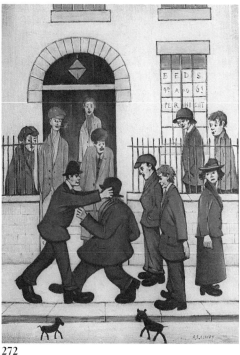

272

PROV: purchased from Greengate
 Hospital, 1951

In the spring of 1930, Lowry held
a one-man exhibition of twenty-
five drawings of Ancoats at
the Manchester University
Settlement, The Roundhouse,
Manchester. This drawing, made
from a sketch (254), was almost
certainly in the exhibition. See 27,
71, 72, 73.

257. The Steps, Peel Park 1930
Pencil on paper. 38.5 × 27 cm.
Signed b.l: L. S. Lowry 1930
EXH: Salford 1953 (113);
 Nottingham 1967; Norwich
 1970; Nottingham 1974 (32);
 Royal Academy 1976 (96);
 Sheffield 1979; Stockport 1980
LIT: Levy, 1963, pp. 11–12 Pl. 41;
 Levy, 1976, Pl. 117; Salford
 Lowry Collection, 1977 (114);
 (Leber and Sandling), 1983,
 repr.
PROV: purchased from the artist,
 1952

A view from the park looking up
the steps to the Museum and Art
Gallery. The drawing shows the
ornamental flower beds, which
survive, and Lark Hill Mansion,
which was demolished in the
1930s.

258. Farm on Wardley Moss
1930
Pencil on paper. 12.2 × 17.7 cm.
Signed b.l: L. S. Lowry 1930
EXH: Lytham St Annes 1967 (16);
 Leigh 1972 (37); Royal
 Academy 1976 (92) repr.
LIT: Levy, 1976, Pl. 111; Salford
 Lowry Collection, 1977 (113)
PROV: purchased from the artist by
 Gerald Cotton, 1965; presen-
 ted, 1966 (Swinton Collection)

Wardley Moss is a large area of
open farmland to the west of
Swinton. Despite the construction
of a motorway across the moss,
much of the scenery is unaltered.
The view shows Morton Moss
Farm which stood near Wardley
Grange.

**259. St Augustine's Church,
 Pendlebury** 1930 (Fig. 35)
Pencil on paper. 35.1 × 26 cm.
Signed b.r: L. S. Lowry 1930
EXH: Pendlebury 1961 (3);
 Pendlebury 1964 (29);
 Pendlebury 1973; Nottingham
 1974 (31); Sheffield 1979
LIT: Levy, 1976, Pl. 116;
 Clements, 1985, p. 19, repr.;
 Salford Lowry Collection, 1977
 (111); (Leber and Sandling),
 1983, repr.
PROV: purchased from the artist,
 1952

One of the finest churches designed by G. F. Bodley. The small memorial at the foot of the church records the loss of 178 lives in the Clifton Hall Colliery explosion of 1885.

260. Swinton Industrial Schools 1930
Pencil on paper. 27.3 × 36.4 cm.
Signed b.l: L. S. Lowry 1930
EXH: Eccles 1961 (17); Pendlebury 1961 (22); Bury 1962 (11); Sheffield 1962 (145); Pendlebury 1964 (13); Pendlebury 1966 (3); Lytham St Annes 1967 (3); Accrington 1971 (4); Leigh 1972 (39); Preston 1977 (16)
LIT: Levy, 1976, Pl. 112; Salford Lowry Collection, 1977 (110)
PROV: purchased from the artist, 1961 (Swinton Collection)

Founded in 1843, the schools provided moral and industrial training for homeless children. They were praised by Charles Dickens on a visit in 1850. The schools were closed in 1925 and demolished in 1933. The site is now occupied by Salford's Civic Centre.

261. The Gamekeeper's Cottage, Swinton Moss 1930
Pencil on paper. 25 × 37 cm.
Signed b.l: L. S. Lowry 1930
EXH: Eccles 1961 (13); Pendlebury 1961 (21); Bury 1962 (31); Sheffield 1962 (146); Pendlebury 1964 (4); Pendlebury 1966 (4); Lytham St Annes 1967 (4); Swinton 1970 (29); Leigh 1972 (38); Royal Academy 1976 (95)
LIT: Levy, 1976, Pl. 113; Salford Lowry Collection, 1977 (109)
PROV: purchased from the artist, 1961 (Swinton Collection)

Known locally for generations as 'Foxholes', the cottage stood close to Arden's Farm (110) and near to where the M62 motorway now crosses Manchester Road, Wardley.

262. Waiting for the Newspapers 1930
Pencil on paper. 24.1 × 24.3 cm.
Signed b.r: L. S. Lowry 1930
Inscribed in brown ink on reverse: Drawing by L. S. Lowry 1930 used by the artist in 1932 for his painting *Waiting for the Newspapers* in Maurice Collis' Collection. Maurice Collis

EXH: Eccles 1961 (4); Nottingham 1967; Norwich 1970; Belfast 1971 (7); Leigh 1972 (35); Liverpool 1973 (30); Sheffield 1979; Leicester 1982/3; Stalybridge 1983 (16) repr.; Swansea 1985 (5); Leigh 1986; Lancaster 1986
LIT: Levy, 1963, Pl. 37, pp. 12, 14; Levy, 1976, Pl. 109; Salford Lowry Collection, 1977 (115), repr.
PROV: purchased from Alex Reid & Lefevre Ltd., 1960

263. Town Square, Montrose 1930
Pencil on paper. 13.2 × 20.2 cm.
Signed b.r: LSL 1930
Inscribed on reverse:
Town Square Montrose
Montrose 1930
PROV: purchased from the artist's estate, 1981
On the reverse of letterheaded paper of Central Hotel, Montrose.

264. Rear of Property on Bolton Road, Pendlebury c.1930
26 × 36.2 cm.
RECTO: Pencil on paper
Signed b.r: L. S. Lowry
EXH: Pendlebury 1964 (25); Lytham St Annes 1967 (17); Leigh 1972 (82)
LIT: Salford Lowry Collection, 1977 (116)
The houses which stood near Slack Lane have since been demolished.
VERSO: *Discus Thrower* c.1908
Pencil
Unsigned
LIT: Salford Lowry Collection, 1977 (11)
PROV: purchased from the artist by Gerald Cotton, 1965; presented, 1966 (Swinton Collection)

265. In Clitheroe c.1930
25 × 17.6 cm.
RECTO: Pencil on paper
(*above*) *Street in Clitheroe*
Unsigned
Inscribed in blue ballpoint pen b.l: In Clitheroe
Inscribed below sketch: green dark Green door
(*below*) Sketches relating to *In Clitheroe*
Unsigned
Inscribed on gable end of building: dry stone white
Inscribed to right of chimney: brick

VERSO: Three Figures (scribbled over)
Pencil
Unsigned
PROV: purchased from the artist's estate, 1981

266. The Windmill, Amlwych c.1930
14.2 × 20.4 cm.
RECTO: Pencil on paper
(*above*) Windmill in Landscape
Unsigned
Inscribed below sketch: The Windmill Amlwych
(*below*) Windmill
Unsigned
Inscribed r.c: Amlwych
VERSO: Windmill in Landscape
Pencil
Unsigned
Inscribed t.c: much larger
EXH: Swansea 1985 (24)
PROV: purchased from the artist's estate, 1981

See 267.

267. Windmill at Amlwych c.1930
20.2 × 14 cm.
RECTO: Pencil on paper
(*above*) Windmill in Landscape
Unsigned
(*below*) Detail of Windmill
Unsigned
Inscribed right edge: etc.
VERSO: (*above* and *below*) Windmill in Landscape
Pencil
Unsigned
Inscribed in blue ballpoint pen t.l: sketches at the windmill at Amlwych
PROV: purchased from the artist's estate, 1981

268. Stately Home Sketches c.1930
37.5 × 27.7 cm.
RECTO: Pencil on paper
(*above*) Stately Home (scribbled out)
Unsigned
(*below*) Stately Home and Drive
Unsigned
VERSO: Façade
Pencil
Unsigned
Inscribed t.l: longer
Inscribed b.r: light green
PROV: purchased from the artist's estate, 1981

269. Pendlebury Scene 1931
(Fig. 5)
28.3 × 37.8 cm.
RECTO: Pencil on paper.
Signed b.r: L. S. Lowry 1931
EXH: Lytham St Annes 1967 (19); Leigh 1972 (40); Royal Academy 1976 (105); Stockport 1980
LIT: Levy, 1976, Pl. 118; Salford Lowry Collection, 1977 (117), repr. (Leber and Sandling), 1983, repr.

In one account describing his introduction to the industrial scene, Lowry commented that, in 1916, 'As I got to the top of the station steps, I saw the Acme Mill, a great dark-red block with the low streets of mill cottages running right up to it—and suddenly I knew what I had to paint.' This was a key view, portrayed by the artist many times. See 430.

VERSO: *Seated Figure (Woman in Indian Costume)* c.1917
Pencil
Signed t.l: L. S. Lowry
PROV: purchased from the artist by Gerald Cotton, 1965; presented, 1966 (Swinton Collection)

270. The Tree 1931
Pencil on postcard. 9 × 13.9 cm.
Signed b.l: LSL 1931
Inscribed on reverse: Pendlebury is this it! or have I found another one! Hope all is well. L. S. L. I saw it one mng when I was there for a few minutes. Feb. 22/31
PROV: purchased from Mrs E. Timperley, widow of Harold Timperley, 1977

Harold Timperley was the author of *A Cotswold Book* which L. S. Lowry illustrated.

A painting, *The Tree*, dated 1931, is of the same scene. It was exhibited and illustrated in an exhibition at the Crane Kalman Gallery, London 1969.

271. A Northern Street 1935
Pencil on paper. 11.2 × 12.8 cm.
Signed b.r: LSL 1935
EXH: Swansea 1985 (20)
PROV: purchased from the artist's estate, 1981

On the reverse of fragment of typed letter.

272. A Fight c.1935
Oil on canvas. 53.2 × 39.5 cm.
Signed b.r: L. S. Lowry
EXH: possibly Salford 1941 (9);

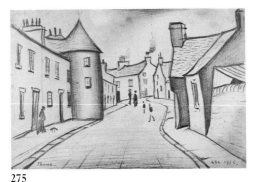

275

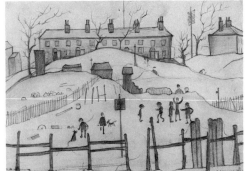

277

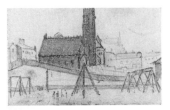

283

289

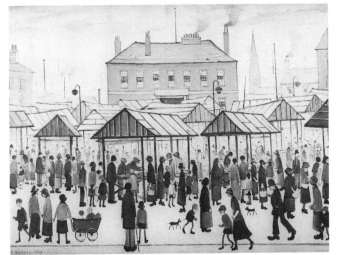

279

Royal Academy 1959; Harrogate 1960 (128); Nottingham 1967; Swinton 1970 (18); Nottingham 1974 (6); Royal Academy 1976 (109) repr.; Manchester, Cornerhouse 1985
LIT: Levy, 1961, p. 8, Pl. 8; Levy, 1975, p. 23, Pl. 15; Andrews, 1977, pp. 25, 52, 64, 74; Martin, 1977, p. 20; Ingham, 1977, Pl. 4; Salford Lowry Collection, 1977 (118), repr.; Levy, 1978, Pl. 15; McLean, 1978, Pl. 5; Spalding, 1979, p. 8, Pl. 24; Woods, 1981, p. 11; Cornerhouse Catalogue, 1985, pp. 20, 67, repr.; Great Artists, 1986, p. 2286, repr.
PROV: purchased from Alex Reid & Lefevre Ltd., 1959

Lowry witnessed this scene outside a lodging house in Manchester. A drawing (77), dated 1937, shows only minor differences.

273. Steps and Lamp-posts *c.*1935
Pencil on paper. 27.1 × 18.5 cm.

Unsigned
PROV: purchased from the artist's estate, 1981

274. A Landmark 1936 (Pl. 17)
Oil on canvas. 43.4 × 53.6 cm.
Signed b.l: L. S. Lowry 1936
EXH: possibly Salford 1941 (45); Wakefield 1955 (5); Scottish Arts Council 1977/8 (20); Sheffield 1979
LIT: Levy, 1975, p. 21, Pl. 47; Salford Lowry Collection, 1977 (119), repr.; Rohde, 1979, p. 136; (Leber and Sandling), 1983, repr.; Clements, 1985, p. 18
PROV: purchased from Alex Reid & Lefevre Ltd., 1959

Landscape was an important and recurring theme in Lowry's work but the peace and tranquillity of the early studies (141, 198) changed in the 1930s. Possibly as a result of the distress he felt at his mother's illness, he began to paint the so-called 'lonely landscapes' which are mirrors of the artist as much as expressions of desolate countryside. See 87, 293, 295, 296.

275. Shore Street, Thurso 1936
Pencil on paper. 18.2 × 27.7 cm.
Signed b.r: LSL 1936
Inscribed b.l: Thurso
Inscribed on reverse: Shore Street Thurso
EXH: probably Manchester 1959 (103)
LIT: (Leber and Sandling), 1983, repr.
PROV: purchased from the artist's estate, 1981

276. The Lake 1937 (Pl. 18)
Oil on canvas. 43.4 × 53.5 cm.
Signed b.l: L. S. Lowry 1937
EXH: probably Lefevre Gallery 1939 (26); Salford 1948 (53); Belfast 1951; Salford 1951 (23); Manchester 1959 (29); Altrincham 1960 (21); Bury 1962 (26); Sheffield 1962 (24); Nottingham 1967; Norwich 1970; Liverpool 1973 (38)
LIT: Salford Lowry Collection, 1977 (120), repr.; Levy, 1978, Pl. 44; Rohde, 1979, p. 136; (Leber and Sandling), 1983, repr.; Clements, 1985, p. 21, repr.
PROV: purchased from Alex Reid & Lefevre Ltd., 1939

A classic example of the artist's technique of creating composite 'dreamscapes' which symbolized the industrial north of the 1930s. *River Irwell at the Adelphi* (201) appears to be a key image relating to this painting. See also 20, 92.

277. Houses in Broughton 1937
25.3 × 35.6 cm.
RECTO: Pencil on paper
Signed b.r: L. S. Lowry 1937

EXH: Manchester 1959 (104); Altrincham 1960 (8); Harrogate 1960 (114); Nottingham 1967; Norwich 1970; Belfast 1971 (8); Leigh 1972 (42); Sheffield 1979; Leicester 1982/3
LIT: Levy, 1963, Pl. 45, p. 20; Levy, 1976, Pl. 122; Salford Lowry Collection, 1977 (121), repr.
VERSO: *Street Scene* 1924
Pencil
Signed b.r: LSL 1924
PROV: purchased from Alex Reid & Lefevre Ltd., 1959

278. Head of a Man 1938 (p. 6)
Oil on canvas. 50.7 × 41 cm.
Signed b.l: L. S. Lowry 1938
EXH: possibly Society of Modern Painters, Salford 1942 (103); Wakefield 1955 (9); Manchester 1959 (32); Harrogate 1960 (125); Arts Council 1966/7 (30) Pl. 27; Nottingham 1967; Norwich 1970; Nottingham 1974 (7); Royal Academy 1976 (122)
LIT: Levy, 1961, Pl. 9, p. 10; Levy, 1975, Pl. 5 pp. 16–17; Andrews, 1977, p. 74; Ingham, 1977, repr. (inside front cover); Salford Lowry Collection, 1977 (122), repr.; Levy, 1978, Pl. 5; McLean, 1978, p. 5, repr., p. 13; Rohde, 1979, pp. xxiv, 136, Pl. VIII; Woods, 1981, pp. 15–17, repr.; Great Artists, 1986, p. 2287, repr.
PROV: purchased from Alex Reid & Lefevre Ltd., 1959

Also called *Portrait* and *Head of a Man With Red Eyes*. One of the finest of Lowry's imaginary por-

traits completed shortly before the death of his mother. The artist confessed that it was really an emotional self-portrait. 'It was just a way of letting off steam, I suppose', he remarked to Mervyn Levy.

279. Market Scene, Northern Town 1939
Oil on canvas. 45.7 × 61.1 cm.
Signed b.l: L. S. Lowry 1939
EXH: Salford 1941; Belfast 1951; Salford 1951 (25); Manchester 1959 (33); Altrincham 1960 (25); Harrogate 1960 (126); Belfast 1971 (11); Leigh 1972 (43); Liverpool 1973 (39)
LIT: Levy, 1975, Pl. 58; Salford Lowry Collection, 1977 (123), repr.; Spalding, 1979, pp. 9–10, Pl. 28
PROV: presented by the artist, 1942

Also exhibited as *Market Place, Northern Town* and *Market Street, Northern Town*, this is a composite painting based on Pendlebury Market, close to the artist's former home in Station Road.

280. The Bedroom, Pendlebury 1940 (Pl. 19)
Oil on canvas. 35.8 × 51.2 cm.
Signed b.r: L. S. Lowry 1940
EXH: Liverpool 1973 (40) Pl. 3; Sheffield 1979
LIT: Levy, 1975, Pl. 6; Andrews, 1977, p. 81; Salford Lowry Collection, 1977 (124), repr.; Levy, 1978, Pl. 6; Spalding, 1979, Pl. 23; (Leber and Sandling), 1983, repr.
PROV: bequeathed by the artist, 1976

Entitled from the artist's death until recently *The Artist's Bedroom, Pendlebury*. New evidence casts considerable doubt on this title and suggests that the painting portrays the bedroom of Elizabeth Lowry, the artist's mother. Painted shortly after her death, the picture may represent a final tribute.

281. Rivington Pike c.1940
Pencil on paper. 11.9 × 20.1 cm.
Signed b.r: LSL
Inscribed on reverse: Rivington Pike
PROV: purchased from the artist's estate, 1981

A popular place for walkers and sightseers, located to the north of Bolton.

282. The Meeting c.1940
Pencil on paper. 22.4 × 20.7 cm.
Signed (twice) b.r: LSL
PROV: purchased from the artist's estate, 1981

283. Playground c.1940
9 × 14 cm.
RECTO: Pencil on postcard
Unsigned
EXH: Swansea 1985 (21)
VERSO: Pencil
Unsigned
PROV: purchased from the artist's estate, 1981

Studies for *Britain at Play* (35).

284. Blitzed Site 1942 (Pl. 22)
Oil on canvas. 39.2 × 49.4 cm.
Signed b.r: L. S. Lowry 1942
EXH: Altrincham 1960 (18); Eccles 1961 (3); Nottingham 1967; Liverpool 1973 (42)
LIT: Levy, 1975, Pl. 104; Andrews, 1977, p. 82; Salford Lowry Collection, 1977 (125)
PROV: purchased from Alex Reid & Lefevre Ltd., 1959

One of the artist's rare interpretations of the wartime scene. Working as a fire-watcher in Manchester, Lowry recalled that he was 'first down in the morning to sketch the blitzed buildings before the smoke and grime had cleared.'

285. Blitz, Piccadilly, Manchester c.1942 (Fig. 25)
25.5 × 35.5 cm.
RECTO: Pencil on paper
Unsigned
Formerly titled by the Lefevre Gallery *Roofs and Chimneys*. The same scene is portrayed in a painting. The view is of bomb damage in the Manchester blitz of late 1941, probably as surveyed from the roof of Rylands departmental store (now Debenhams).
VERSO: *Seated Child*
Pencil
Unsigned
PROV: purchased from the artist's estate, 1981

286. Manchester Blitz (St Augustine's Church, Hulme) 1943
Pen and black ink, and pencil on paper. 15.7 × 20.7 cm.
Unsigned
Inscribed on reverse:
Manchester blitz L S Lowry 1943 – Hulme

PROV: purchased from the artist's estate, 1981

From 1942 to 1945 Lowry was an Official War Artist, commissioned by the War Artists' Advisory Committee. He produced very few works and the committee became rather exasperated with him. The correspondence between the artist and the committee (in the archives of the Imperial War Museum) includes a letter from Lowry requesting an authorization to purchase canvas, which was then in short supply. The request was duly granted.

This drawing is a sketch for the painting *St Augustine's Church, Manchester*, 1945 (80).

287. An Old Farm 1943
Oil on panel. 28.5 × 37.9 cm.
Signed b.l: L. S. Lowry 1943
EXH: Liverpool 1973 (45); Nottingham 1974 (9); Sheffield 1979
LIT: Salford Lowry Collection, 1977 (126)
PROV: purchased from Alex Reid & Lefevre Ltd., 1959

288. Level-crossing 1946 (Fig. 14)
Oil on canvas. 46.1 × 56.1 cm.
Signed b.l: L. S. Lowry 1946
EXH: Altrincham 1960 (23); Eccles 1961 (16); Swinton 1970 (13); Liverpool 1973 (48); Sheffield 1979; Nottingham 1985
LIT: Levy, 1975, Pl. 113; Salford Lowry Collection, 1977 (127), repr.
PROV: purchased from Alex Reid & Lefevre Ltd., 1959

Lowry completed several such paintings and drawings after visits to Burton-on-Trent. See 24.

289. Steam Traction Engine, Glasgow 1946
12.8 × 17.7 cm.
RECTO: Pencil on paper
Signed b.l: LSL
Inscribed and dated b.r: Glasgow 1946
EXH: Stalybridge 1983 (17); Swansea 1985 (32)
VERSO: *Cranes* c.1946
Pencil
Unsigned
PROV: purchased from the artist's estate, 1981

290. Dean's Mill, Swinton c.1946
Pencil on paper. 27.5 × 37.5 cm.
Signed b.l: L. S. Lowry
EXH: Eccles 1961 (5 or 14); Pendlebury 1961 (28); Bury 1962 (10); Sheffield 1962 (154); Pendlebury 1964 (14 or 15); Pendlebury 1966 (13); Lytham St Annes 1967 (13); Leigh 1972 (47)
LIT: Levy, 1976, Pl. 155; Salford Lowry Collection, 1977 (128)
PROV: purchased from the artist, 1961 (Swinton Collection)

Opened in 1856, Dean's Mill was operated by Simpson and Godlee Ltd. who commissioned several paintings of it from Lowry in 1946. The mill, on Dean's Road, Swinton, was closed in 1973.

291. The Cripples 1949 (Fig. 19)
Oil on canvas. 76.3 × 101.8 cm.
Signed b.l: L. S. Lowry 1949
EXH: Lefevre Gallery 1951 (45); Manchester Academy of Fine Arts 1955 (136); Harrogate 1960 (127); Kendal 1964 (33); Arts Council 1966/7 (59) Pl. 20; Nottingham 1967; Royal Academy 1976 (176) repr.; Tokyo 1986 (p. 118), repr.
LIT: Collis, 1951, p. 21; Levy, 1961, pp. 8, 14, Pl. 13; Levy, 1963, p. 22; Levy, 1975, pp. 16, 26, Pl. 74; Phaidon, 1975, p. 225; Levy, 1976, p. 25; Andrews, 1977, pp. 90–1; Salford Lowry Collection, 1977 (129), repr.; Levy, 1978, Pl. 41; Spalding, 1979, p. 10; Rohde, 1979, p. xxiii, Pl. XXII (top); Woods, 1981, pp. 17, 18, repr., p. 20; (Leber and Sandling), 1983, repr.; Clements, 1985, p. 32, repr.; Great Artists, 1986, pp. 2280–1
PROV: purchased from Alex Reid & Lefevre Ltd., 1959

Cripples Lowry knew by sight in the Manchester area. Whilst he spoke of cripples and down-and-outs as 'real people, sad people' he painted them without sentiment. In a letter to David Carr, dated 13 September 1948, he wrote: '"The Cripples" picture is progressing —I have operated on one of the gentlemen in the far distance and given him a wooden leg—... I still laugh heartily at the hook on the arm of the gentleman . . . that suggestion of yours was a masterstroke.' *In a Park* (89) is a later reworking of the theme.

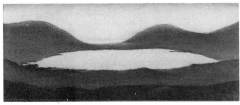

295

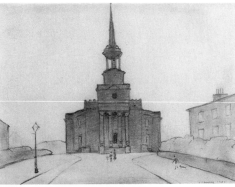

303

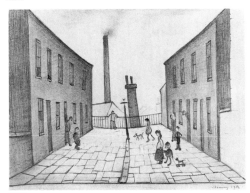

307

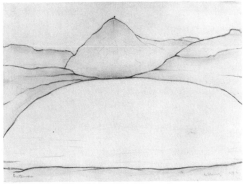

299

309

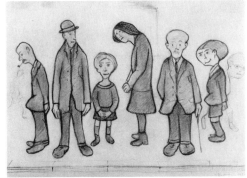

311

292. Bennett Street Sunday School *c.*1949
20.8 × 10.5 cm.
RECTO: Pencil on paper
(*above*) Unsigned
Inscribed in blue ballpoint pen b.c: Bennett Street Sunday School
Inscribed on building: Lighter
(*below*) Unsigned
Inscribed below sketch and upside down: Benne[]
[] Sunday School
VERSO: Pencil
Unsigned
Inscribed t.c: []tt Stree[]
The bottom of the page was originally folded down and the two inscriptions joined to read: Bennett Street Sunday School

PROV: purchased from the artist's estate, 1981

Elizabeth Lowry attended the school for many years and played the organ in one of the adult classes. Lowry accompanied his mother for four years from the age of seven.

293. House on the Moor 1950 (Pl. 26)
Oil on canvas. 49 × 59.5 cm.
Signed b.r: L. S. Lowry 1950
EXH: Wakefield 1955 (23); Royal Academy 1956 (490); Harrogate 1960 (129); Sheffield

1962 (56); Kendal 1964 (31); Arts Council 1966/7 (64); Nottingham 1967; Crane Kalman Gallery 1968; Norwich 1970; Royal Academy 1976 (186) repr.; Scottish Arts Council 1977/8 (40)
LIT: Levy, 1961, p. 13, Pl. 16; Levy, 1975, p. 21, Pl. 3; Andrews, 1977, p. 89; Salford Lowry Collection, 1977 (130); Levy, 1978, Pl. 3
PROV: purchased from Alex Reid & Lefevre Ltd., 1959

Based on a house on the Derbyshire moors. Lowry told Crane Kalman that this picture epitomized the mood of his 'lonely landscapes'. See 87, 274, 295, 296.

294. Lincoln Cathedral *c.*1950
17.6 × 24.5 cm.
RECTO: Pencil on paper
Unsigned
Inscribed b.r: Lincoln
Inscribed on drawing: some red on here [and] green he[re]
LIT: (Leber and Sandling), 1983, repr.
VERSO: *An Urban Landscape*
Pencil
Unsigned
Inscribed b.c: small setts

PROV: purchased from the artist's estate, 1981

The artist visited Lincoln on several occasions. He spent a

few days there with Clifford Openshaw, a colleague from the Pall Mall Property Co., during the Second World War. He returned in the late 1940s and produced an oil painting.

295. The Lake 1951
Oil on hardboard. 19.1 × 47.3 cm.
Signed b.r: L. S. Lowry 1951
EXH: Norwich 1970; Liverpool 1973 (54); Scottish Arts Council 1977/8 (43)
LIT: Salford Lowry Collection, 1977 (131)
PROV: purchased from Alex Reid & Lefevre Ltd., 1959

Probably a Cumbrian scene. See 87, 296.

296. Landscape in Cumberland 1951
Oil on panel. 15.9 × 58.7 cm.
Signed b.r: L. S. Lowry 1951
EXH: Altrincham 1960 (22); Bury 1962 (8); Kendal 1964 (32); Norwich 1970; Liverpool 1973 (53)
LIT: Salford Lowry Collection, 1977 (132), repr.
PROV: purchased from Alex Reid & Lefevre Ltd., 1959

Lowry was a friend and patron of Sheila Fell and stayed with her and her family regularly. They often sketched together and she recalled: 'Once . . . I looked at his drawing at the end of the day; it was of an industrial landscape

which he had done whilst sitting facing Skiddaw.' See 87, 295.

297. Seascape 1952
Oil on canvas. 39.5 × 49.3 cm.
Signed b.r: L. S. Lowry 1952
EXH: Salford 1954 (43); Liverpool 1973 (55); Nottingham 1974 (12); Sheffield 1979
LIT: Salford Lowry Collection, 1977 (133); Andrews, 1977, pp. 89–90; Rohde, 1979, p. 231
PROV: purchased from the artist at the fourth 'Lancashire Scene' Exhibition, Salford Art Gallery, 1954

On 2 December 1954, the *Manchester Guardian* produced a particularly apt headline: 'Not a pebble on the beach, nor a cloud in the sky. But a storm breaks over Seascape.' Purchased for 54 guineas, the painting was greeted with a hostile reception by some councillors and many visitors to the gallery. Lowry was drawn into the controversy and commented, in the *Manchester Evening Chronicle* of 3 December 1954, 'I never expected the picture to be very popular. It took me 18 months to paint and I think it is one of the best things I've done.' The argument rumbled on for several months before it finally petered out. Lowry made light of the fuss, but it did little to allay his suspicions about galleries and civic representatives. See 14, 43, 358.

298. The Funeral Party 1953 (Pl. 31)
Oil on canvas. 76.1 × 102 cm.
Signed b.r: L. S. Lowry 1953
EXH: Royal Academy 1956; Manchester Academy of Fine Arts 1957; Altrincham 1960 (20); Harrogate 1960 (130); Nottingham 1967; Norwich 1970; Liverpool 1973 (58); Sheffield 1979
LIT: Levy, 1975, Pl. 54; Andrews, 1977, p. 59; Salford Lowry Collection, 1977 (134), repr.
PROV: purchased from Alex Reid & Lefevre Ltd., 1959

Lowry was a keen observer of human nature and he often saw humour in people's odd behaviour. He used to relish explaining that the man on the far right of this picture is being treated as an outcast for coming to the funeral in boots and a red tie. The painting was described in the *News*

Chronicle of 26 January 1957 as: 'Like asking for a drink of water and having it thrown in your face. . . . A painting with all the love and compassion drained away . . .'

299. Tin Mine near Gurnards Head 1955
36.6 × 26.7 cm.
RECTO: Pencil on paper
Signed b.r: L. S. Lowry 1955
VERSO: Sketch of a Wall
Pencil
Unsigned
Inscribed: Tin Mine near Gurnards Head
PROV: purchased from the artist's estate, 1981

One of a number of Cornish subjects drawn by the artist in 1955.

300. 12 Pins, Cumbria c.1955
Pencil on paper. 25.2 × 34.7 cm.
Signed and inscribed b.l: L. S. Lowry 12 pins
Inscribed b.r: 12 pins
EXH: Stalybridge 1983 (23); Swansea 1985 (14)
PROV: purchased from the artist's estate, 1981

301. An Artist c.1955
Pencil on paper. 22.2 × 20.5 cm.
Unsigned
Inscribed b.r: An artist
LIT: Rohde, 1979, chapter heading, p. 35
PROV: purchased from the artist's estate, 1981

A drawing, probably of the same artist, dated 1955 and located in Cornwall was exhibited at the Lefevre Gallery in 1976 (38). Of artists in general, Lowry commented: 'The longer the beard, the shorter the art.'

302. Christ Church, Salford (1) 1956
Pencil on paper. 33 × 23.7 cm.
Signed b.r: L. S. Lowry 1956
EXH: Altrincham 1960 (4); Pendlebury 1961 (31); Wigan 1976; Preston 1977 (8); Stalybridge 1983 (20); Swansea 1985 (16); Leigh 1986; Lancaster 1986
LIT: Levy, 1976, Pl. 162; Salford Lowry Collection, 1977 (136)
PROV: purchased from the artist, 1956

View of the church looking up Acton Square from the Crescent. This drawing, together with 303, was completed from sketches

made on the same day and Lowry expressed a preference for this version. The church was demolished in 1958. See 232.

303. Christ Church, Salford (2) 1956
Pencil on paper. 24.3 × 33.6 cm.
Signed b.r: L. S. Lowry 1956
LIT: Levy, 1963, Pl. 53; Levy, 1976, Pl. 161; Salford Lowry Collection, 1977 (137)
PROV: presented by the artist, 1957

See 232, 302.

304. St Stephen's Church, Salford (2) 1956
Pencil on paper. 24.3 × 35.2 cm.
Signed b.r: L. S. Lowry 1956
EXH: Pendlebury 1961 (32); 'Lancashire South of the Sands' 1987 (26)
LIT: Levy, 1976, Pl. 164; Salford Lowry Collection, 1977 (138)
PROV: presented by the artist, 1959

In the spring of 1956, Lowry was asked by the gallery to record some of the Trinity and St Matthias's areas of Salford before they were demolished. See 305–307, 319.

305. Chapel, St Stephen's Street, Salford 1956
Pencil on paper. 24.3 × 33.9 cm.
Signed b.r: L. S. Lowry 1956
EXH: Stalybridge 1983 (18); Swansea 1985 (13); Leigh 1986; Lancaster 1986
LIT: Levy, 1976, Pl. 160; Salford Lowry Collection, 1977 (139)
PROV: presented by the artist, 1957

306. North James Henry Street, Salford 1956
Pencil on paper. 24.4 × 33.7 cm.
Signed b.r: L. S. Lowry 1956
EXH: Eccles 1961 (6); Norwich 1970; Liverpool 1973 (60); Wigan 1976; Preston 1977 (18); Stockport 1980; Stalybridge 1983 (19) repr.; Swansea 1985 (15); Leigh 1986; Lancaster 1986
LIT: Levy, 1976, Pl. 166; Salford Lowry Collection, 1977 (140)
PROV: purchased from the artist, 1957

307. Francis Terrace, Salford 1956
Pencil on paper. 25.3 × 34.9 cm.
Signed b.r: L. S. Lowry 1956
EXH: Harrogate 1960 (115); Kendal 1964 (53); Arts Council 1966/7 (151); Nottingham 1967; Norwich 1970; Royal

Academy 1976 (225)
LIT: Levy, 1963, Pl. 55; Levy, 1976, Pl. 165; Salford Lowry Collection, 1977 (141), repr.
PROV: purchased from the artist, 1957

A painting of the same subject was exhibited at Salford in 1957 and subsequently purchased by Newport Museum and Art Gallery (94).

308. Glencoe 1956
Pencil on paper. 21.8 × 28 cm.
Signed b.r: L. S. Lowry 1956
Inscribed b.l: Glencoe
Signed and inscribed on reverse: Glencoe L. S. Lowry 1956
PROV: purchased from the artist's estate, 1981

There is a painting of this subject in the collection of J. M. Maitland.

309. Buttermere 1956
Pencil on paper. 26.5 × 36.8 cm.
Signed b.r: L. S. Lowry 1956
Inscribed b.l: Buttermere
Signed and inscribed on reverse: L. S. Lowry Buttermere 1 September 1956
PROV: purchased from the artist's estate, 1981

Drawn on a visit to Sheila Fell's family in Cumbria.

310. The Pier, Berwick on Tweed 1956
Pencil on paper. 21.3 × 27.8 cm.
Signed b.r: L. S. Lowry 1956
Inscribed b.l: The Pier Berwick on Tweed
PROV: purchased from the artist's estate, 1981

311. Family Group 1956
Pencil on paper. 25.5 × 35.5 cm.
Signed b.r: L. S. Lowry 1956
EXH: Manchester 1959 (113); Altrincham 1960 (6); Norwich 1970; Leigh 1972 (55); Liverpool 1973 (61); Sheffield 1979; Stockport 1980
LIT: Levy, 1976, Pl. 170; Salford Lowry Collection, 1977 (135)
PROV: purchased from Alex Reid & Lefevre Ltd., 1959

312. The Cemetery 1956
Pencil on paper. 34.5 × 25.2 cm.
Signed b.r: L. S. Lowry 1956
PROV: purchased from the artist's estate, 1981

The artist made a number of drawings and paintings of cemeteries. See 226.

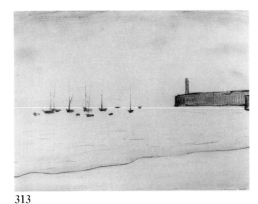

313

320

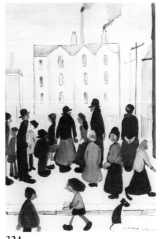

326

331

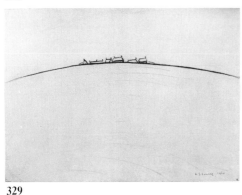

329

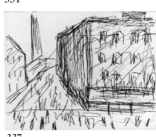

337

324

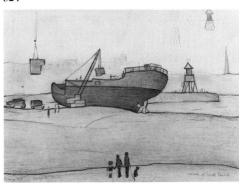

338

313. Boats 1956
Pencil on paper. 24 × 33.6 cm.
Signed b.r: L. S. Lowry 1956
EXH: Royal Academy 1976 (224);
Preston 1977 (12); Sheffield
1979; Swansea 1980
LIT: Levy, 1976, Pl. 169; Salford
Lowry Collection, 1977 (142)
PROV: presented by Mr V. G.
Funduklian, 1974

314. The Estuary 1956–9 (Pl. 33)
Watercolour on paper. 24 ×
34.2 cm.
Signed and inscribed b.l: L. S.
Lowry 1956. Finished 1959
EXH: Scottish Arts Council 1977/8
(52); Sheffield 1979; Staly-
bridge 1983 (21); Swansea 1985
(10)
LIT: Salford Lowry Collection,
1977 (143)
PROV: purchased from the artist,
1959

Lowry recalled that he had com-
pleted 'no more than a dozen'
watercolours as it was a medium
which he did not find to his liking.
See 81, 323, 324, 325.

315. Great Harwood c.1956
Pencil on paper. 10.2 × 13.1 cm.
Signed r. of c: LSL
Inscribed below sketch: Gt.
Harwood
PROV: purchased from the artist's
estate, 1981

On reverse of a tailor's letter-
headed paper, dated 18 May 1956.

316. Portrait of Ann 1957
(Pl. 34)
Oil on board. 38.6 × 33.3 cm.
Signed b.r: L. S. Lowry 1957
EXH: Nottingham 1967; Norwich
1970; Sheffield 1979; Whit-
worth Art Gallery 1986 (pp. 35,
37) repr.
LIT: Levy, 1975, p. 16, Pl. 52;
Salford Lowry Collection, 1977
(146), repr.; Levy, 1978, Pl. 43;
Rohde, 1979, pp. 180–6, Pl.
XV; Woods, 1981, p. 15, Pl. 15;
Sieja, 1983, p. 87, repr.; Great
Artists, 1986, p. 2281, repr.
PROV: presented by the artist, 1960

'Ann' was an extremely important
image to Lowry and her portrait
appears in numerous drawings
and paintings. Her identity has
remained secret, for Lowry gave
several accounts none of which
could be authenticated. The sub-
ject is explored in detail in Rohde,
1979.

317. Man Lying on a Wall 1957
(Fig. 18)
Oil on canvas. 40.7 × 50.9 cm.
Signed b.r: L. S. Lowry 1957
EXH: Manchester 1959 (66);
Altrincham 1960 (24);
Harrogate 1960 (131); Bury
1962 (32); Sheffield 1962 (75);
Arts Council 1966/7 (80) Pl. 24;
Nottingham 1967; Nottingham
1974 (14) Pl. VIII; Sheffield
1979
LIT: Levy, 1961, Pl. 18; Levy,
1975, Pl. 71, p. 19; Salford
Lowry Collection, 1977 (147),
repr.; Rohde, 1979, Pl. XXIII;
Spalding, 1979, p. 12, Pl. 39;
(Leber and Sandling), 1983,
repr.; Abse, 1986, p. 127, repr.;
Great Artists, 1986, p. 2277,
repr.
PROV: purchased from Alex Reid
& Lefevre Ltd., 1959

In 1959, Lowry commented that:
'People . . . refuse to believe me
when I tell them I saw a man
dressed just like that, doing just
that, from the top of a bus at
Haslingden [near Manchester]. It
was the umbrella propped against
the wall which caught my eye and

prompted the picture. . . . The
chap was well-dressed, obviously
enjoying the smoke and his rest. I
couldn't resist doing him as a
subject.' Lowry's approval led
him to put his own initials on the
man's briefcase.

318. Richmond Hill 1957
Pencil on paper. 34.6 × 24.4 cm.
Signed and inscribed below draw-
ing: L. S. Lowry 1957 From an
old sketch 1924
EXH: Stockport 1980; Swansea
1985 (30)
LIT: Levy, 1976, Pl. 180; Salford
Lowry Collection, 1977 (145)
PROV: presented by the artist, 1957

View down Richmond Hill,
Salford, looking towards
Blackfriars Road with St
Matthias's Church on left.

**319. St Stephen's Church,
Salford** (1) 1957
Pencil on paper. 35 × 24.5 cm.
Signed b.l: L. S. Lowry 1957
EXH: Arts Council 1966/7 (152);
Nottingham 1967; Wigan
1976; Preston 1977 (11)

LIT: Levy, 1963, Pl. 56, p. 20; Levy, 1976, Pl. 163; Salford Lowry Collection, 1977 (144)

PROV: presented by the artist, 1957

By 1956 the railings were only part way round the churchyard. View of Church looking towards Chapel Street. See 304.

320. Church in Hulme c.1957

11 × 15.7 cm.

RECTO: Pencil on paper

Unsigned

VERSO: Central Tower, Church in Hulme

Pencil

Unsigned

Inscribed below: Church in Hulme

PROV: purchased from the artist's estate, 1981

On Royal Academy Summer Exhibition invitation, 1957.

321. The Street 1958

Pencil on paper. 25 × 34.5 cm.

Signed b.r: L. S. Lowry 1958

LIT: Levy, 1976, Pl. 181

PROV: purchased from the artist by Pendleton High School Parent Teacher Association; deposited with Salford Art Gallery, 1976

322. A Tanker c.1958

12.7 × 20.4 cm.

RECTO: Pencil on paper

Signed b.r: LSL

EXH: Stalybridge 1983 (28)

VERSO: Bow of Tanker

Pencil

Unsigned

Inscribed b.l: Liverpool

PROV: purchased from the artist's estate, 1981

The verso is a piece of City of Salford Pendleton High School letterhead paper with a list of paintings in the Salford Collection—*The Cripples*, *Funeral Party*, *Self-Portrait*, etc.

323. Going to Work 1959

Watercolour on paper. 27 × 38.5 cm.

Signed b.r: L. S. Lowry 1959

EXH: Altrincham 1960 (17); Harrogate 1960 (117); Pendlebury 1961 (33); Norwich 1970; Scottish Arts Council 1977/8 (51)

LIT: Levy, 1975, Pl. 117; Salford Lowry Collection, 1977 (149); Levy, 1978, Pl. 36

PROV: purchased from the artist, 1959

324. Group of People 1959

35.6 × 25.5 cm.

RECTO: Watercolour on paper

Signed b.r: L. S. Lowry 19th August 1959

EXH: Harrogate 1960 (116); Norwich 1970; Wigan 1976

LIT: Levy, 1975, Pl. 16; Levy, 1978, Pl. 16; Salford Lowry Collection, 1977 (150)

VERSO: Head of a Man c.1959

Watercolour

Unsigned

LIT: Salford Lowry Collection, 1977 (153), repr.

PROV: purchased from the artist, 1959

325. Yachts 1959

Watercolour on paper. 26 × 36.2 cm.

Signed b.r: L. S. Lowry 1959

EXH: Royal Academy 1976 (250); Sheffield 1979; Swansea 1980

LIT: Levy, 1975, Pl. 28; Salford Lowry Collection, 1977 (151); Levy, 1978, Pl. 28; Sieja, 1983, p. 93; Great Artists, 1986, p. 2281, repr.

PROV: purchased from the artist, 1959

326. Gentleman Looking at Something 1960

Oil on hardboard. 24.5 × 10 cm.

Signed b.l: L. S. Lowry 1960

EXH: Liverpool 1973 (67)

LIT: Salford Lowry Collection, 1977 (154)

PROV: purchased from the artist, 1961

327. St Mary's Church, Swinton 1960

Oil on board. 22 × 14.5 cm.

Signed b.r: L. S. Lowry 1960

EXH: Swinton 1970 (17); Accrington 1971 (72); Leigh 1972 (58)

LIT: Salford Lowry Collection, 1977 (156)

PROV: purchased from the artist by Gerald Cotton; presented, 1966 (Swinton Collection)

A Roman Catholic church which stood on the corner of Swinton Hall Road opposite Victoria Park and adjacent to the Acme Mill. Lowry made a number of views from the top of Temple Drive looking down the alley towards the church. See 121, 437.

328. Man in Overcoat 1960 (Fig. 41)

Pencil on paper. 30.6 × 22.6 cm.

Signed b.r: L. S. Lowry 1960

EXH: Norwich 1970; Wigan 1976; Sheffield 1979; Stockport 1980

LIT: Levy, 1976, Pl. 235; Salford Lowry Collection, 1977 (155), repr.

PROV: purchased from the artist, 1963

In his later life, the artist moved away from large composite pictures to small portrayals of individual figures. He considered that these figure studies were as important as anything he achieved earlier, although critics have called them 'types, not characters'.

In the March 1963 issue of *Studio*, Lowry comments: 'I am particularly interested in down-and-outs, and misfits. . . . In fact I'm interested in all curious people, but especially in the sordidness of down-and-outs. I am not really interested in the human story behind these characters, only in what they have become, and in how their defeat and poverty have helped to isolate them, to set them apart, and give them the curious, often comical, look that interests me.'

329. Houses on a Hill 1960

Pencil on paper. 25 × 35.2 cm.

Signed b.r: L. S. Lowry 1960

EXH: Stalybridge 1983 (22); Swansea 1985 (7)

PROV: purchased from the artist's estate, 1981

Brookes number

330. Head of a Boy c.1960

Oil on board. 21.5 × 21 cm.

Unsigned

LIT: (Leber and Sandling), 1983, repr.

PROV: purchased from the artist's estate, 1981

331. Seascale, Cumbria c.1960

Blue ballpoint pen on paper. 9 × 13.8 cm.

Unsigned

PROV: purchased from the artist's estate, 1981

On the reverse of a postcard of Queen Street, Aspatria. Lowry went to Aspatria with the artist Sheila Fell who came from that village.

332. Harrington c.1960

17.5 × 9.1 cm.

RECTO: Pencil on paper

Signed b.r: LSL

Inscribed b.l: Harrington

A small village on the north-east coast.

VERSO: Steps and Railings

Pencil

Signed b.r: LSL

PROV: purchased from the artist's estate, 1981

333. In Edinburgh c.1960

Pencil on paper. 29.6 × 36.6 cm.

Signed b.r: L. S. Lowry

Inscribed b.l: In Edinburgh

PROV: purchased from the artist's estate, 1981

334. Yachts c.1960

Pencil on paper. 25.7 × 14.6 cm.

Unsigned

PROV: purchased from the artist's estate, 1981

335. Man Shouting c.1960

Pencil and ballpoint pen on paper. 13.2 × 8.8 cm.

Signed in pencil b.r: LSL

EXH: Stalybridge 1983 (24)

PROV: purchased from the artist's estate, 1981

336. A Meeting c.1960

Blue ballpoint pen on paper. 17.7 × 12.5 cm.

Unsigned

EXH: Swansea 1985 (25)

LIT: Rohde, 1979, chapter heading, p. 110

PROV: purchased from the artist's estate, 1981

337. A Mill c.1960

Black ballpoint pen on card. 11.5 × 15.2 cm.

Unsigned

PROV: purchased from the artist's estate, 1981

On the reverse of a Royal Academy invitation card.

338. Wreck at South Shields 1961

Pencil on paper. 25.1 × 34.5 cm.

Signed and inscribed b.l: L. S. Lowry 1961 Adelfotis Beirot

Inscribed b.r: Wreck at South Shields

EXH: Royal Academy 1976 (271)

PROV: purchased from the artist's estate, 1981

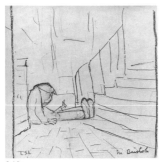

340

357

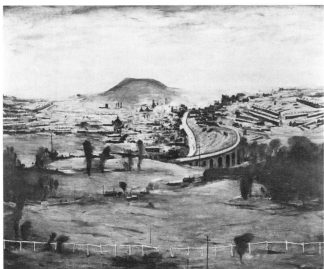

361

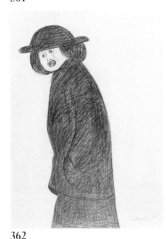

362

366

370

355

339. Over the Hill 1961
Pencil on paper. 34.5 × 25.1 cm.
Signed b.r: L. S. Lowry 1961
Inscribed on reverse: Over the Hill
PROV: purchased from the artist's estate, 1981
Brookes number

340. In Bristol c.1961
Blue ballpoint pen over pencil on paper. 12.8 × 13.3 cm.
Signed in pencil b.l: LSL
Inscribed in blue ballpoint pen b.r: In Bristol
PROV: purchased from the artist's estate, 1981

This drawing is a sketch for the painting *Man Lying at the Foot of Stairs*, 1961.

341. Two People 1962 (Pl. 36)
Oil on plywood. 29.5 × 24.5 cm.
Signed b.l: L. S. Lowry 1962
EXH: Norwich 1970; Liverpool 1973 (84)
LIT: Salford Lowry Collection, 1977 (157)
PROV: purchased from the artist, 1963

342. Footbridge at Newbiggin 1962
Blue ballpoint pen and pencil on paper. 13 × 20.5 cm.
Signed in black ballpoint pen b.r: LSL 1962
Inscribed in pencil on reverse: Newbiggin
PROV: purchased from the artist's estate, 1981

Sketch is on the reverse of Seaburn Hotel notepaper.

343. Footbridge at Newbiggin c.1962
Blue ballpoint pen on paper. 13 × 20.4 cm.
Unsigned
Inscribed on reverse: Footbridge at Newbiggin
PROV: purchased from the artist's estate, 1981

Sketch is on the reverse of Seaburn Hotel notepaper.

344. A Street (and Other Sketch) c.1962
25.5 × 20.5 cm.
RECTO: Blue ballpoint pen on paper
 Unsigned
 Inscribed with a list of numbers
VERSO: Single-decker Bus
 Blue ballpoint pen
 Unsigned

PROV: purchased from the artist's estate, 1981

Sketches are on a letter, dated 28 August 1962, from Mr G. H. Reid to L. S. Lowry.

345. Eccles Railway Station 1963
Pencil on paper. 25.6 × 35.6 cm.
Signed b.l: L. S. Lowry 1963
EXH: Swinton 1970 (44); Accrington 1971 (79); Leigh 1972 (63)
LIT: Salford Lowry Collection, 1977 (158), repr.
PROV: commissioned by Eccles Corporation, 1963 (Monks Hall Collection)

In 1963 Lowry was invited to Eccles to discuss a planned exhibition at Monks Hall Museum. It was suggested that he might undertake one or two local views. Lowry agreed but mentioned that he was carrying no drawing materials. Frank Mullineux, the keeper of the museum, hastily purchased a sketch pad and pencils and the commission got under way. Lowry sat unrecognized on a bench and made several sketches of the railway station (see 346, 347, 348). After making more sketches of the Town Hall, he returned to Mottram to complete the drawings.

346. Eccles Railway Station (preliminary sketch) 1963
Blue ballpoint pen on paper. 12.8 × 17.8 cm.
Unsigned
PROV: presented by Mr Frank Mullineux, 1983

Numbers 346–8, 350, 351, 354–6 are on loose pages from a Rowney sketch pad.

347. Eccles Railway Station and Chimney (preliminary sketch) 1963
Blue ballpoint pen on paper. 12.8 × 17.8 cm.
Unsigned
PROV: presented by Mr Frank Mullineux, 1983

348. Eccles Railway Station (preliminary sketch) 1963
Blue ballpoint pen on paper. 12.8 × 35.6 cm.
Signed in black ballpoint pen b.l: L. S. Lowry 1963
Inscribed right of centre above

roof, with line to building:
British Rys Eccles
at left on gable:
Lower
above gable:
Lower
right of gable, with arrow
leading down:
Station cigar store
under sign:
B[]
LIT: (Leber and Sandling), 1983,
repr.
PROV: purchased from Mr Frank
Mullineux, 1983

Sketch on two pieces of Rowney
sketchpad paper glued on to
board.

349. Eccles Town Hall 1963
Pencil on paper. 34.3 × 24.8 cm.
Signed b.r: L. S. Lowry 1963
EXH: Swinton 1970 (36);
Accrington 1971 (80); Leigh
1972 (62); Sheffield 1979
LIT: Salford Lowry Collection,
1977 (159)
PROV: commissioned by Eccles
Corporation, 1963 (Monks Hall
Collection)

Made from sketches on a visit to
Eccles. See 345, 350, 351.

350. Eccles Town Hall (pre-
liminary sketch) 1963
Black ballpoint pen on paper.
12.8 × 17.8 cm.
Unsigned
PROV: presented by Mr Frank
Mullineux, 1983

351. Town Hall, Eccles 1963
Black ballpoint pen on paper.
17.8 × 12.8 cm.
Signed b.r: LSL 63
PROV: presented by Mr Frank
Mullineux, 1983

352. At Anchor 1963
Pencil on paper. 25.4 × 34 cm.
Signed b.l: L. S. Lowry 1963
PROV: purchased from the artist's
estate, 1981

353. Three Figures with a Dog
1963
Black ballpoint pen on paper.
17.8 × 12.8 cm.
Signed b.r: L. S. Lowry 1963
PROV: purchased from Mr Frank
Mullineux, 1983

354. Four Figures 1963
Black ballpoint pen on paper.
17.8 × 12.8 cm.
Signed b.l: LSL; dated b.r: 1963

PROV: presented by Mr Frank
Mullineux, 1983

355. Spotted Dog 1963
Black ballpoint pen on paper.
17.8 × 12.8 cm.
Unsigned
PROV: presented by Mr Frank
Mullineux, 1983

356. Group of Figures 1963
Black ballpoint pen on paper.
12.8 × 17.8 cm.
Signed b.r: LSL
EXH: Swansea 1985 (22)
PROV: presented by Mr Frank
Mullineux, 1983

**357. Man Playing a Harp,
Brighton** 1963
Blue ballpoint pen on paper.
11.4 × 17.6 cm.
(*left sketch*) Signed in blue ball-
point pen b.l: LSL
Dated in black ballpoint pen b.l:
1963
Inscribed in pencil b.r: Brighton
(*right sketch*) Signed in black ball-
point pen b.r: LSL
Dated in blue ballpoint pen b.r:
1963
EXH: Royal Academy 1976 (334)
PROV: purchased from the artist's
estate, 1981

On the reverse of a letter to Lowry
from Carol Ann Lowry. Lowry
also did an oil painting of this
subject.

358. The Sea 1963 (Pl. 37)
Oil on canvas. 76.6 × 102.3 cm.
Signed b.l: L. S. Lowry 1963
PROV: the artist; Stone Gallery;
Monty Bloom; Hamet Gallery;
Dr F. H. Kroch; presented by
Mrs Carol Kroch Rhodes in
memory of her father, Dr F. H.
Kroch, 1985

The artist had a lifelong fasci-
nation with the sea. Whilst many
of his early seascapes are holiday
reminiscences, the empty sea-
scapes of the 1950s and 1960s
reflect a more introspective
approach. See 14, 43, 297.

359. Ferry c.1963
Black ballpoint pen on paper.
12.1 × 15.3 cm.
Signed in blue ballpoint pen b.l:
LSL
Inscribed below drawing: Light
green with gold streak rest yellow
PROV: purchased from the artist's
estate, 1981

Drawing on the reverse of an in-
vitation card from Lefevre Gallery
for an exhibition of drawings by
the artist from Wednesday, 6
March to Friday, 29 March 1963.

360. Mill Scene 1965
Oil on canvas. 51 × 61.1 cm.
Signed b.l: L. S. Lowry 1965
EXH: Swinton 1970 (1); Royal
Academy 1976 (303); Bolton
1983
LIT: Salford Lowry Collection,
1977 (160), repr.
PROV: purchased from the artist
and presented by the Memorial
Hall Committee, 1970 (Swin-
ton Collection)

361. Bargoed 1965
Oil on canvas. 122.2 × 151.7 cm.
Signed b.l: L. S. Lowry 1965
PROV: Alex Reid & Lefevre Ltd.;
private collection; purchased
by public appeal for Salford Art
Gallery, 1987

See 13, 61.

362. Woman in Black 1965
Pencil on paper. 34.7 × 25.4 cm.
Signed b.r: L. S. Lowry 1965
PROV: purchased from the artist's
estate, 1981
Brookes number

363. Tanker c.1965
Oil on board. 25.3 × 35.5 cm.
Unsigned
PROV: purchased from the artist's
estate, 1981

364. A Beggar c.1965
Oil on board. 19 × 11.5 cm.
Unsigned
LIT: Spalding, 1979, Pl. 44;
(Leber and Sandling), 1983,
repr.
PROV: purchased from the artist's
estate, 1981

365. A Ship c.1965 (Fig. 20)
Oil on board. 11.5 × 19 cm.
Unsigned
PROV: purchased from the artist's
estate, 1981

366. People with Dogs c.1965
Oil on board. 18 × 13 cm.
Unsigned
PROV: purchased from the artist's
estate, 1981

367. Four Figures c.1965
Oil on board. 19 × 15.2 cm.
Unsigned
LIT: Spalding, 1979, Pl. 44
PROV: purchased from the artist's
estate, 1981

368. Teenagers c.1965
Oil on board. 25.5 × 21.5 cm.
Unsigned
PROV: purchased from the artist's
estate, 1981

369. On the Thames c.1965
Pencil with blue and black ball-
point pen on card. 11 × 22.5 cm.
Signed in blue ballpoint pen b.l:
LSL
Inscribed on reverse: On the
Thames
PROV: purchased from the artist's
estate, 1981

The sketch is on the reverse of a
New Year greetings card from
Granada Television. In 1966, in
an interview with Edwin Mullins,
Lowry mentioned that he had
done 'one or two things on the
Thames as well'.

**370. Sea Tests off South
Shields** c.1965
Blue ballpoint pen and pencil on
paper. 12.8 × 20.5 cm.
Signed in blue ballpoint pen b.l:
LSL
Inscribed on reverse: Sea Tests off
South Shields
PROV: purchased from the artist's
estate, 1981

On Seaburn Hotel notepaper.

371. Harrington c.1965
Blue ballpoint pen on paper.
10.5 × 13.9 cm.
Unsigned
Inscribed in pencil on reverse:
Harrington
PROV: purchased from the artist's
estate, 1981

On envelope sent from Tyne Tees
Television. See 332.

372. Llanthony Church c.1965
Blue ballpoint pen and pencil on
paper. 17.6 × 25.1 cm.
Signed b.l: L. S. Lowry
Inscribed b.r: Llanthony Church
EXH: Swansea 1985 (23)
PROV: presented by Mr Frank
Mullineux, 1983

From a sketch pad.

377

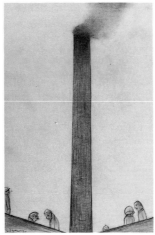

381

384

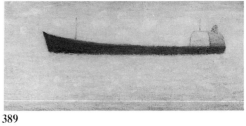

389

382

386

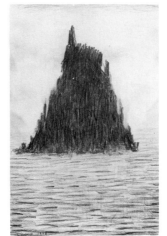

391

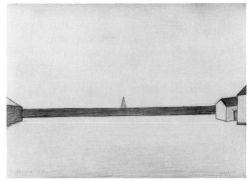

395

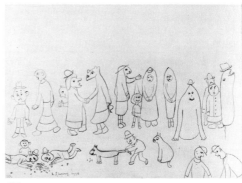

402

397

399

373. Bamburgh Castle *c*.1965
Blue ballpoint pen and pencil on paper. 25.3 × 17.8 cm.
(*above*) Bamburgh Castle in Landscape
Signed in pencil b.l: LSL
Inscribed left centre: large
Inscribed on reverse: Bamburgh Castle
(*below*) Bamburgh Castle in Landscape
Signed in pencil b.r: LSL
Inscribed on reverse: Bamburgh
PROV: purchased from the artist's estate, 1981

374. Cargo Boat, Poole *c*.1965
Faded black felt tip pen and pencil on paper. 25.2 × 35.7 cm.
Signed in blue ballpoint pen b.l: L. S. Lowry
Inscribed in blue ballpoint pen b.r: Poole
PROV: purchased from the artist's estate, 1981

375. 'Apple Annie', Newcastle *c*.1965
Pencil on paper. 15.9 × 14.8 cm.
Signed b.r: LSL
Inscribed b.l: Newcastle
Inscribed on reverse: Apple Annie, Newcastle
PROV: purchased from the artist's estate, 1981

376. Man on a Park Bench *c*.1965
Pencil on paper. 11.7 × 15.5 cm.
Unsigned
PROV: purchased from the artist's estate, 1981

377. Man with a Walking Stick *c*.1965
Red ballpoint pen and pencil on paper. 18.8 × 9 cm.
Unsigned
EXH: Stalybridge 1983 (26)

PROV: purchased from the artist's estate, 1981

On reverse of envelope addressed to the artist.

378. Man with a Flat Hat *c*.1965
Black ballpoint pen with pencil on paper. 15.6 × 10.9 cm.
Signed in pencil b.l: LSL
EXH: Stalybridge 1983 (27)
LIT: Rohde, 1979, chapter heading, p. 269
PROV: purchased from the artist's estate, 1981

On Swallow Hotels envelope.

379. Pantomime Cat *c*.1965
Pencil on paper. 13.7 × 17.8 cm.
Unsigned
PROV: purchased from the artist's estate, 1981

On reverse of The Elms notepaper.

380. Boats at Sea *c*.1965
Blue ballpoint pen on paper.
13 × 20.8 cm.
Unsigned
EXH: Swansea 1985 (19)
PROV: purchased from the artist's
estate, 1981

On reverse of Seaburn Hotel
notepaper.

381. The Chimney *c*.1965
Pencil on paper. 40.3 × 28 cm.
Signed b.l: L. S. Lowry
PROV: purchased from the artist's
estate, 1981
Brookes number

382. Teenager *c*.1965
Pencil on paper. 37.7 × 19.7 cm.
Unsigned
PROV: purchased from the artist's
estate, 1981

383. A Ship *c*.1965 (Fig. 39)
Pencil on paper. 17.7 × 24.5 cm.
Signed b.r: LSL
PROV: purchased from the artist's
estate, 1981

384. Man in an Archway *c*.1965
37 × 26.5 cm.
RECTO: Pencil on paper
 Signed b.l: L. S. Lowry
 EXH: Stalybridge 1983 (32) as *Man
 in Bowler Hat*
VERSO: Sketch of Kiosks
 Pencil
 Unsigned
 Inscribed t.r: taller

PROV: purchased from the artist's
estate, 1981

385. Group of Figures 1966
Black ballpoint pen on paper.
20.3 × 29.9 cm.
Signed b.r: F. Lowry Esq.
PROV: purchased from Mr Frank
Mullineux, 1983

On the back of De Moorcock Inn
Menu, Waddington, near
Clitheroe—menu dated Sunday,
8 May 1966.
 'Lots of people have an L. S.
Lowry, nobody has a Fred
Lowry,' joked the artist.

**386. Minimal Drawing of a
Girl** 1966
Pencil on paper. 21.7 × 15.5 cm.
Signed and inscribed across
centre: L. S. Lowry Carlisle 2
April 1966
Inscribed in pencil on reverse:
Minimal drawing of a girl drawn
specially for Alice Bennett

LIT: Levy, 1976, Pl. 246
PROV: presented by the Revd
Geoffrey Bennett, 1983

**387. On the Sands, Sunder-
land** 1966
Pencil on paper. 13 × 20.5 cm.
Signed and inscribed b.r: LSL
1966 On the Sands, Sunderland
PROV: purchased from the artist's
estate, 1981

On the reverse of Seaburn Hotel
paper.
 A return after forty years to the
theme of figures on a beach. See
192–5.

388. Statue and Birds *c*.1966
Blue ballpoint pen and pencil on
paper. 25.4 × 20.3 cm.
Unsigned
PROV: purchased from the artist's
estate, 1981

Drawing on the reverse of a letter,
dated 11 May 1964, addressed to
Mr Lowry.
 The artist is shown making this
sketch in Leslie Woodhead's film
made for Granada Television in
1966. The statue stands in Albert
Square, Manchester, and depicts
W. E. Gladstone. Lowry also
painted the same subject.

**389. Waiting for the Tide,
South Shields** 1967
Oil on canvas. 15.1 × 30.5 cm.
Signed b.r: L. S. Lowry 1967
EXH: Liverpool 1973 (89);
Sheffield 1979; Arts Council
1983/4 (38) repr.
LIT: Salford Lowry Collection,
1977 (161), repr.; Spalding,
1979, p. 13
PROV: purchased from the artist,
1971

390. Ancoats *c*.1967
Blue ballpoint pen over pencil on
paper. 13 × 20.6 cm.
Signed in pencil b.l: LSL; over-
signed in blue ballpoint pen at
second L: Lowry
Inscribed in pencil b.r: Ancoats
Inscribed within drawing: black
new brick No Road this bridge
LIT: (Leber and Sandling), 1983,
repr.
PROV: purchased from the artist's
estate, 1981

Reverse of letterheaded paper of
Jewish Woman's Discussion
Group, dated 4 May 1967. It was
in Ancoats that Lowry made many
sketches and drawings in the late
1920s. See 256.

391. The Rock 1968
Pencil on paper. 41.7 × 29.6 cm.
Signed b.l: L. S. Lowry 1968
PROV: purchased from the artist's
estate, 1981
Brookes number

392. Tanker at Sea 1968
Pencil on paper. 29.7 × 41.8 cm.
Signed b.l: L. S. Lowry 1968
LIT: (Leber and Sandling), 1983,
repr.
PROV: purchased from the artist's
estate, 1981
Brookes number

393. Maryport 1968
Pencil on paper. 29.3 × 41.6 cm.
Signed b.l: L. S. Lowry 1968
Inscribed b.r: Maryport
PROV: purchased from the artist's
estate, 1981
Brookes number

394. Maryport *c*.1968
Blue ballpoint pen and pencil on
paper. 10.9 × 13.8 cm.
Signed b.r: LSL
Inscribed on reverse: Maryport
PROV: purchased from the artist's
estate, 1981

Reverse is envelope addressed to
Sheila Fell, dated 9/7/1968.

395. Maryport *c*.1968
Pencil on paper. 18 × 22.9 cm.
Signed b.l: L. S. Lowry
Inscribed b.r: Maryport
EXH: Stalybridge 1983 (29);
Swansea 1985 (17)
PROV: purchased from the artist's
estate, 1981

On reverse of The Elms
notepaper.

396. Group of Figures *c*.1968
Pencil on paper. 11.5 × 15.3 cm.
Unsigned
EXH: Stalybridge 1983 (25)
PROV: purchased from the artist's
estate, 1981

Reverse of Royal Academy in-
vitation to Summer Exhibition
1968.

397. Woman in Black 1969
Felt tip pen over pencil on paper.
29.4 × 41 cm.
Signed in blue ballpoint pen b.r:
L. S. Lowry 1969
PROV: purchased from the artist's
estate, 1981
Brookes number

398. The Sea 1969
Blue ballpoint pen over pencil on
paper. 20.8 × 23.6 cm.
Signed in pencil b.r: L. S. Lowry
1969
PROV: purchased from the artist's
estate, 1981

On the reverse of a list of Swallow
Group Hotels.

399. Yachts *c*.1969
Black ballpoint pen on paper.
12.7 × 18.8 cm.
Signed in pencil b.r: LSL
PROV: purchased from the artist's
estate, 1981

On reverse of Hamet Gallery in-
vitation to Sculpture of Michael
Ayrton 1954–1966, Tuesday,
4 March 1969. Ayrton was one of
Lowry's fiercest critics.

400. Woman with a Handbag
c.1969
Oil on board. 16.7 × 11.9 cm.
Unsigned
PROV: purchased from the artist's
estate, 1981

**401. Man in Black Coat and
Bowler Hat** 1970
Black felt tip pen and pencil on
paper. 40.8 × 29.5 cm.
Signed in blue ballpoint pen b.l:
L. S. Lowry 1970
PROV: purchased from the artist's
estate, 1981
Brookes number

402. A Game of Marbles 1970
Pencil on paper. 25.2 × 35.3 cm.
Signed b.l: L. S. Lowry 1970
PROV: purchased from the artist's
estate, 1981

The artist was as puzzled as any-
body about the half-animal and
half-ghost figures he drew late in
his life. 'They just come when I
put pencil to paper,' he explained
to Frank Mullineux.

403. The Shark 1970 (Fig. 22)
Pencil and black ballpoint pen,
with traces of felt tip on paper.
25.4 × 35.6 cm.
Signed b.l: L. S. Lowry 1970
LIT: Rohde, 1979, chapter head-
ing, p. 255; (Leber and
Sandling), 1983, repr.
PROV: purchased from the artist's
estate, 1981
Brookes number

Lowry identified the figure being
consumed by the shark as himself.

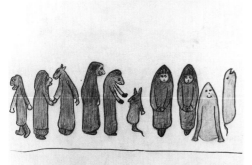

407

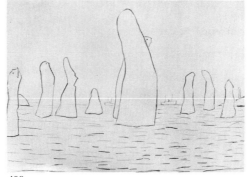

408

415

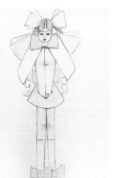

422

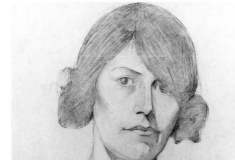

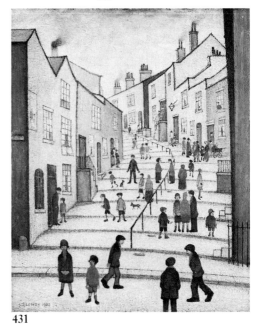

425

431

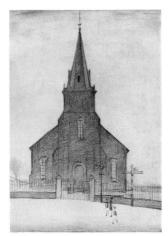

427

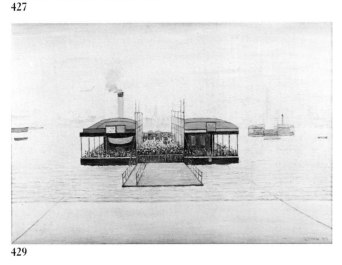

429

404. The Appeal 1970
Pencil on paper. 29.5 × 21 cm.
Signed b.r: LSL 1970
PROV: purchased from the artist's
 estate, 1981

405. Meeting Friends *c*.1970
Pencil on paper. 30.6 × 22.7 cm.
Unsigned
PROV: purchased from Mr Frank
 Mullineux, 1983

On reverse in black pen: auto-
graph address of Frank
Mullineux.

406. Offering a Hand *c*.1970
 (Fig. 28)
Pencil on paper. 34.4 × 25.5 cm.
Signed b.l: L. S. Lowry
PROV: purchased from the artist's
 estate, 1981
Brookes number

407. The Group 1970
Pencil and black felt tip pen on
paper. 29.5 × 41.7 cm.
Signed in pencil: L. S. Lowry
1970
EXH: Stalybridge 1983 (33) as
 Figures and Animals
PROV: purchased from the artist's
 estate, 1981
Brookes number

408. In the Sea *c*.1970
Pencil on paper. 29.6 × 41.9 cm.
Unsigned
PROV: purchased from the artist's
 estate, 1981
Brookes number

409. Man in an Overcoat *c*.1970
Pencil on paper. 41.9 × 29.5 cm.
Signed b.r: L. S. Lowry
LIT: (Leber and Sandling), 1983,
 repr.

PROV: purchased from the artist's estate, 1981

410. Wall by the Sea c.1970
Pencil on paper. 29.6 × 41.8 cm.
Unsigned
PROV: purchased from the artist's estate, 1981

411. Two Women on a Promenade (and Other Sketches) c.1970
20.4 × 12.9 cm.
RECTO: Black ballpoint pen on paper
Unsigned
VERSO: Various Sketches
Black ballpoint pen
Unsigned
PROV: purchased from the artist's estate, 1981

On Seaburn Hotel notepaper.

412. Man and a Dog c.1970
Pencil on paper. 29.6 × 20.5 cm.
Unsigned
PROV: purchased from the artist's estate, 1981

In an A3 spiral bound sketchpad.

413. Figures and Two Dogs 1971
Felt tip pen on paper. 41.1 × 29.5 cm.
Signed in blue ballpoint pen b.r: L. S. Lowry 1971
PROV: purchased from the artist's estate, 1981
Brookes number

414. The Greeting 1972
Pencil on paper. 29.2 × 41 cm.
Signed in black ballpoint pen b.r: L. S. Lowry 1972
LIT: (Leber and Sandling), 1983, repr. as *Men Shaking Hands*
PROV: purchased from the artist's estate, 1981
Brookes number

415. The Notice Board 1972
Black felt tip pen and pencil on paper. 40.9 × 29.4 cm.
Signed in blue ballpoint pen b.r: L. S. Lowry 1972
PROV: purchased from the artist's estate, 1981
Brookes number

416. Woman on a Promenade 1972
Pencil on paper. 29.4 × 40.9 cm.
Signed in black ballpoint pen b.r: L. S. Lowry 1972

LIT: (Leber and Sandling), 1983, repr.
PROV: purchased from the artist's estate, 1981
Brookes number

Lowry also did a painting of the same subject.

417. Girl with Bows c.1973
Pencil on paper. 21 × 10.5 cm.
Unsigned
PROV: purchased from the artist's estate, 1981

On reverse of invitation to College Party, Royal College of Art.

418. Girl with Bows c.1973
Black felt tip pen and pencil on paper. 28.8 × 22.3 cm.
Unsigned
PROV: purchased from the artist's estate, 1981

419. Girl with a Bow c.1973
Pencil on paper. 33 × 21.5 cm.
Unsigned
PROV: purchased from the artist's estate, 1981

On the reverse of a photocopied birthday card.

420. Girl with Bows c.1973
Black and red pencil on paper. 28.2 × 22.3 cm.
Unsigned
PROV: purchased from the artist's estate, 1981

421. Girl with Bows c.1973
Pencil on paper. 29.7 × 21 cm.
Unsigned
PROV: purchased from the artist's estate, 1981

422. Girl with Bows c.1973
Black and red pencil on paper. 29.8 × 21 cm.
Unsigned
PROV: purchased from the artist's estate, 1981

423. Girl with a Bow c.1973
Pencil on paper. 41.6 × 29.6 cm.
Unsigned
PROV: purchased from the artist's estate, 1981

424. High Heels c.1973
Pencil on paper. 34.7 × 25.9 cm.
Signed b.r: L. S. Lowry
LIT: Rohde, 1979, Pl. XIV
PROV: purchased from the artist's estate, 1981
Brookes number

SHEFFIELD
City Art Galleries

425. Woman's Head with Figures c.1916
Pencil on paper. 52.7 × 36.2 cm.
Signed t.r: L. S. Lowry
EXH: Mercury Gallery 1965; Accrington 1971 (6); Leigh 1972 (4)
PROV: purchased from Mercury Gallery, London, 1965

A study from Lowry's time at art school.

426. Street Scene c.1925 (Fig. 12)
40.7 × 50.1 cm.
RECTO: Oil on panel.
Signed b.l: L. S. Lowry
EXH: Arts Council 1966/7 (25); Accrington 1971 (51); Leigh 1972 (46); Nottingham 1974 (5) Pl. IV; Royal Academy 1976 (57); Scottish Arts Council 1977/8 (33)
Street Scene is one of several pictures which can be related to *Coming from the Mill* c.1917–18 (140). The same basic composition was repeated in 1928 with *Coming Home from the Mill* (70) and, in 1930, in *Coming from the Mill* (255).
VERSO: *Portrait of a Fire-watcher* 1943
Oil
Signed b.l: L. S. Lowry 1943
EXH: Arts Council, 'Paintings with Red in Them' 1983
Lowry was himself a fire-watcher during the Second World War.

PROV: artist to G. Corcoran of Alex Reid & Lefevre Ltd.; purchased from Alex Reid & Lefevre Ltd., 1965

427. The Old Church c.1950–60
Pencil on paper. 38.1 × 27.3 cm.
Unsigned
EXH: Accrington 1971 (69); Leigh 1972 (78)
PROV: Alex Reid & Lefevre Ltd.; purchased Christie's, 11 December 1970, lot 48

Compare Royal Academy 1976 (174), *Church, Wath Brow, Cleator Moor*, coll. of the Revd G. Bennett, dated 1948.

SOUTHAMPTON
Art Gallery

428. The Canal Bridge 1949 (Fig. 44)

Oil on canvas. 71 × 91.2 cm.
Signed b.r: L. S. Lowry 1949
EXH: Lefevre Gallery 1951 (28) repr.
LIT: Ingham, 1977, Pl. 5
PROV: purchased from Alex Reid & Lefevre Ltd., 1951

Compare *Industrial Panorama* (97).

429. The Floating Bridge, Southampton 1956
Oil on canvas. 50.8 × 76.3 cm.
Signed b.r: L. S. Lowry 1956
EXH: Lefevre Gallery 1956 (19); Arts Council 1966/7 (78); Le Havre 1975 (16); Royal Academy 1976 (220); Chichester 1985
PROV: purchased from Alex Reid & Lefevre Ltd., 1956

A combination of crowds of people, condensed on the ferries, and empty space. The subject is Woolston Ferry which crossed the River Itchen until the mid-1970s. Betty Doe, in *The Lady* of 3 May 1984, remembered: 'passengers cramming on board, shoulder to shoulder, just as Lowry depicted them . . .'

SOUTHPORT
Atkinson Art Gallery

430. Street Scene 1935 (Pl. 15)
Oil on canvas. 43 × 53 cm.
Signed b.l: L. S. Lowry 1935
EXH: Salford 1951 (52); Manchester 1959 (27); Pendlebury 1961 (25); Sheffield 1962 (19); Pendlebury 1964 (27); Swinton 1970 (14); Rochdale 1970; Kirkcaldy 1971; Liverpool 1973 (36) Pl. 11; Royal Academy 1976 (111)
PROV: purchased from Atkinson Art Gallery Spring Exhibition, 1939

Painted from a drawing of George Street, Pendlebury, in the district's 'Stump Park' near to the Acme Mill. See *Pendlebury Scene* (269).

STOCKPORT
Art Gallery

431. A Street in Stockport: Crowther Street 1930
Oil on board. 51.5 × 41.3 cm.
Signed b.l: L. S. Lowry 1930
EXH: Royal Academy 1933; Salford 1951 (36)

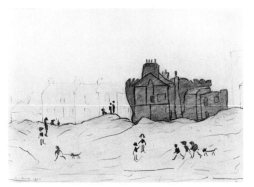

435

436

440

PROV: purchased from James Bourlet and Sons, 1935

One of several workings of the same subject. In 1933 the painting was exhibited at the Royal Academy. It had presumably been submitted by James Bourlet and Sons. In a front page article, the *Manchester Evening News* proclaimed, 'Academy Honour for Stockport' and gave details of the artist's career to date.

The houses were demolished around 1967 but the street, off Middle Hillgate, survives as a footpath.

STOKE-ON-TRENT
City Museum and Art Gallery

432. The Empty House 1934 (Pl. 14)
Oil on plywood. 43.2 × 51.3 cm.
Signed b.r: L. S. Lowry 1934
EXH: Salford 1941; Salford 1951 (64); Manchester 1959 (24); Sheffield 1962 (17); Midland Area Service, 1962/3 (8); Arts Council 'Contemporary British Art' (21); Accrington 1971 (42); Leigh 1972 (41); Royal Academy 1976 (106) repr.; Scottish Arts Council 1977/8 (18)
PROV: purchased from a circulating exhibition organized by James Bourlet and Sons, 1942

The house captivated Lowry who admired Georgian architecture. Even empty and derelict it had pride and presence, both of which Lowry could associate with. The painting, inspired by an old farmhouse at Gatley, Cheshire, was called 'an essay in the dignity of solitariness' by Eric Newton in the *Guardian* of 3 June 1959. See 78.

SUNDERLAND
Museum and Art Gallery

433. Interior Discord 1922 (Fig. 7)
Pencil on paper. 27.1 × 20.9 cm.
Signed b.l: L. S. Lowry 1922
EXH: Colnaghi Gallery 1978 (4)
PROV: the artist; Colnaghi Ltd., London; purchased, 1978

A scene that Lowry must have witnessed many times in his days as a rent collector.

434. River Wear at Sunderland 1961 (Pl. 38)
Oil on board. 51 × 60 cm.
Signed b.r: L. S. Lowry 1961
EXH: Royal Academy 1976 (270)
LIT: Levy, 1975, Pl. 116
PROV: the artist; Alex Reid & Lefevre Ltd.; purchased, 1963

The view is of Lampton Drops, Sunderland. In *Nova* of August 1966, Lowry commented: 'I like Sunderland, because of the shipping and shipbuilding and the countryside at the back.'
'Some people like to go to the theatre, some like to watch television. I just like watching ships.' (Lowry, reported in the *Daily Telegraph*, 1 November 1963.)

435. Demolition – Monkwearmouth 1962
Pencil and ballpoint pen on paper. 34.8 × 43.5 cm.
Signed b.l: L. S. Lowry 1962
EXH: Stone Gallery 1967 (40)
PROV: the artist; Stone Gallery, Newcastle; purchased from private owner, 1983
Brookes number

Demolition – Roker was the original title of this drawing. In general, Lowry left the recording of

the passing of the industrial scene to others.

436. The Half Moon Inn 1963
Pencil on paper. 34.5 × 25 cm.
Signed b.r: L. S. Lowry 1963
Inscribed b.l: Sunderland
EXH: Colnaghi Gallery 1978 (28)
PROV: the artist; Colnaghi Ltd., London; purchased, 1978
Brookes number

SWINDON
Borough of Thamesdown Museum and Art Gallery

437. Winter in Pendlebury 1943 (Pl. 24)
44 × 24 cm.
RECTO: Oil on panel
Signed b.l: L. S. Lowry 1943
VERSO: *Family Group* c.1920
Oil
Unsigned
Subject incomplete
PROV: presented by H. J. P. Bomford, 1946

Winter in Pendlebury is based on St Mary's Church, Swinton (see 121 and 327), a view which Lowry first drew in 1913. This is one of Lowry's few winter scenes. A James Bourlet sticker is attached to the reverse of the picture.

WAKEFIELD
Art Gallery

438. The Tollbooth, Glasgow 1947 (Fig. 40)
Oil on paper. 55 × 45.5 cm.
Signed b.r: L. S. Lowry 1947
EXH: Lefevre Gallery 1951 (36); Salford 1951 (20); Wakefield 1955 (18) repr.; Manchester 1959 (46); Sheffield 1962 (46)

Pl. 1; Arts Council 1966/7 (57); Halifax 1968 (12); Accrington 1971 (56); Leigh 1972 (49); Arts Council 1972/3 (17); Royal Academy 1976 (172)
PROV: purchased from the artist, 1955

YORK
City of York Art Gallery

439. The Bandstand, Peel Park, Salford 1931 (Fig. 11)
Oil on canvas. 43.2 × 62.2 cm.
Signed b.l: L. S. Lowry 1931
EXH: possibly Lefevre Gallery 1939 (2); New English Art Club 1941 (283); Lefevre Gallery 1943 (19)
PROV: the artist; purchased from Alex Reid & Lefevre Ltd. by Mrs Grey, 1943; presented by Mrs Grey, 1953

An almost literal reworking of a drawing of the same title in the collection of Salford Art Gallery (207). The view is from the Royal Technical College looking across the park to Lower Broughton. The bandstand has been long demolished but in the 1920s it was a popular feature of community life.

440. Clifford's Tower, York 1953
Oil on canvas. 35.6 × 50.8 cm.
Signed b.r: L. S. Lowry 1953
EXH: Arts Council, 'British Painters of Today' 1955 (17)
PROV: purchased as the Evelyn Award, 1953

The Evelyn Award allowed for the purchase of a view of the city by a leading contemporary British artist. Generally, the value of the award was sufficient only to purchase a watercolour drawing but Lowry chose to provide an oil painting.

Select Bibliography

Abse, Dannie and Joan (compilers), *Voices in the Gallery*, The Tate Gallery, London, 1986

Andrews, Allen, *The Life of L. S. Lowry*, Jupiter Books, London 1977

Barber, Noel, *Conversations with Painters*, pp. 9–22, Collins, London, 1964

Clark, Lord *et al.*, *A Tribute to Lowry*, Monks Hall Museum, 1964

Clements, Keith, 'Artists and Places, Four: L. S. Lowry' *The Artist*, Vol. 100, no. 10, October 1985, pp. 18–21, 32

Collis, Maurice, *The Discovery of L. S. Lowry*, Alex Reid & Lefevre, London, 1951

Dolman, Bernard (ed.), *A Dictionary of Contemporary British Artists*, 1929, reprinted, Antique Collectors Club, Woodbridge, Suffolk, 1981

Great Artists = Gregory, Clive (ed.), *The Great Artists: Lowry*, Part 72, Vol. 14, Marshall Cavendish Partworks, 1986

Harries, Meirion and Susie, *The War Artists*, Michael Joseph, London, in association with the Imperial War Museum and The Tate Gallery, 1983

Ingham, Margo, *Fine Art Editions No. 2: L. S. Lowry*, Aquarius Publications, 1977

Jeffrey, Ian, *The British Landscape, 1920–1950*, Thames and Hudson, London, 1984

(Leber, Michael, and Sandling, Judith), *L. S. Lowry: His Life and Work*, City of Salford, 1983

Levy, Mervyn, *Painters of Today: L. S. Lowry*, Studio Books, London, 1961

Levy, Mervyn, *Drawings of L. S. Lowry*, Cory, Adams & Mackay, London, 1963, reprinted, Jupiter Books, London, 1973

Levy, Mervyn, *The Paintings of L. S. Lowry*, Jupiter Books, London, 1975

Levy, Mervyn, *The Drawings of L. S. Lowry: Public and Private*, Jupiter Books, London, 1976

Levy, Mervyn, *Selected Paintings of L. S. Lowry*, Jupiter Books, London, 1978 (first impression, 1976)

McLean, David, *L. S. Lowry*, The Medici Society, London, 1978

Marshall, Tilly, *Life with Lowry*, Hutchinson and Co., London, 1981

Martin, Sandra, *A Pre-Raphaelite Passion: The Private Collection of L. S. Lowry*, Manchester City Art Gallery, 1977

Phaidon Press, *Dictionary of Twentieth-Century Art*, London, 1975

Rohde, Shelley, *A Private View of L. S. Lowry*, Collins, London, 1979, reprinted, Methuen, London, 1987

Rothenstein, Sir John, *British Art Since 1900*, Phaidon Press, London, 1962

Rothenstein, Sir John, *Modern English Painters II: Lewis to Moore*, Macdonald and Jane's, London, 1976

Royal Academy, *L. S. Lowry R.A. 1887–1976*, Exhibition Catalogue, London, 1976

Salford Lowry Collection = Mullineux, Frank, and Shaw, Stanley, *L. S. Lowry: The Salford Collection*, City of Salford, 1977

Sieja, Doreen, *The Lowry I Knew*, Jupiter Books, London, 1983

Spalding, Julian, *Lowry*, Phaidon Press, London, 1979

Woods, Alan, 'Mr. Lowry: Community, Crowds, Cripples', *The Cambridge Quarterly*, Vol. 10, no. 1, pp. 1–23, 1981

Photographic Acknowledgements

The authors and publishers are grateful to all the museums, galleries and individuals who supplied photographs of works by Lowry in their collections. Acknowledgement is also due to:

The City of Salford Local History Library (page 48, below right)

Hartlepool Borough Council (Cat. illus. 23)

Kirklees Metropolitan Council (Fig. 37 and Cat. illus. 24, 26)

Lincolnshire County Council, Recreational Services: Usher Gallery, Lincoln (Plate 23 and Cat. illus. 34)

The Metropolitan Borough of Sefton, Libraries and Arts Services (Plate 15)

Mirror Group Newspapers (page 8)

Norfolk Museums Service (Cat. illus. 95)

Harold Riley (page 53, below left and right)

Rugby Borough Council (Cat. illus. 100)

The Trustees of the Cecil Higgins Art Gallery and Museum, Bedford (Cat. illus. 3, 4)

The Trustees of the Imperial War Museum, London (Fig. 15)

The Trustees of the Tate Gallery, London (Figs. 16, 36 and 45, Plates 27, 32, and Cat. illus. 56, 57, 61)

The Trustees of the Victoria and Albert Museum, London (Cat. illus. 63)

Tyne and Wear Museums Service (Fig. 7, Plates 16 and 38, and Cat. illus. 93, 435, 436)

The University of Manchester (Plate 28 and Cat. illus. 84, 85, 86, 87, 89, 90)

The University of Salford (page 85)

Special thanks are also due to Derek Seddon for his help with the illustrations in this book.

Index